Picture Bible Old Testament

Volume 1
Genesis to I Samuel 16

Script by Iva Hoth
Illustrations
by André Le Blanc
Bible Editor
C. Elvan Olmstead, Ph.D

SCRIPTURE UNION
47 Marylebone Lane, London W1M 6AX

© 1973 David C. Cook Publishing Company, Elgin, Illinois 60120
First published 1973
First published in this edition 1978 by Scripture Union, 47
Marylebone Lane, London W1M 6AX.

ISBN 0 85421 531 X

Printed in Great Britain by Purnell & Sons Ltd.
Paulton (Bristol) and London.

Picture Bible
Old Testament

Volume 1
Genesis
to
I Samuel 16

Calgarm
Sabbath
School

PRESENTED TO

Alison McClean

December 1980

KERING & INGLIS LTD. PRINTED IN GREAT BRITAIN

Also in this series:

ILLUSTRATED STORIES

FOREWORD

Much of the information we receive comes to us visually—on television, through adverts, in newspapers. So we find it increasingly hard to concentrate on a mass of solid print.

This is why the Picture Bible has been produced. It is for everyone for whom reading can be a boring chore. It is not designed to displace the more usual Bible, but it is a Bible reading aid, a way-in for people to read and enjoy the Bible for themselves.

The Brazilian artist, André Le Blanc, researched and checked each detail of the artwork, making many trips to the Middle East and visiting villages where the way of life has barely changed since Bible times. He studied the landscape of Palestine and the features and facial expressions of its people.

As a result, the Bible stories are presented vividly and accurately. Palestine becomes a real place, and the Roman and Eastern worlds living cultures. Above all, the men and women of the Bible are seen as real people who knew God in their everyday experiences.

It is our aim that men and women of today may meet this same God as they read the Picture Bible.

IN
THE BEGINNING

1st DAY

THERE WAS DARKNESS—DARKNESS AND SILENCE.
GOD CREATED HEAVEN AND EARTH. HIS SPIRIT MOVED
THROUGH THE DARKNESS AND ACROSS THE WATERS. GOD
SAID, "LET THERE BE LIGHT": AND THERE WAS LIGHT.
HOW BEAUTIFUL THE LIGHT WAS! THEN GOD DIVIDED
THE LIGHT FROM THE DARKNESS AND CALLED THE LIGHT
DAY AND THE DARKNESS NIGHT.

2nd DAY

GOD MADE THE SKY.
IN THE SKY HE PLACED CLOUDS
TO HOLD THE MOISTURE
AND THE SKY WAS CALLED HEAVEN

3rd DAY

THEN GOD GATHERED TOGETHER THE
WATERS UNDER THE SKY. HE CALLED
THESE "SEAS" AND HE NAMED THE
DRY LAND "EARTH." ON THE LAND HE
MADE GRASS AND FLOWERS AND
TREES, AND IN EACH WAS THE SEED
TO REPLENISH ITSELF. THE FRUITFUL
EARTH WAS TO
BECOME A PLACE
OF BEAUTY.

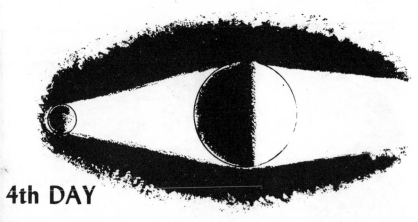

4th DAY

TO LIGHT THE EARTH,
GOD MADE THE SUN TO SHINE BY DAY, AND THE
MOON TO SHINE BY NIGHT...THE DAYS,
THE YEARS, AND THE SEASONS WERE ALSO SET
BY GOD. THEN HE MADE THE STARS
AND PLACED THEM IN THE HEAVENS.

5th DAY

GOD LOOKED UPON THE
LAND AND SEAS AND SAID:
"LET THE WATERS BRING FORTH
LIFE" — AND THE SEAS AND
RIVERS BECAME ALIVE WITH
WHALES AND FISH...
"LET THERE BE BIRDS" AND THE
OPEN SKY ABOVE THE EARTH
WAS FILLED WITH WINGED CREATURES.
"BE FRUITFUL AND MULTIPLY," GOD
SAID AS HE BLESSED THE LIVING
CREATURES OF THE SEA AND SKY.

3

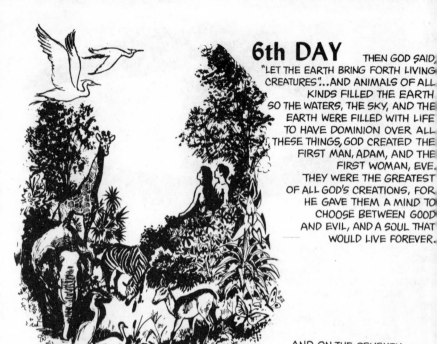

6th DAY

THEN GOD SAID, "LET THE EARTH BRING FORTH LIVING CREATURES"... AND ANIMALS OF ALL KINDS FILLED THE EARTH SO THE WATERS, THE SKY, AND THE EARTH WERE FILLED WITH LIFE TO HAVE DOMINION OVER ALL THESE THINGS, GOD CREATED THE FIRST MAN, ADAM, AND THE FIRST WOMAN, EVE. THEY WERE THE GREATEST OF ALL GOD'S CREATIONS, FOR HE GAVE THEM A MIND TO CHOOSE BETWEEN GOOD AND EVIL, AND A SOUL THAT WOULD LIVE FOREVER.

AND ON THE SEVENTH DAY GOD RESTED...

GOD TOOK ADAM AND EVE TO THE GARDEN OF EDEN AND SHOWED THEM THE BEAUTY AND FRUITFULNESS OF IT. AND GOD COMMANDED: OF EVERY TREE THOU MAYEST EAT FREELY...
BUT OF THE TREE OF KNOWLEDGE OF GOOD AND EVIL THOU MAYEST NOT EAT,
FOR IN THE DAY THAT THOU EATEST OF IT THOU SHALT SURELY DIE...

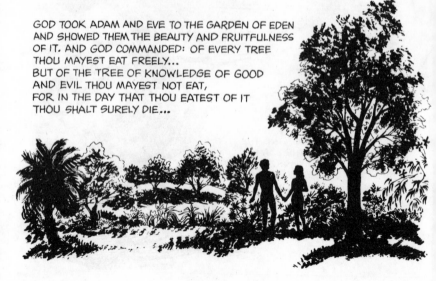

4

Temptation in the Garden

FROM GENESIS 3

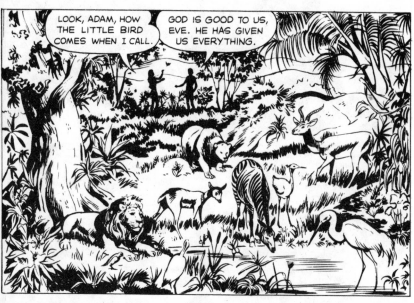

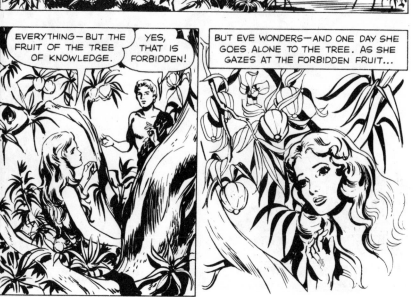

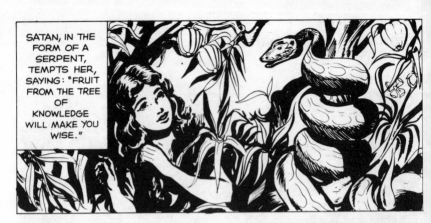

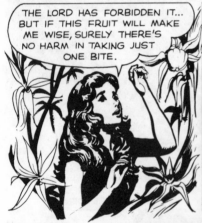

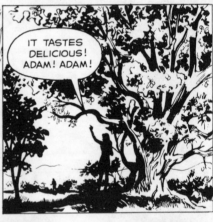

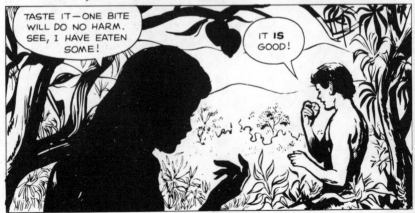

6

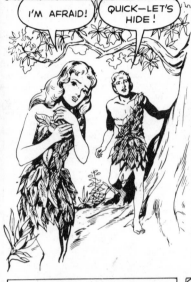

BUT ADAM AND EVE KNOW THEY HAVE DISOBEYED GOD. THEN THEY HEAR HIS VOICE CALLING THEM.

I'M AFRAID!

QUICK—LET'S HIDE!

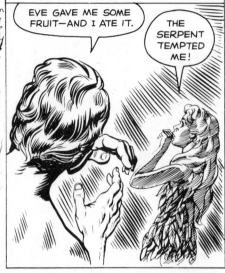

IN THE STILLNESS OF THE GARDEN THEY HEAR GOD ASK: "HAVE YOU EATEN THE FRUIT THAT I TOLD YOU NOT TO EAT?"

EVE GAVE ME SOME FRUIT—AND I ATE IT.

THE SERPENT TEMPTED ME!

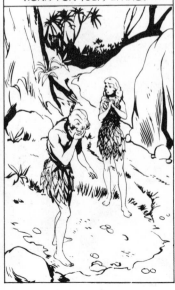

"BECAUSE YOU DISOBEYED ME," GOD SAID, "YOU MUST LEAVE THIS BEAUTIFUL GARDEN AND WORK FOR YOUR LIVING."

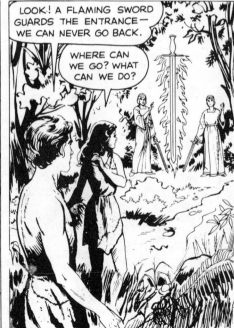

LOOK! A FLAMING SWORD GUARDS THE ENTRANCE— WE CAN NEVER GO BACK.

WHERE CAN WE GO? WHAT CAN WE DO?

Jealous Brothers

FROM GENESIS 4: 1-8

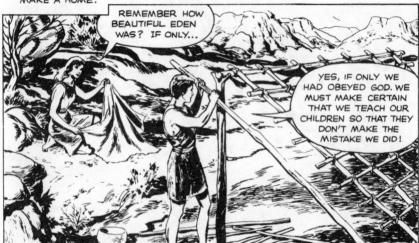

OUTSIDE THE GARDEN OF EDEN THE LAND IS BARREN, HOT AND DRY. WEARY, ALONE AND FRIGHTENED, ADAM AND EVE SEARCH UNTIL THEY FIND A PLACE TO MAKE A HOME.

REMEMBER HOW BEAUTIFUL EDEN WAS? IF ONLY...

YES, IF ONLY WE HAD OBEYED GOD. WE MUST MAKE CERTAIN THAT WE TEACH OUR CHILDREN SO THAT THEY DON'T MAKE THE MISTAKE WE DID!

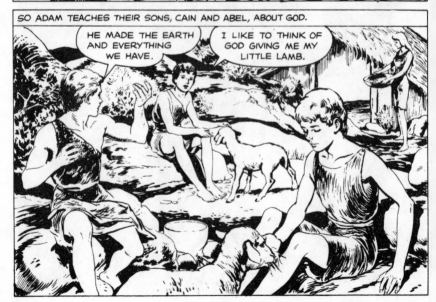

SO ADAM TEACHES THEIR SONS, CAIN AND ABEL, ABOUT GOD.

HE MADE THE EARTH AND EVERYTHING WE HAVE.

I LIKE TO THINK OF GOD GIVING ME MY LITTLE LAMB.

HOW CAN I THANK HIM?

WHEN YOU'RE OLDER, ABEL, YOU CAN GIVE GOD THE BEST OF YOUR FLOCK. HE TOLD US WE SHOULD MAKE SACRIFICES TO SHOW OUR THANKFULNESS.

AS THE BOYS GROW TO MANHOOD, ABEL PLANS FOR THE DAY WHEN HE CAN GIVE HIS THANK OFFERING TO GOD. BUT CAIN THINKS ONLY OF HIS CROPS...

IF ABEL GIVES GOD A SACRIFICE, I'LL HAVE TO OFFER ONE, TOO!

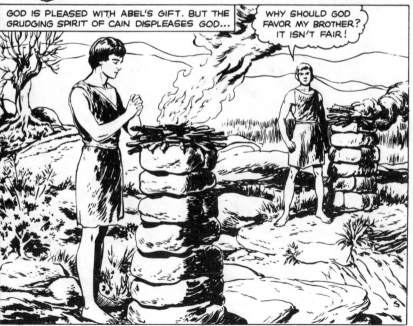

GOD IS PLEASED WITH ABEL'S GIFT. BUT THE GRUDGING SPIRIT OF CAIN DISPLEASES GOD...

WHY SHOULD GOD FAVOR MY BROTHER? IT ISN'T FAIR!

9

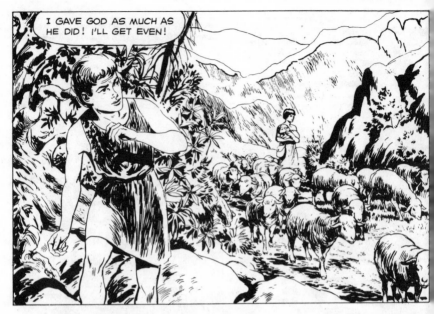

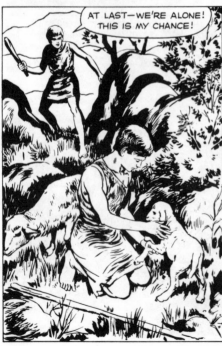

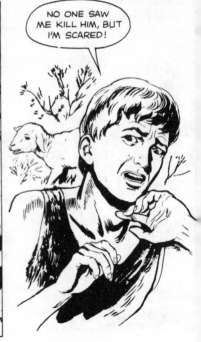

The Verdict

FROM GENESIS 4: 8-26; 5; 6: 1-8

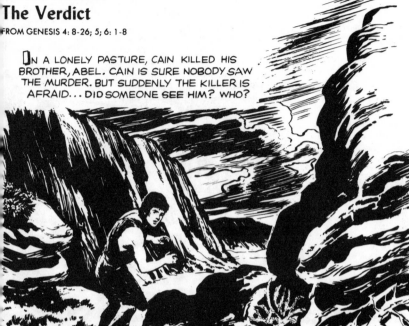

ON A LONELY PASTURE, CAIN KILLED HIS BROTHER, ABEL. CAIN IS SURE NOBODY SAW THE MURDER. BUT SUDDENLY THE KILLER IS AFRAID... DID SOMEONE SEE HIM? WHO?

HE LOOKS AROUND... AND THEN HE HEARS THE VOICE OF GOD ASKING: "WHERE IS ABEL, YOUR BROTHER?"

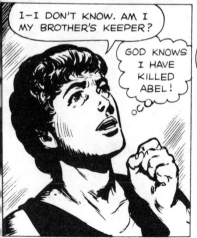

I—I DON'T KNOW. AM I MY BROTHER'S KEEPER?

GOD KNOWS I HAVE KILLED ABEL!

TERRIFIED, CAIN HEARS GOD'S VERDICT—AS PUNISHMENT FOR MURDERING ABEL, CAIN MUST LEAVE HOME AND FOREVER BE A FUGITIVE.

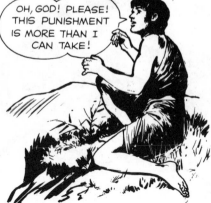

OH, GOD! PLEASE! THIS PUNISHMENT IS MORE THAN I CAN TAKE!

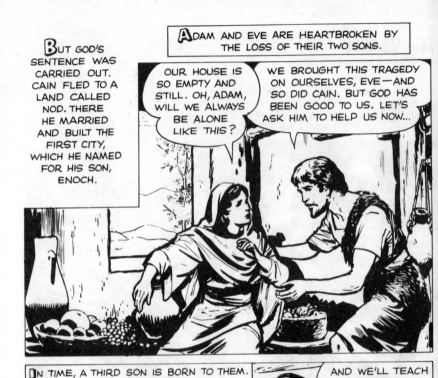

But God's sentence was carried out. Cain fled to a land called Nod. There he married and built the first city, which he named for his son, Enoch.

ADAM AND EVE ARE HEARTBROKEN BY THE LOSS OF THEIR TWO SONS.

OUR HOUSE IS SO EMPTY AND STILL. OH, ADAM, WILL WE ALWAYS BE ALONE LIKE THIS?

WE BROUGHT THIS TRAGEDY ON OURSELVES, EVE—AND SO DID CAIN. BUT GOD HAS BEEN GOOD TO US. LET'S ASK HIM TO HELP US NOW...

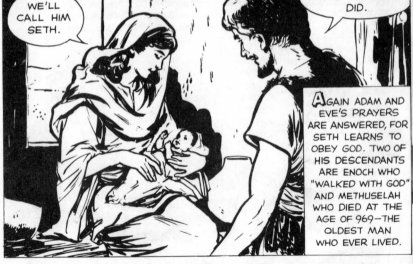

IN TIME, A THIRD SON IS BORN TO THEM.

WE'LL CALL HIM SETH.

AND WE'LL TEACH HIM TO OBEY GOD THE WAY ABEL DID.

AGAIN ADAM AND EVE'S PRAYERS ARE ANSWERED, FOR SETH LEARNS TO OBEY GOD. TWO OF HIS DESCENDANTS ARE ENOCH WHO "WALKED WITH GOD" AND METHUSELAH WHO DIED AT THE AGE OF 969—THE OLDEST MAN WHO EVER LIVED.

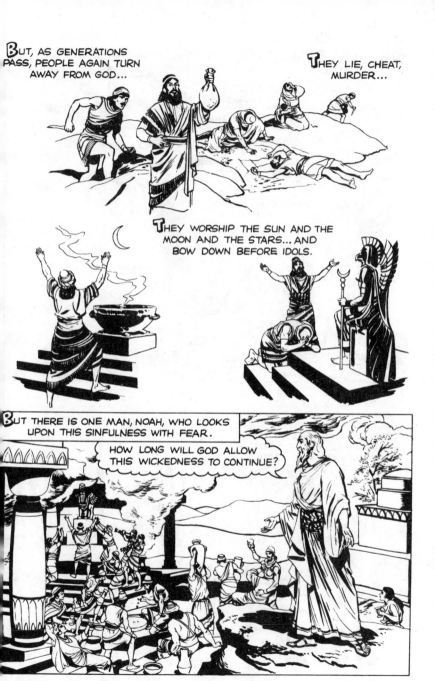

13

OUR BIBLE IN PICTURES
When the Rains Came
FROM GENESIS 6: 7-22; 7: 1-10

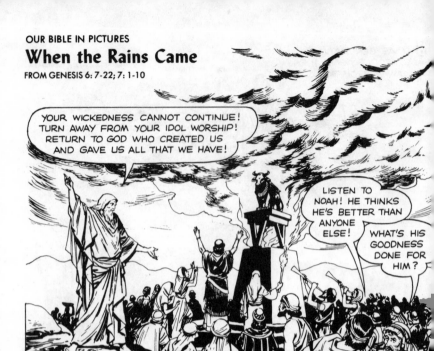

BUT NOAH REMAINS TRUE TO GOD. AND ONE DAY GOD SPEAKS TO HIM: "THE EARTH IS FILLED WITH VIOLENCE...I WILL DESTROY MAN WHOM I HAVE CREATED. MAKE THEE AN ARK, FOR BEHOLD I WILL BRING A FLOOD OF WATERS UPON THE EARTH."

NOAH OBEYS—AND SETS TO WORK BUILDING AN ARK ACCORDING TO THE DIRECTIONS GIVEN HIM BY GOD.

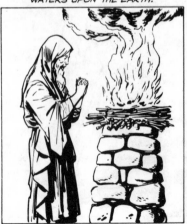

14

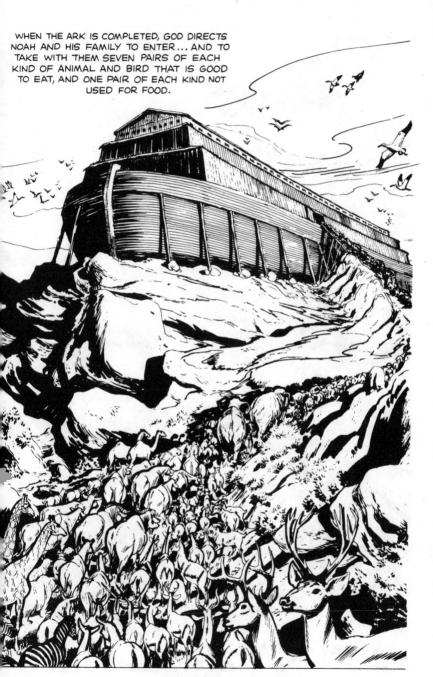

WHEN THE ARK IS COMPLETED, GOD DIRECTS NOAH AND HIS FAMILY TO ENTER... AND TO TAKE WITH THEM SEVEN PAIRS OF EACH KIND OF ANIMAL AND BIRD THAT IS GOOD TO EAT, AND ONE PAIR OF EACH KIND NOT USED FOR FOOD.

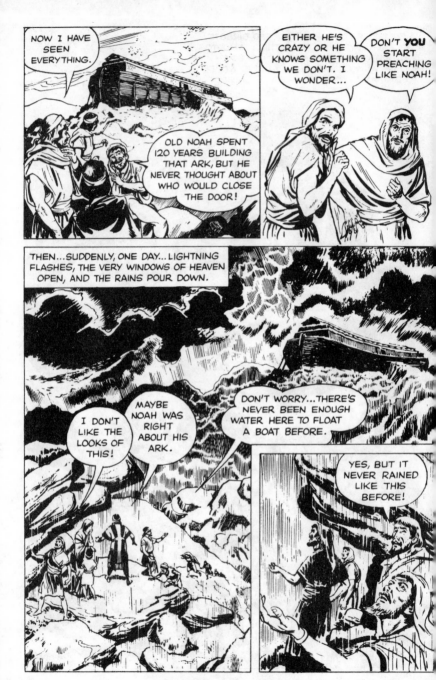

16

The Great Flood

FROM GENESIS 7: 16-24; 8; 9; 11

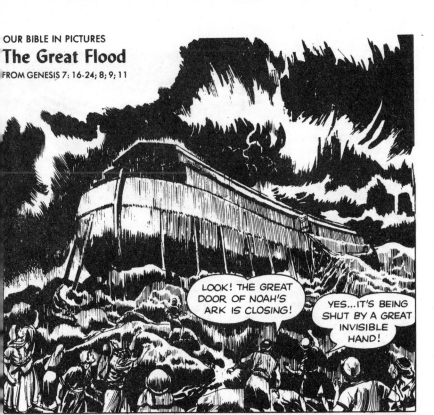

LOOK! THE GREAT DOOR OF NOAH'S ARK IS CLOSING!

YES...IT'S BEING SHUT BY A GREAT INVISIBLE HAND!

THE RAINS POUR DOWN STEADILY FOR FORTY DAYS AND FORTY NIGHTS.

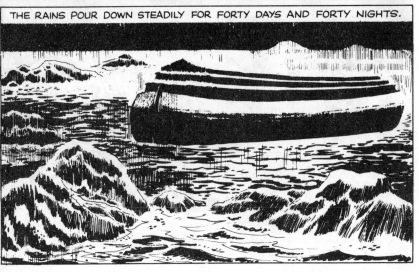

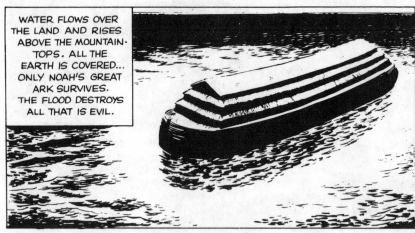

WATER FLOWS OVER THE LAND AND RISES ABOVE THE MOUNTAIN-TOPS. ALL THE EARTH IS COVERED... ONLY NOAH'S GREAT ARK SURVIVES. THE FLOOD DESTROYS ALL THAT IS EVIL.

AT LAST THE WATER LEVEL DROPS AND THE ARK RESTS ON THE TOP OF THE MOUNTAINS OF ARARAT.

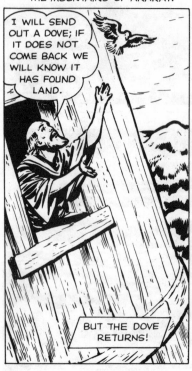

I WILL SEND OUT A DOVE; IF IT DOES NOT COME BACK WE WILL KNOW IT HAS FOUND LAND.

BUT THE DOVE RETURNS!

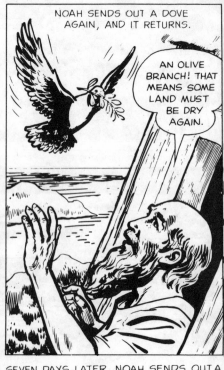

NOAH SENDS OUT A DOVE AGAIN, AND IT RETURNS.

AN OLIVE BRANCH! THAT MEANS SOME LAND MUST BE DRY AGAIN.

SEVEN DAYS LATER, NOAH SENDS OUT A DOVE A THIRD TIME. IT DOES NOT RETURN BECAUSE IT HAS FOUND A PLACE TO NEST.

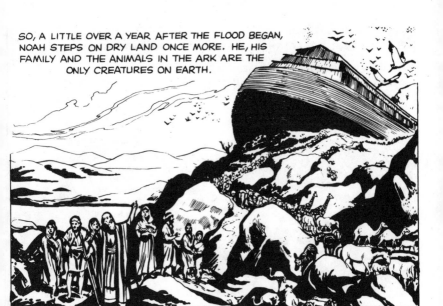

SO, A LITTLE OVER A YEAR AFTER THE FLOOD BEGAN, NOAH STEPS ON DRY LAND ONCE MORE. HE, HIS FAMILY AND THE ANIMALS IN THE ARK ARE THE ONLY CREATURES ON EARTH.

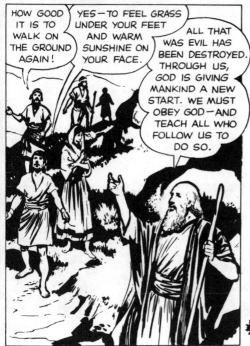

HOW GOOD IT IS TO WALK ON THE GROUND AGAIN!

YES—TO FEEL GRASS UNDER YOUR FEET AND WARM SUNSHINE ON YOUR FACE.

ALL THAT WAS EVIL HAS BEEN DESTROYED. THROUGH US, GOD IS GIVING MANKIND A NEW START. WE MUST OBEY GOD—AND TEACH ALL WHO FOLLOW US TO DO SO.

AS SOON AS NOAH LEAVES THE ARK, HE BUILDS AN ALTAR. HERE HE THANKS GOD FOR HIS CARE AND ASKS GOD'S GUIDANCE IN HELPING NOAH AND HIS FAMILY TO MAKE A NEW START. THEN GOD MAKES A PROMISE TO NOAH AND TO ALL HIS CHILDREN, FOREVER...

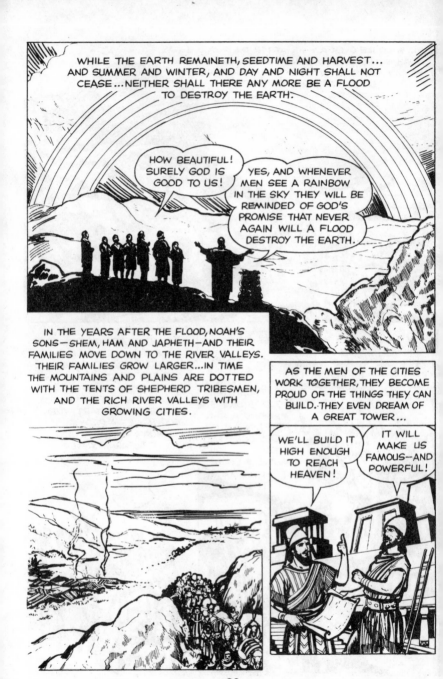

The Tower that Crumbled

FROM GENESIS 11

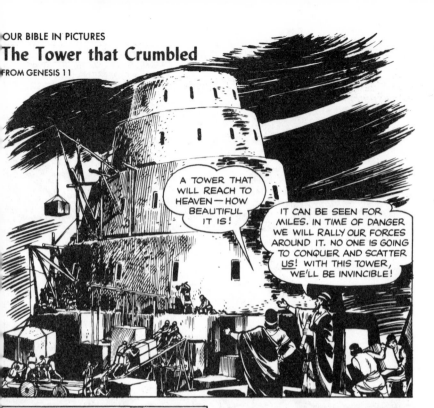

A TOWER THAT WILL REACH TO HEAVEN — HOW BEAUTIFUL IT IS!

IT CAN BE SEEN FOR MILES. IN TIME OF DANGER WE WILL RALLY OUR FORCES AROUND IT. NO ONE IS GOING TO CONQUER AND SCATTER US! WITH THIS TOWER, WE'LL BE INVINCIBLE!

BUT GOD IS DISPLEASED WITH THE PEOPLE'S DESIRE FOR FAME AND POWER. TO STOP THEIR WORK ON THE TOWER, HE CAUSES THE PEOPLE TO SPEAK IN DIFFERENT LANGUAGES.

WHAT KIND OF TALK IS THAT? HOW CAN I WORK WITH A MAN I CAN'T UNDERSTAND?

BECAUSE THEY CANNOT UNDERSTAND ONE ANOTHER, THE BUILDERS ARE CONFUSED. THEY STOP WORKING ON THE TOWER. ONE BY ONE, THE FAMILIES WHO SPEAK THE SAME LANGUAGE MOVE AWAY. THE GIANT TOWER, CALLED BABEL, BEGINS TO CRUMBLE...

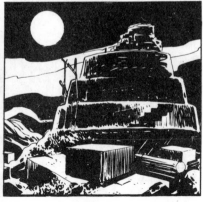

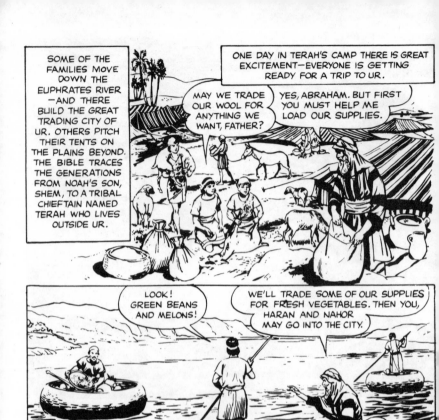

SOME OF THE FAMILIES MOVE DOWN THE EUPHRATES RIVER—AND THERE BUILD THE GREAT TRADING CITY OF UR. OTHERS PITCH THEIR TENTS ON THE PLAINS BEYOND. THE BIBLE TRACES THE GENERATIONS FROM NOAH'S SON, SHEM, TO A TRIBAL CHIEFTAIN NAMED TERAH WHO LIVES OUTSIDE UR.

ONE DAY IN TERAH'S CAMP THERE IS GREAT EXCITEMENT—EVERYONE IS GETTING READY FOR A TRIP TO UR.

MAY WE TRADE OUR WOOL FOR ANYTHING WE WANT, FATHER?

YES, ABRAHAM. BUT FIRST YOU MUST HELP ME LOAD OUR SUPPLIES.

LOOK! GREEN BEANS AND MELONS!

WE'LL TRADE SOME OF OUR SUPPLIES FOR FRESH VEGETABLES. THEN YOU, HARAN AND NAHOR MAY GO INTO THE CITY.

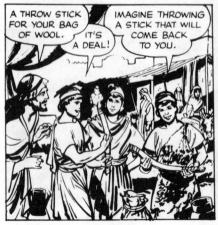

A THROW STICK FOR YOUR BAG OF WOOL.

IT'S A DEAL!

IMAGINE THROWING A STICK THAT WILL COME BACK TO YOU.

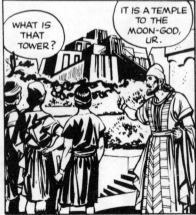

WHAT IS THAT TOWER?

IT IS A TEMPLE TO THE MOON-GOD, UR.

BACK HOME, ABRAHAM THINKS OFTEN ABOUT HIS VISIT TO UR. AND AS HE GROWS OLDER HE WONDERS ABOUT THE TEMPLE OF THE MOON-GOD.

ONE EVENING ABRAHAM TALKS TO SARAH, THE MOST BEAUTIFUL GIRL IN HIS FATHER'S CAMP.

IT'S ONLY THE MOON, SARAH, NOT SOMETHING TO WORSHIP.

ABRAHAM—BE CAREFUL. MANY PEOPLE HERE WORSHIP THE MOON-GOD. THEY MIGHT HEAR YOU AND DO YOU HARM.

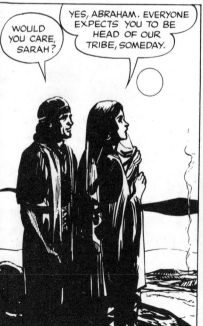

WOULD YOU CARE, SARAH?

YES, ABRAHAM. EVERYONE EXPECTS YOU TO BE HEAD OF OUR TRIBE, SOMEDAY.

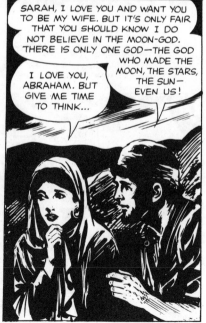

SARAH, I LOVE YOU AND WANT YOU TO BE MY WIFE. BUT IT'S ONLY FAIR THAT YOU SHOULD KNOW I DO NOT BELIEVE IN THE MOON-GOD. THERE IS ONLY ONE GOD—THE GOD WHO MADE THE MOON, THE STARS, THE SUN— EVEN US!

I LOVE YOU, ABRAHAM. BUT GIVE ME TIME TO THINK...

23

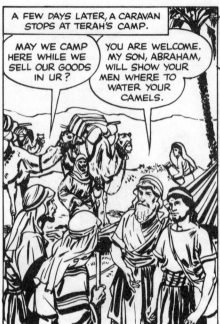

A FEW DAYS LATER, A CARAVAN STOPS AT TERAH'S CAMP.

MAY WE CAMP HERE WHILE WE SELL OUR GOODS IN UR?

YOU ARE WELCOME. MY SON, ABRAHAM, WILL SHOW YOUR MEN WHERE TO WATER YOUR CAMELS.

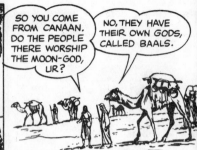

SO YOU COME FROM CANAAN. DO THE PEOPLE THERE WORSHIP THE MOON-GOD, UR?

NO, THEY HAVE THEIR OWN GODS, CALLED BAALS.

BAAL! THE MOON-GOD! EVERY-ONE HAS A DIFFERENT GOD. ABRAHAM, I BELIEVE AS YOU DO—THERE IS ONLY ONE GOD.

DO YOU, SARAH? THEN WE'LL BOTH TRUST IN GOD—NO MATTER WHAT HAPPENS.

IT IS A FESTIVE DAY FOR ALL OF THE TRIBE WHEN ABRAHAM AND SARAH ARE MARRIED. DURING THE CEREMONY SARAH PRAYS TO GOD, ASKING FOR COURAGE TO STAND BY HER HUSBAND—FOR THEY ARE TWO AGAINST MANY WHO BELIEVE IN OTHER GODS.

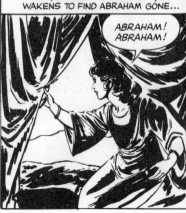

ONE NIGHT, SEVERAL WEEKS LATER, SARAH WAKENS TO FIND ABRAHAM GONE...

ABRAHAM! ABRAHAM!

24

Night Attack

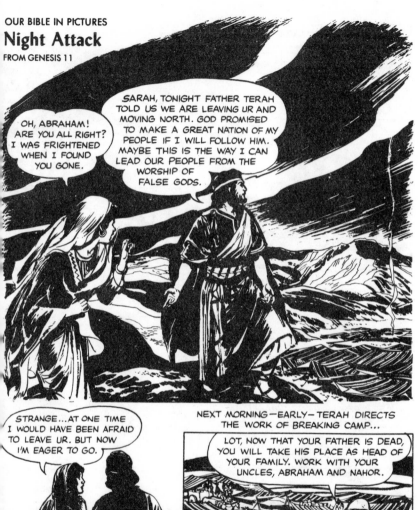

OH, ABRAHAM! ARE YOU ALL RIGHT? I WAS FRIGHTENED WHEN I FOUND YOU GONE.

SARAH, TONIGHT FATHER TERAH TOLD US WE ARE LEAVING UR AND MOVING NORTH. GOD PROMISED TO MAKE A GREAT NATION OF MY PEOPLE IF I WILL FOLLOW HIM. MAYBE THIS IS THE WAY I CAN LEAD OUR PEOPLE FROM THE WORSHIP OF FALSE GODS.

STRANGE...AT ONE TIME I WOULD HAVE BEEN AFRAID TO LEAVE UR. BUT NOW I'M EAGER TO GO.

NEXT MORNING—EARLY—TERAH DIRECTS THE WORK OF BREAKING CAMP...

LOT, NOW THAT YOUR FATHER IS DEAD, YOU WILL TAKE HIS PLACE AS HEAD OF YOUR FAMILY. WORK WITH YOUR UNCLES, ABRAHAM AND NAHOR.

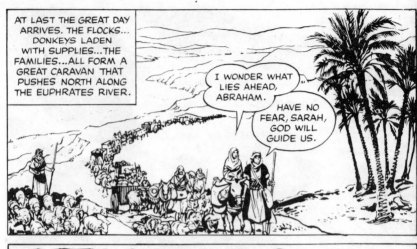

AT LAST THE GREAT DAY ARRIVES. THE FLOCKS... DONKEYS LADEN WITH SUPPLIES...THE FAMILIES...ALL FORM A GREAT CARAVAN THAT PUSHES NORTH ALONG THE EUPHRATES RIVER.

I WONDER WHAT LIES AHEAD, ABRAHAM.

HAVE NO FEAR, SARAH, GOD WILL GUIDE US.

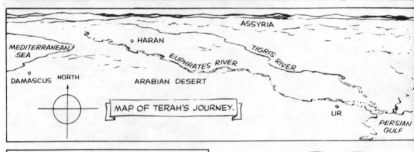

ASSYRIA

MEDITERRANEAN SEA

HARAN

TIGRIS RIVER

EUPHRATES RIVER

DAMASCUS

NORTH

ARABIAN DESERT

MAP OF TERAH'S JOURNEY.

UR

PERSIAN GULF

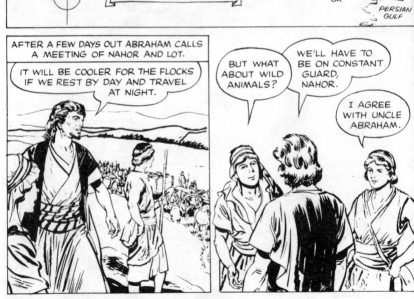

AFTER A FEW DAYS OUT ABRAHAM CALLS A MEETING OF NAHOR AND LOT.

IT WILL BE COOLER FOR THE FLOCKS IF WE REST BY DAY AND TRAVEL AT NIGHT.

BUT WHAT ABOUT WILD ANIMALS?

WE'LL HAVE TO BE ON CONSTANT GUARD, NAHOR.

I AGREE WITH UNCLE ABRAHAM.

26

BUT ONE NIGHT A CARELESS GUARD LETS THE FLOCKS SCATTER...AND HUNGRY JACKALS ATTACK.

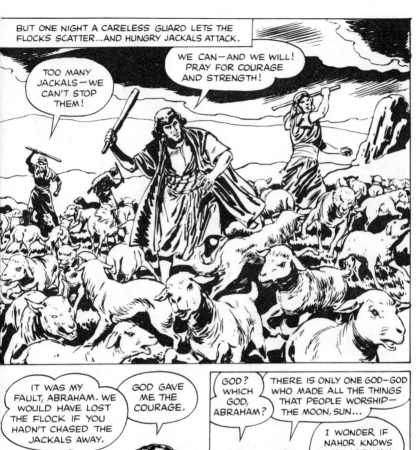

TOO MANY JACKALS—WE CAN'T STOP THEM!

WE CAN—AND WE WILL! PRAY FOR COURAGE AND STRENGTH!

IT WAS MY FAULT, ABRAHAM. WE WOULD HAVE LOST THE FLOCK IF YOU HADN'T CHASED THE JACKALS AWAY.

GOD GAVE ME THE COURAGE.

GOD? WHICH GOD, ABRAHAM?

THERE IS ONLY ONE GOD—GOD WHO MADE ALL THE THINGS THAT PEOPLE WORSHIP—THE MOON, SUN...

I WONDER IF NAHOR KNOWS WHAT ABRAHAM IS TEACHING!

OUR BIBLE IN PICTURES

Into the Unknown

FROM GENESIS 11

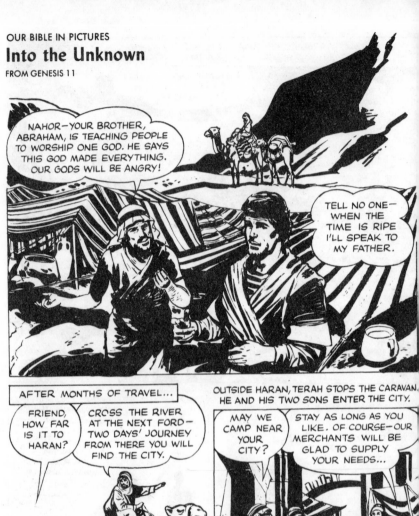

NAHOR—YOUR BROTHER, ABRAHAM, IS TEACHING PEOPLE TO WORSHIP ONE GOD. HE SAYS THIS GOD MADE EVERYTHING. OUR GODS WILL BE ANGRY!

TELL NO ONE— WHEN THE TIME IS RIPE I'LL SPEAK TO MY FATHER.

AFTER MONTHS OF TRAVEL...

FRIEND, HOW FAR IS IT TO HARAN?

CROSS THE RIVER AT THE NEXT FORD— TWO DAYS' JOURNEY FROM THERE YOU WILL FIND THE CITY.

OUTSIDE HARAN, TERAH STOPS THE CARAVAN. HE AND HIS TWO SONS ENTER THE CITY.

MAY WE CAMP NEAR YOUR CITY?

STAY AS LONG AS YOU LIKE. OF COURSE— OUR MERCHANTS WILL BE GLAD TO SUPPLY YOUR NEEDS...

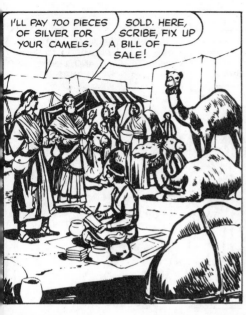

I'LL PAY 700 PIECES OF SILVER FOR YOUR CAMELS.

SOLD. HERE, SCRIBE, FIX UP A BILL OF SALE!

ABRAHAM WEIGHS OUT THE SILVER. SOON HE IS RAISING HIS OWN HERDS AND FLOCKS.

ALL GOES WELL IN TERAH'S CAMP UNTIL ONE DAY WORD SPREADS THROUGHOUT THE TENTS—TERAH IS ILL!

THIS IS THE TIME TO TELL YOUR FATHER ABOUT ABRAHAM'S GOD —BEFORE ABRAHAM BECOMES CHIEF!

NO, MY FATHER IS TOO ILL.

THAT NIGHT TERAH, THE OLD CHIEFTAIN, DIES. GRIEF STRICKEN, HIS SONS LEAVE THE TENT OF THEIR FATHER...

OH, ABRAHAM!

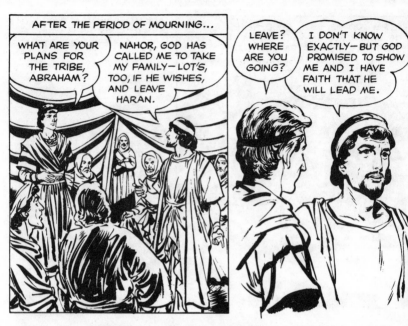

A Tight Spot

ROM GENESIS 12:1-15

MILE AFTER MILE ABRAHAM'S GREAT CARAVAN TRAVELS ON—STOPPING AT WATER HOLES TO REST AND WATER THE FLOCKS.

I KEEP WONDERING— WHAT IF WE'RE ATTACKED, OR THE PASTURES DRY UP, OR...

WE'RE NOT COWARDS, MAN! THERE ARE DANGERS, SURE, BUT ABRAHAM, OUR LEADER, HAS FAITH IN GOD. I'M LEARNING TO HAVE FAITH, TOO!

AT LAST THE CARAVAN REACHES CANAAN. THE PEOPLE THERE ARE FRIENDLY...

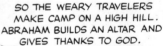

SO THE WEARY TRAVELERS MAKE CAMP ON A HIGH HILL. ABRAHAM BUILDS AN ALTAR AND GIVES THANKS TO GOD.

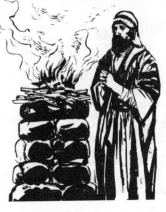

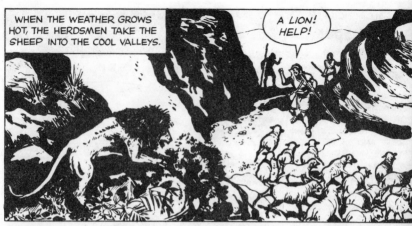

WHEN THE WEATHER GROWS HOT, THE HERDSMEN TAKE THE SHEEP INTO THE COOL VALLEYS.

A LION! HELP!

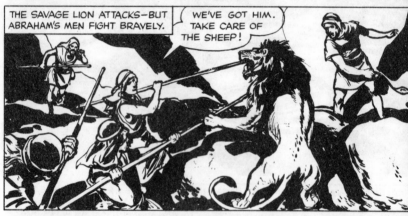

THE SAVAGE LION ATTACKS—BUT ABRAHAM'S MEN FIGHT BRAVELY.

WE'VE GOT HIM. TAKE CARE OF THE SHEEP!

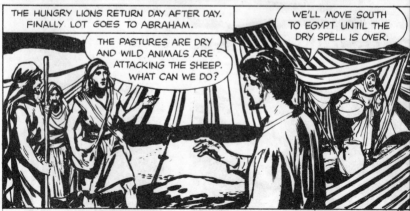

THE HUNGRY LIONS RETURN DAY AFTER DAY. FINALLY LOT GOES TO ABRAHAM.

THE PASTURES ARE DRY AND WILD ANIMALS ARE ATTACKING THE SHEEP. WHAT CAN WE DO?

WE'LL MOVE SOUTH TO EGYPT UNTIL THE DRY SPELL IS OVER.

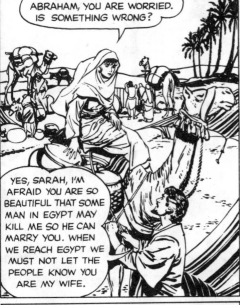

SO ONCE AGAIN THE TENTS ARE TAKEN DOWN, CLOTHING PACKED AND THE ANIMALS ROUNDED UP FOR THE MOVE SOUTH.

ABRAHAM, YOU ARE WORRIED. IS SOMETHING WRONG?

YES, SARAH, I'M AFRAID YOU ARE SO BEAUTIFUL THAT SOME MAN IN EGYPT MAY KILL ME SO HE CAN MARRY YOU. WHEN WE REACH EGYPT WE MUST NOT LET THE PEOPLE KNOW YOU ARE MY WIFE.

KILL YOU! OH, ABRAHAM, I'LL DO ANYTHING YOU ASK!

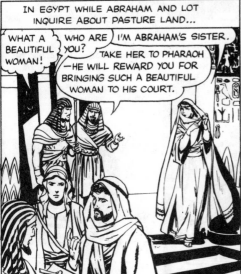

IN EGYPT WHILE ABRAHAM AND LOT INQUIRE ABOUT PASTURE LAND...

WHAT A BEAUTIFUL WOMAN!

WHO ARE YOU?

I'M ABRAHAM'S SISTER. TAKE HER TO PHARAOH —HE WILL REWARD YOU FOR BRINGING SUCH A BEAUTIFUL WOMAN TO HIS COURT.

PHARAOH'S COURT! WILL I NEVER SEE ABRAHAM AGAIN?

33

Raiders at Sodom

FROM GENESIS 12: 16-20; 13; 14: 1-13

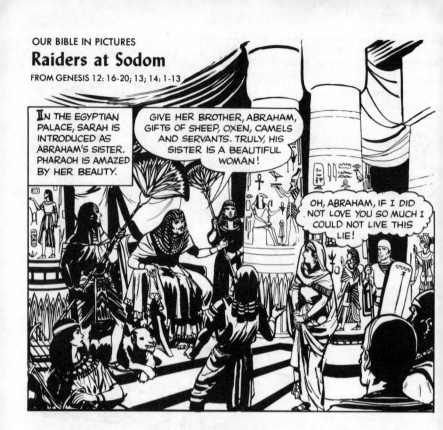

IN THE EGYPTIAN PALACE, SARAH IS INTRODUCED AS ABRAHAM'S SISTER. PHARAOH IS AMAZED BY HER BEAUTY.

GIVE HER BROTHER, ABRAHAM, GIFTS OF SHEEP, OXEN, CAMELS AND SERVANTS. TRULY, HIS SISTER IS A BEAUTIFUL WOMAN!

OH, ABRAHAM, IF I DID NOT LOVE YOU SO MUCH I COULD NOT LIVE THIS LIE!

BUT SARAH'S PRESENCE IN PHARAOH'S COURT BRINGS TROUBLE. A PLAGUE BREAKS OUT...

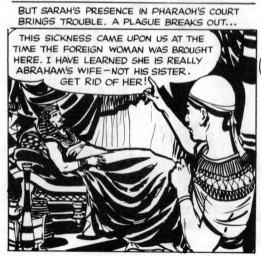

THIS SICKNESS CAME UPON US AT THE TIME THE FOREIGN WOMAN WAS BROUGHT HERE. I HAVE LEARNED SHE IS REALLY ABRAHAM'S WIFE—NOT HIS SISTER. GET RID OF HER!

WHEN PHARAOH LEARNS THE TRUTH ABOUT SARAH, HE CALLS FOR HIS SOLDIERS.

BRING ABRAHAM AND SARAH TO ME—NOW!

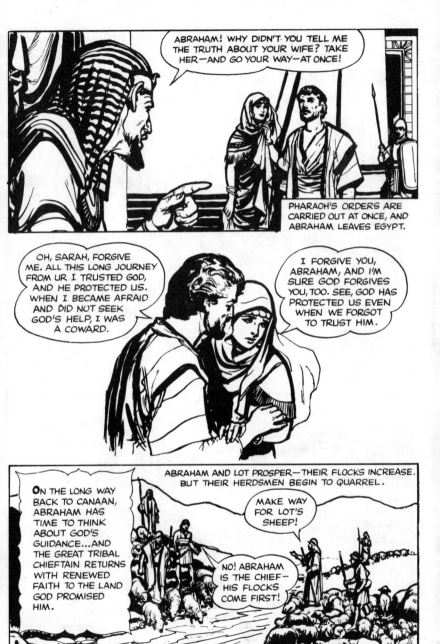

ABRAHAM! WHY DIDN'T YOU TELL ME THE TRUTH ABOUT YOUR WIFE? TAKE HER—AND GO YOUR WAY—AT ONCE!

PHARAOH'S ORDERS ARE CARRIED OUT AT ONCE, AND ABRAHAM LEAVES EGYPT.

OH, SARAH, FORGIVE ME. ALL THIS LONG JOURNEY FROM UR I TRUSTED GOD, AND HE PROTECTED US. WHEN I BECAME AFRAID AND DID NOT SEEK GOD'S HELP, I WAS A COWARD.

I FORGIVE YOU, ABRAHAM, AND I'M SURE GOD FORGIVES YOU, TOO. SEE, GOD HAS PROTECTED US EVEN WHEN WE FORGOT TO TRUST HIM.

ON THE LONG WAY BACK TO CANAAN, ABRAHAM HAS TIME TO THINK ABOUT GOD'S GUIDANCE...AND THE GREAT TRIBAL CHIEFTAIN RETURNS WITH RENEWED FAITH TO THE LAND GOD PROMISED HIM.

ABRAHAM AND LOT PROSPER—THEIR FLOCKS INCREASE. BUT THEIR HERDSMEN BEGIN TO QUARREL.

MAKE WAY FOR LOT'S SHEEP!

NO! ABRAHAM IS THE CHIEF—HIS FLOCKS COME FIRST!

35

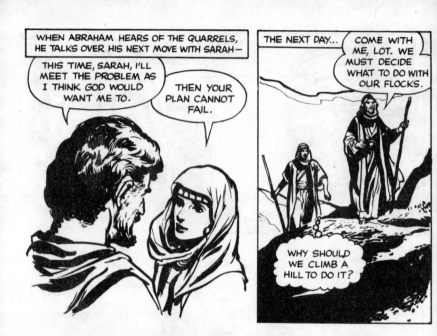

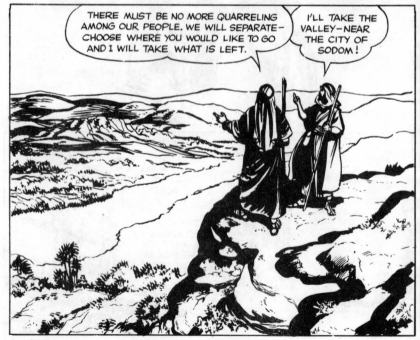

36

AFTER LOT LEAVES, GOD SPEAKS TO ABRAHAM: "ALL THE LAND WHICH THOU SEEST, TO THEE WILL I GIVE IT, AND TO THY SEED FOR EVER."

TRUSTING IN GOD, ABRAHAM MOVES TO HEBRON, AND THERE BUILDS AN ALTAR TO WORSHIP GOD. NEIGHBORING CHIEFTAINS LEARN TO RESPECT ABRAHAM, AND ONE DAY THEY SEEK HIS HELP...

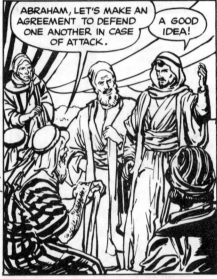

ABRAHAM, LET'S MAKE AN AGREEMENT TO DEFEND ONE ANOTHER IN CASE OF ATTACK.

A GOOD IDEA!

NOT LONG AFTER, THE WHOLE CAMP IS SURPRISED BY A MESSENGER WHO RACES IN DEMANDING TO SEE ABRAHAM.

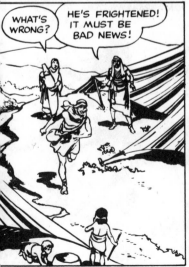

WHAT'S WRONG?

HE'S FRIGHTENED! IT MUST BE BAD NEWS!

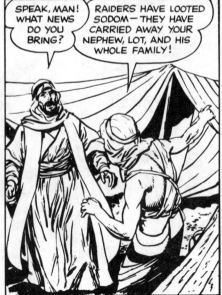

SPEAK, MAN! WHAT NEWS DO YOU BRING?

RAIDERS HAVE LOOTED SODOM — THEY HAVE CARRIED AWAY YOUR NEPHEW, LOT, AND HIS WHOLE FAMILY!

37

To the Rescue

FROM GENESIS 14: 12-24; 15

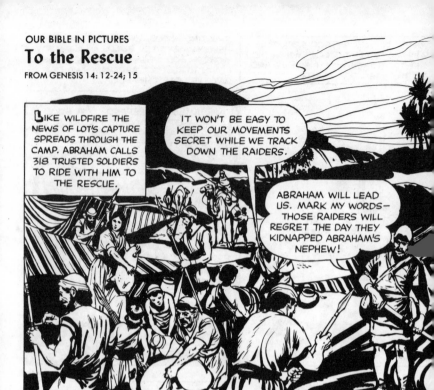

LIKE WILDFIRE THE NEWS OF LOT'S CAPTURE SPREADS THROUGH THE CAMP. ABRAHAM CALLS 318 TRUSTED SOLDIERS TO RIDE WITH HIM TO THE RESCUE.

IT WON'T BE EASY TO KEEP OUR MOVEMENTS SECRET WHILE WE TRACK DOWN THE RAIDERS.

ABRAHAM WILL LEAD US. MARK MY WORDS— THOSE RAIDERS WILL REGRET THE DAY THEY KIDNAPPED ABRAHAM'S NEPHEW!

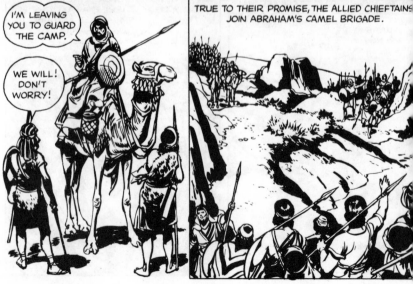

I'M LEAVING YOU TO GUARD THE CAMP.

WE WILL! DON'T WORRY!

TRUE TO THEIR PROMISE, THE ALLIED CHIEFTAINS JOIN ABRAHAM'S CAMEL BRIGADE.

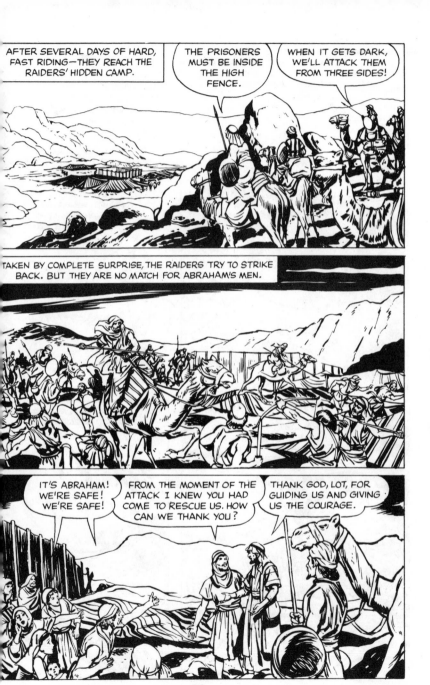

AFTER SEVERAL DAYS OF HARD, FAST RIDING—THEY REACH THE RAIDERS' HIDDEN CAMP.

THE PRISONERS MUST BE INSIDE THE HIGH FENCE.

WHEN IT GETS DARK, WE'LL ATTACK THEM FROM THREE SIDES!

TAKEN BY COMPLETE SURPRISE, THE RAIDERS TRY TO STRIKE BACK. BUT THEY ARE NO MATCH FOR ABRAHAM'S MEN.

IT'S ABRAHAM! WE'RE SAFE! WE'RE SAFE!

FROM THE MOMENT OF THE ATTACK I KNEW YOU HAD COME TO RESCUE US. HOW CAN WE THANK YOU?

THANK GOD, LOT, FOR GUIDING US AND GIVING US THE COURAGE.

BACK HOME THE TRIUMPHANT WARRIORS ARE GIVEN A JOYOUS RECEPTION. BUT ABRAHAM IS DISTURBED BECAUSE SARAH TAKES NO PART IN THE CELEBRATION.

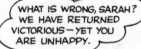

WHAT IS WRONG, SARAH? WE HAVE RETURNED VICTORIOUS—YET YOU ARE UNHAPPY.

OH, ABRAHAM, WHEN YOU LEFT THE CAMP IN CHARGE OF THE YOUNG MEN, IT OPENED AN OLD ACHE IN MY HEART. WE HAVE NO SON. NO SON TO GUARD THE CAMP WHILE YOU ARE GONE. NO SON TO RIDE WITH YOU...

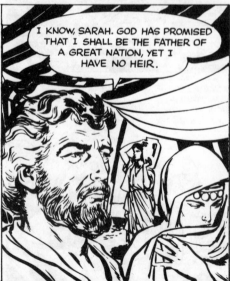

I KNOW, SARAH. GOD HAS PROMISED THAT I SHALL BE THE FATHER OF A GREAT NATION, YET I HAVE NO HEIR.

THAT NIGHT ABRAHAM HAS A VISION AND GOD SPEAKS TO HIM...

A Stranger's Prophecy

FROM GENESIS 16; 17; 18; 19: 1-10

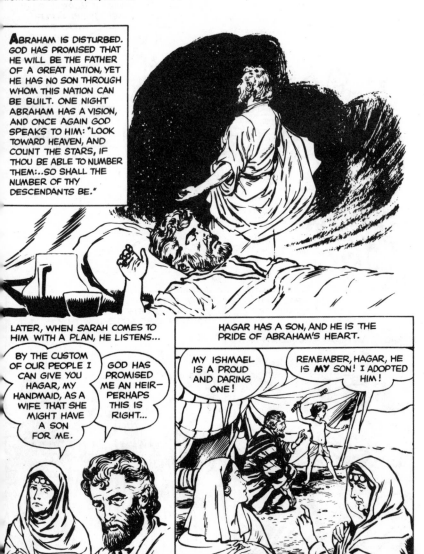

ABRAHAM IS DISTURBED. GOD HAS PROMISED THAT HE WILL BE THE FATHER OF A GREAT NATION, YET HE HAS NO SON THROUGH WHOM THIS NATION CAN BE BUILT. ONE NIGHT ABRAHAM HAS A VISION, AND ONCE AGAIN GOD SPEAKS TO HIM: "LOOK TOWARD HEAVEN, AND COUNT THE STARS, IF THOU BE ABLE TO NUMBER THEM:..SO SHALL THE NUMBER OF THY DESCENDANTS BE."

LATER, WHEN SARAH COMES TO HIM WITH A PLAN, HE LISTENS...

BY THE CUSTOM OF OUR PEOPLE I CAN GIVE YOU HAGAR, MY HANDMAID, AS A WIFE THAT SHE MIGHT HAVE A SON FOR ME.

GOD HAS PROMISED ME AN HEIR— PERHAPS THIS IS RIGHT...

HAGAR HAS A SON, AND HE IS THE PRIDE OF ABRAHAM'S HEART.

MY ISHMAEL IS A PROUD AND DARING ONE!

REMEMBER, HAGAR, HE IS **MY** SON! I ADOPTED HIM!

41

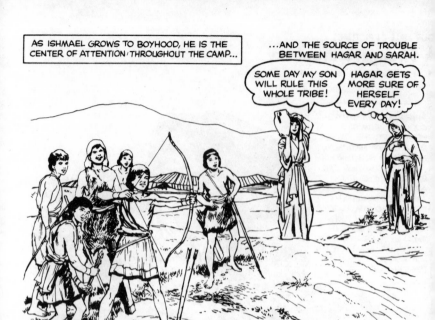

AS ISHMAEL GROWS TO BOYHOOD, HE IS THE CENTER OF ATTENTION THROUGHOUT THE CAMP...

...AND THE SOURCE OF TROUBLE BETWEEN HAGAR AND SARAH.

SOME DAY MY SON WILL RULE THIS WHOLE TRIBE!

HAGAR GETS MORE SURE OF HERSELF EVERY DAY!

ABRAHAM WORRIES ABOUT THE TROUBLE IN HIS CAMP. ONE DAY WHILE HE IS RESTING AT NOON TIME AND THINKING ABOUT ISHMAEL, HAGAR AND SARAH, HE LOOKS UP...

THREE STRANGERS APPROACH HIS CAMP. ABRAHAM GREETS THEM AND INVITES THEM TO REST AND EAT WITH HIM.

WHILE THEY ARE EATING, ONE OF THE STRANGERS GIVES ABRAHAM SURPRISING NEWS!

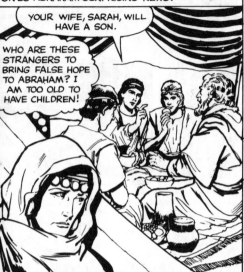

YOUR WIFE, SARAH, WILL HAVE A SON.

WHO ARE THESE STRANGERS TO BRING FALSE HOPE TO ABRAHAM? I AM TOO OLD TO HAVE CHILDREN!

BUT SARAH IS NOT THE ONLY ONE WHO OVERHEARS THE NEWS. HAGAR ALSO LISTENS AND IS AFRAID...

IF SARAH HAS A SON, WHAT WILL HAPPEN TO ISHMAEL —AND ME!

WHEN THE STRANGERS LEAVE, ABRAHAM WALKS A WAY WITH THEM.

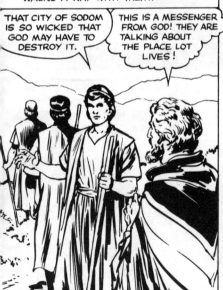

THAT CITY OF SODOM IS SO WICKED THAT GOD MAY HAVE TO DESTROY IT.

THIS IS A MESSENGER FROM GOD! THEY ARE TALKING ABOUT THE PLACE LOT LIVES!

ABRAHAM PRAYS FOR SODOM, AND GOD PROMISES THAT THE CITY WILL BE SAVED IF THERE ARE TEN GOOD MEN IN IT.

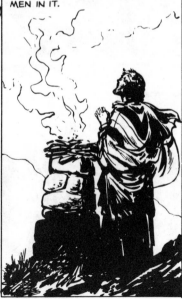

MEANTIME TWO OF THE STRANGERS HAVE REACHED SODOM. ABRAHAM'S NEPHEW, LOT, WELCOMES THEM.

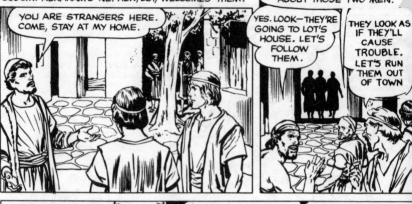

YOU ARE STRANGERS HERE. COME, STAY AT MY HOME.

THERE'S SOMETHING STRANGE ABOUT THOSE TWO MEN.

YES. LOOK—THEY'RE GOING TO LOT'S HOUSE. LET'S FOLLOW THEM.

THEY LOOK AS IF THEY'LL CAUSE TROUBLE. LET'S RUN THEM OUT OF TOWN

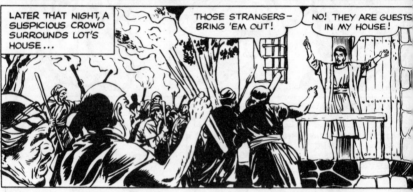

LATER THAT NIGHT, A SUSPICIOUS CROWD SURROUNDS LOT'S HOUSE...

THOSE STRANGERS— BRING 'EM OUT!

NO! THEY ARE GUESTS IN MY HOUSE!

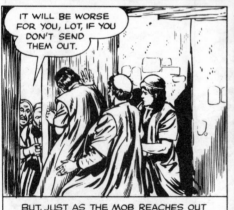

IT WILL BE WORSE FOR YOU, LOT, IF YOU DON'T SEND THEM OUT.

BUT, JUST AS THE MOB REACHES OUT FOR LOT, THE TWO STRANGERS PULL HIM INSIDE AND LOCK THE DOOR!

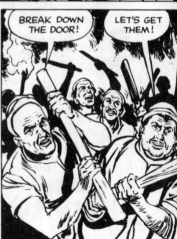

BREAK DOWN THE DOOR!

LET'S GET THEM!

44

ost in the Desert
OM GENESIS 19: 11-30; 21: 1-16

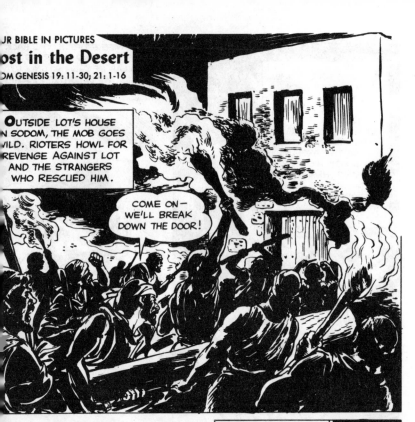

OUTSIDE LOT'S HOUSE N SODOM, THE MOB GOES VILD. RIOTERS HOWL FOR REVENGE AGAINST LOT AND THE STRANGERS WHO RESCUED HIM.

COME ON— WE'LL BREAK DOWN THE DOOR!

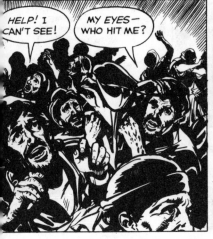

AS THE MEN PUSH AGAINST LOT'S DOOR, THE ANGELS STRIKE THE RIOTERS BLIND.

HELP! I CAN'T SEE!

MY EYES— WHO HIT ME?

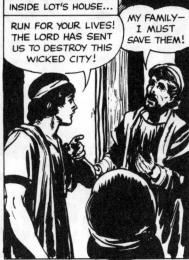

INSIDE LOT'S HOUSE...

RUN FOR YOUR LIVES! THE LORD HAS SENT US TO DESTROY THIS WICKED CITY!

MY FAMILY— I MUST SAVE THEM!

45

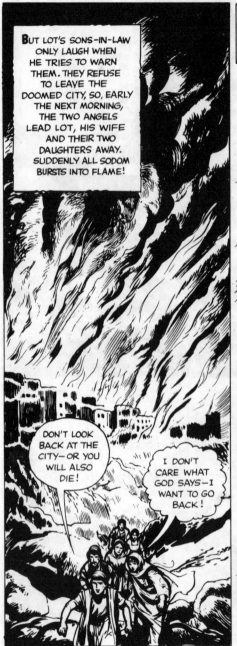

BUT LOT'S SONS-IN-LAW ONLY LAUGH WHEN HE TRIES TO WARN THEM. THEY REFUSE TO LEAVE THE DOOMED CITY. SO, EARLY THE NEXT MORNING, THE TWO ANGELS LEAD LOT, HIS WIFE AND THEIR TWO DAUGHTERS AWAY. SUDDENLY ALL SODOM BURSTS INTO FLAME!

DON'T LOOK BACK AT THE CITY—OR YOU WILL ALSO DIE!

I DON'T CARE WHAT GOD SAYS—I WANT TO GO BACK!

LOT'S WIFE STOPS...LOOKS BACK LONGINGLY... AND IS TURNED INTO A PILLAR OF SALT...SO ONLY LOT AND HIS TWO DAUGHTERS ESCAPE GOD'S PUNISHMENT.

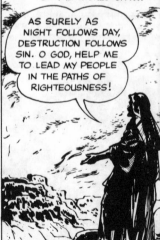

NEXT MORNING, ABRAHAM GOES TO THE HILLTOP TO WORSHIP—AND SEES THE SMOULDERING RUINS OF THE WICKED CITY...

AS SURELY AS NIGHT FOLLOWS DAY, DESTRUCTION FOLLOWS SIN. O GOD, HELP ME TO LEAD MY PEOPLE IN THE PATHS OF RIGHTEOUSNESS!

EAGER TO LEAVE THE RUINS OF SODOM, ABRAHAM MOVES TO BEER-SHEBA, NEAR THE DESERT. HERE, SARAH'S SON IS BORN.

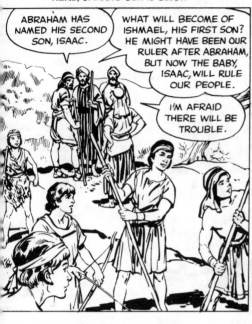

ABRAHAM HAS NAMED HIS SECOND SON, ISAAC.

WHAT WILL BECOME OF ISHMAEL, HIS FIRST SON? HE MIGHT HAVE BEEN OUR RULER AFTER ABRAHAM, BUT NOW THE BABY, ISAAC, WILL RULE OUR PEOPLE.

I'M AFRAID THERE WILL BE TROUBLE.

SARAH AND HAGAR BECOME MORE JEALOUS DAY BY DAY. THEN AT THE BABY ISAAC'S FIRST FEAST...

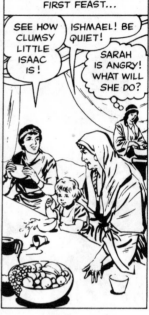

SEE HOW CLUMSY LITTLE ISAAC IS!

ISHMAEL! BE QUIET!

SARAH IS ANGRY! WHAT WILL SHE DO?

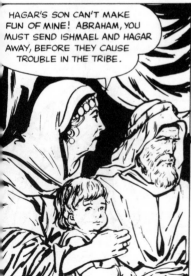

HAGAR'S SON CAN'T MAKE FUN OF MINE! ABRAHAM, YOU MUST SEND ISHMAEL AND HAGAR AWAY, BEFORE THEY CAUSE TROUBLE IN THE TRIBE.

NIGHT AFTER NIGHT, ABRAHAM SEEKS GOD'S ANSWER TO HIS PROBLEM. FINALLY, HE KNOWS WHAT HE MUST DO.

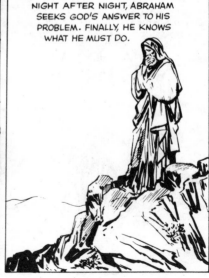

47

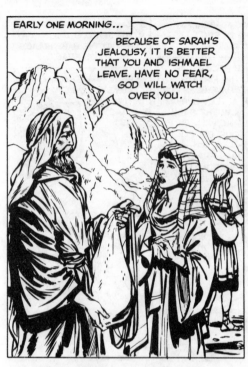

EARLY ONE MORNING...

BECAUSE OF SARAH'S JEALOUSY, IT IS BETTER THAT YOU AND ISHMAEL LEAVE. HAVE NO FEAR, GOD WILL WATCH OVER YOU.

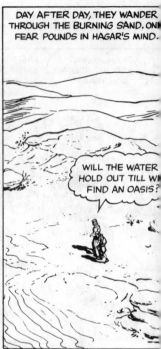

DAY AFTER DAY, THEY WANDER THROUGH THE BURNING SAND. ON[E] FEAR POUNDS IN HAGAR'S MIND.

WILL THE WATER HOLD OUT TILL W[E] FIND AN OASIS?

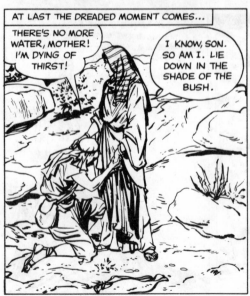

AT LAST THE DREADED MOMENT COMES...

THERE'S NO MORE WATER, MOTHER! I'M DYING OF THIRST!

I KNOW, SON. SO AM I. LIE DOWN IN THE SHADE OF THE BUSH.

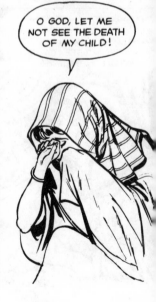

O GOD, LET ME NOT SEE THE DEATH OF MY CHILD!

48

Test of Faith

FROM GENESIS 21: 17-21; 22: 1-10

DEAD TIRED AND CHOKING WITH THIRST, HAGAR TURNS HER BACK ON HER SON, ISHMAEL...SHE CANNOT WATCH HIM DYING. SUDDENLY SHE HEARS A VOICE. IT'S GOD SAYING: "LIFT UP THE LAD, FOR I WILL MAKE HIM A GREAT NATION".

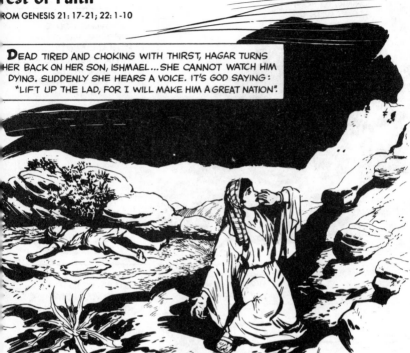

HAGAR STARTS TOWARD HER SON... AND SEES A SPRING NEARBY.

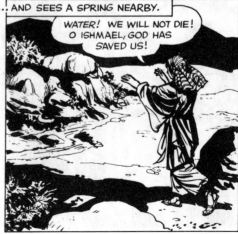

WATER! WE WILL NOT DIE! O ISHMAEL, GOD HAS SAVED US!

49

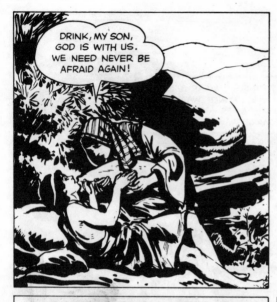

DRINK, MY SON, GOD IS WITH US. WE NEED NEVER BE AFRAID AGAIN!

KNOWING GOD IS WITH THEM, HAGAR AND ISHMAEL CONTINUE THEIR JOURNEY TO A PLACE IN THE WILDERNESS WHERE THEY BUILD A HOME. YEARS PASS—ISHMAEL MARRIES AN EGYPTIAN GIRL AND BECOMES THE HEAD OF A GREAT DESERT TRIBE.

IN ABRAHAM'S CAMP, THE YEARS PASS SWIFTLY, TOO. YOUNG ISAAC PROVES HIMSELF A WORTHY SON OF THE TRIBE'S GREAT LEADER.

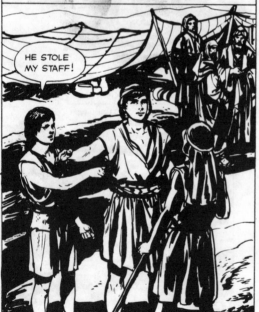

HE STOLE MY STAFF!

IF YOU TOOK HIS STAFF, RETURN IT. AND YOU, EBER, REMEMBER THAT WE DON'T SETTLE QUARRELS WITH OUR FISTS.

50

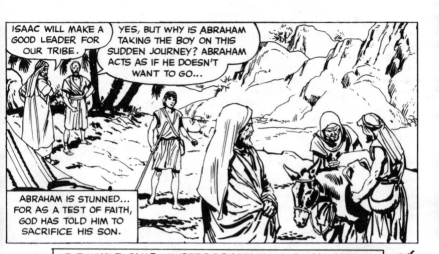

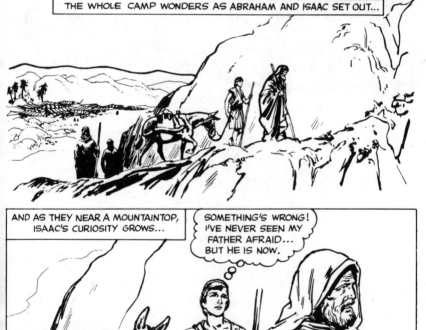

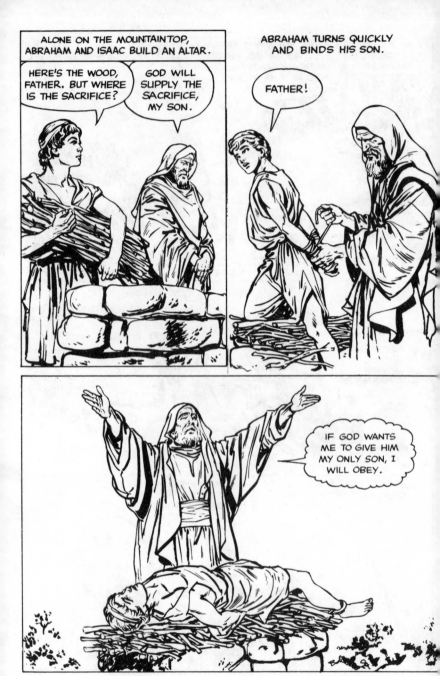

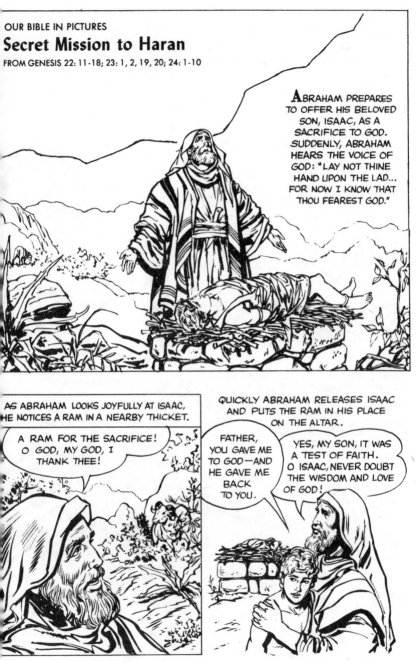

OUR BIBLE IN PICTURES
Secret Mission to Haran
FROM GENESIS 22: 11-18; 23: 1, 2, 19, 20; 24: 1-10

ABRAHAM PREPARES TO OFFER HIS BELOVED SON, ISAAC, AS A SACRIFICE TO GOD. SUDDENLY, ABRAHAM HEARS THE VOICE OF GOD: "LAY NOT THINE HAND UPON THE LAD... FOR NOW I KNOW THAT THOU FEAREST GOD."

AS ABRAHAM LOOKS JOYFULLY AT ISAAC, HE NOTICES A RAM IN A NEARBY THICKET.

A RAM FOR THE SACRIFICE! O GOD, MY GOD, I THANK THEE!

QUICKLY ABRAHAM RELEASES ISAAC AND PUTS THE RAM IN HIS PLACE ON THE ALTAR.

FATHER, YOU GAVE ME TO GOD—AND HE GAVE ME BACK TO YOU.

YES, MY SON, IT WAS A TEST OF FAITH. O ISAAC, NEVER DOUBT THE WISDOM AND LOVE OF GOD!

WITH JOYOUS HEARTS, ABRAHAM AND ISAAC GIVE THANKS TO GOD. AND ABRAHAM HEARS GOD'S PROMISE: "THROUGH YOU, ALL NATIONS OF THE EARTH SHALL BE BLESSED."

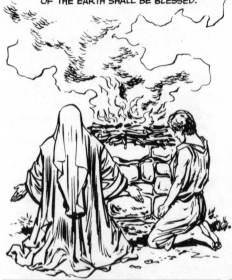

ON THE WAY HOME, ISAAC WALKS AHEAD—AND ALONE. THROUGH HIS MIND FLASH SCENES OF THE DAY. HE CAN STILL FEEL THE ROPES THAT TIED HIM ON THE ALTAR...SEE HIS FATHER'S DAGGER...FEEL THE JOY OF KNOWING HE WOULD NOT BE KILLED.

SARAH RUSHES OUT OF THE CAMP TO GREET THEM.

ISAAC, MY SON, WHAT HAPPENED? YOU LEFT HERE A BOY—YOU HAVE RETURNED A MAN— LIKE YOUR FATHER, STRONG, TALL, WISE.

FROM MY FATHER I LEARNED THE COST OF FAITH... AND FROM GOD, THE REWARD.

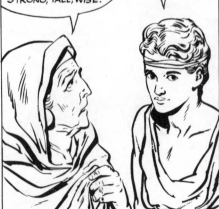

IN THE YEARS THAT FOLLOW, THE TRIBE OF ABRAHAM PROSPERS. THEN ONE DAY, SAD NEWS SPREADS THROUGHOUT THE CAMP...SARAH IS VERY SICK.

ONE EVENING, ABRAHAM APPEARS AT THE DOOR OF HIS TENT... THE CAMP GROWS QUIET... AND LIKE A MAN IN A DREAM, HE TELLS HIS PEOPLE, SARAH, HIS WIFE, IS DEAD.

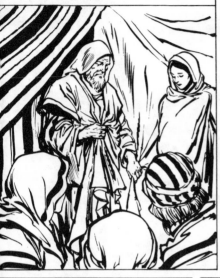

SARAH IS BURIED IN A CAVE AT MACHPELAH, AND THE WHOLE TRIBE MOURNS HER DEATH.

ISAAC IS GOING ALONE INTO THE WILDERNESS TO MOURN FOR HIS MOTHER.

IT IS WELL. HE MUST CONQUER HIS GRIEF.

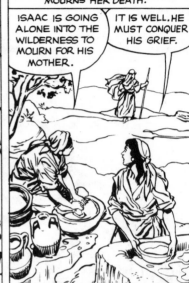

ONE DAY, ABRAHAM CALLS HIS MOST TRUSTED SERVANT TO HIM.

BEFORE I DIE, I WANT TO SEE MY SON HAPPILY MARRIED — TO A WOMAN OF MY OWN PEOPLE. GO TO HARAN AND BRING BACK A WIFE FOR ISAAC.

ABRAHAM'S SERVANT GATHERS A LONG CARAVAN. HE LEADS IT ACROSS THE DESERT AND FINALLY REACHES THE CITY OF HARAN, WHERE ABRAHAM'S RELATIVES LIVE.

WHAT A BIG CITY! HOW WILL I EVER FIND THE RIGHT WIFE FOR THE MAN WHO WILL ONE DAY BE CHIEF OF OUR TRIBE?

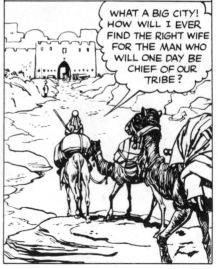

55

A Bride for Isaac

FROM GENESIS 24: 11-67; 25: 7, 8

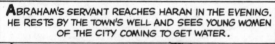

ABRAHAM'S SERVANT REACHES HARAN IN THE EVENING. HE RESTS BY THE TOWN'S WELL AND SEES YOUNG WOMEN OF THE CITY COMING TO GET WATER.

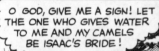

O GOD, GIVE ME A SIGN! LET THE ONE WHO GIVES WATER TO ME AND MY CAMELS BE ISAAC'S BRIDE!

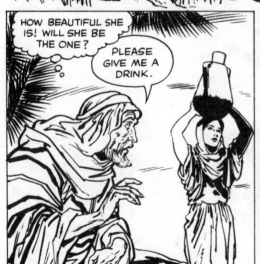

HOW BEAUTIFUL SHE IS! WILL SHE BE THE ONE?

PLEASE GIVE ME A DRINK.

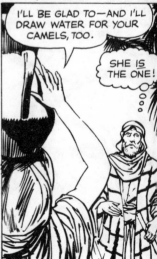

I'LL BE GLAD TO—AND I'LL DRAW WATER FOR YOUR CAMELS, TOO.

SHE IS THE ONE!

WHEN THE GIRL HAS FINISHED WATERING THE CAMELS, THE SERVANT GIVES HER EARRINGS AND GOLD BRACELETS.

WHAT IS YOUR NAME? DO YOU THINK THERE IS ROOM FOR ME TO STAY IN YOUR FATHER'S HOUSE?

HOW BEAUTIFUL THESE PRESENTS ARE! MY NAME IS REBEKAH, AND WE HAVE ROOM FOR YOU IN OUR HOUSE. WAIT...

REBEKAH RUNS TO TELL HER FAMILY. WHEN SHE SHOWS THE PRESENTS, LABAN, HER BROTHER, GOES OUT TO MEET ABRAHAM'S SERVANT.

COME! MY FATHER HAS ROOM FOR YOU AND YOUR CARAVAN.

ABRAHAM'S SERVANT TELLS WHO HE IS AND EXPLAINS THAT GOD HAS CHOSEN REBEKAH TO BE THE BRIDE OF ISAAC, SON AND HEIR OF ABRAHAM, HER GREAT UNCLE.

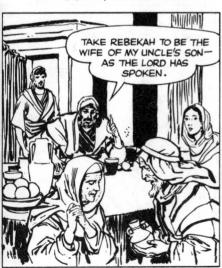

TAKE REBEKAH TO BE THE WIFE OF MY UNCLE'S SON— AS THE LORD HAS SPOKEN.

EARLY THE NEXT MORNING, THE CARAVAN GETS READY TO RETURN TO ABRAHAM'S CAMP. REBEKAH SAYS GOOD-BY TO HER FAMILY AND THE CARAVAN BEGINS ITS LONG JOURNEY.

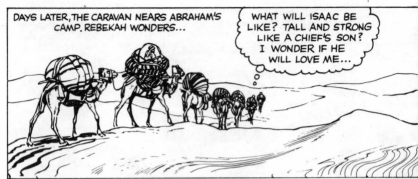

DAYS LATER, THE CARAVAN NEARS ABRAHAM'S CAMP. REBEKAH WONDERS...

WHAT WILL ISAAC BE LIKE? TALL AND STRONG LIKE A CHIEF'S SON? I WONDER IF HE WILL LOVE ME...

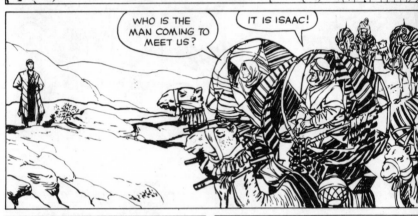

WHO IS THE MAN COMING TO MEET US?

IT IS ISAAC!

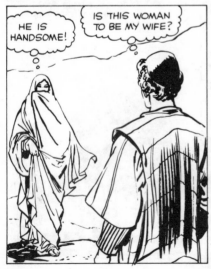

HE IS HANDSOME!

IS THIS WOMAN TO BE MY WIFE?

WHEN ISAAC SEES REBEKAH, HE FALLS IN LOVE WITH HER AT ONCE AND TAKES HER TO HIS FATHER FOR HIS BLESSING.

58

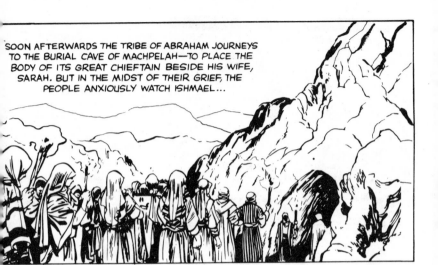

SOON AFTERWARDS THE TRIBE OF ABRAHAM JOURNEYS TO THE BURIAL CAVE OF MACHPELAH—TO PLACE THE BODY OF ITS GREAT CHIEFTAIN BESIDE HIS WIFE, SARAH. BUT IN THE MIDST OF THEIR GRIEF, THE PEOPLE ANXIOUSLY WATCH ISHMAEL...

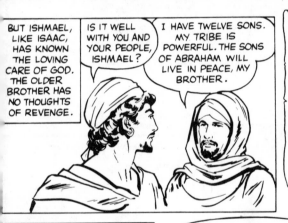

BUT ISHMAEL, LIKE ISAAC, HAS KNOWN THE LOVING CARE OF GOD. THE OLDER BROTHER HAS NO THOUGHTS OF REVENGE.

IS IT WELL WITH YOU AND YOUR PEOPLE, ISHMAEL?

I HAVE TWELVE SONS. MY TRIBE IS POWERFUL. THE SONS OF ABRAHAM WILL LIVE IN PEACE, MY BROTHER.

TIME AND AGAIN GOD HAD TESTED ABRAHAM'S FAITH... AND BY FAITH ABRAHAM HAD OBEYED. TIME AND AGAIN, TOO, GOD HAD PROMISED TO MAKE ABRAHAM THE FOUNDER OF GREAT NATIONS...AND THROUGH HIS SONS THE PROMISE WAS FULFILLED.

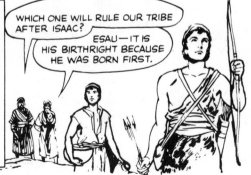

UNDER ISAAC'S PEACEFUL LEADERSHIP, THE TRIBE CONTINUES TO GROW. THE PEOPLE ARE LOYAL, EVEN WHEN ISAAC MOVES THEM FROM PLACE TO PLACE TO AVOID WAR WITH NEIGHBORING TRIBES. OVER WATER HOLES THAT ARE RIGHTFULLY HIS. BUT ISAAC FAILS TO SEE THE CONFLICT BETWEEN HIS OWN SONS.

WHICH ONE WILL RULE OUR TRIBE AFTER ISAAC?

ESAU—IT IS HIS BIRTHRIGHT BECAUSE HE WAS BORN FIRST.

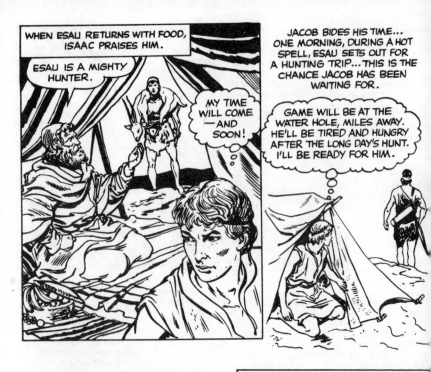

WHEN ESAU RETURNS WITH FOOD, ISAAC PRAISES HIM.

ESAU IS A MIGHTY HUNTER.

MY TIME WILL COME — AND SOON!

JACOB BIDES HIS TIME... ONE MORNING, DURING A HOT SPELL, ESAU SETS OUT FOR A HUNTING TRIP... THIS IS THE CHANCE JACOB HAS BEEN WAITING FOR.

GAME WILL BE AT THE WATER HOLE, MILES AWAY. HE'LL BE TIRED AND HUNGRY AFTER THE LONG DAY'S HUNT. I'LL BE READY FOR HIM.

TOWARD SUNDOWN JACOB WAITS FOR HIS BROTHER OUTSIDE CAMP.

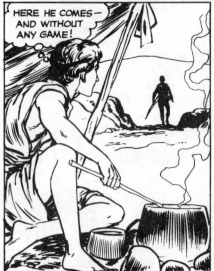

HERE HE COMES — AND WITHOUT ANY GAME!

CAMP WITH ITS FOOD IS ONLY A SHORT DISTANCE AWAY, BUT ESAU IS SO HUNGRY HE CANNOT WAIT...

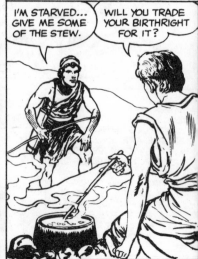

I'M STARVED... GIVE ME SOME OF THE STEW.

WILL YOU TRADE YOUR BIRTHRIGHT FOR IT?

60

CRAFTILY, JACOB OFFERS TO TRADE A DISH OF STEW IN RETURN FOR THE BIRTHRIGHT OF HIS OLDER BROTHER, ESAU. ESAU IS HUNGRY... SO HUNGRY HE DOESN'T STOP TO THINK WHAT HE'S DOING...

GIVE YOU THE RIGHT TO RULE OUR TRIBE SOMEDAY? SURE. YOU CAN HAVE IT!

HERE IS THE SOUP. NOW, SWEAR THAT THE BIRTHRIGHT IS MINE!

I SWEAR—THE BIRTHRIGHT IS YOURS. NOW, LET ME SIT DOWN AND EAT.

HERE, EAT ALL YOU WANT.

ESAU'S BIRTHRIGHT IS MINE! SOMEDAY I WILL INHERIT A DOUBLE PORTION OF MY FATHER'S WEALTH! I WILL RULE THE TRIBE OF MY FATHER!

BUT JACOB HAS A LONG TIME TO WAIT. HIS FATHER IS STILL STRONG AND POWERFUL. WHEN THE PASTURES DRY UP, THE TRIBE MOVES TO BETTER GRASSLANDS NEAR GERAR. THERE HE DIGS WELLS— BUT GIVES THEM UP RATHER THAN FIGHT WITH OTHER SHEPHERDS WHO CLAIM THEM. IN TIME THE KING OF GERAR RECOGNIZES THE STRENGTH AND GOODNESS OF ISAAC, WHO SACRIFICES HIS OWN RIGHTS TO KEEP WARS FROM STARTING. SO THE KING COMES TO ISAAC AND ASKS THAT THE TWO CHIEFTAINS PROMISE ALWAYS TO BE FRIENDS. BEFORE AN ALTAR TO GOD, THEY PLEDGE FRIENDSHIP. AND SO ISAAC WINS A GREATER VICTORY BY PEACE THAN BY FIGHTING.

PEACE-LOVING ISAAC IS NOT AWARE OF THE JEALOUS PLOT THAT IS BUILDING UP IN HIS OWN FAMILY.

FIND MY SON, ESAU. TELL HIM THAT I MUST SEE HIM.

61

ISAAC HAS GROWN OLD. HIS EYESIGHT IS FAILING. NOW HE DECIDES IT IS TIME TO GIVE HIS ELDEST SON THE BLESSING WHICH WILL INCLUDE RULING THE TRIBE.

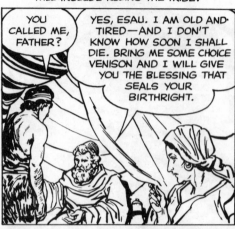

YOU CALLED ME, FATHER?

YES, ESAU. I AM OLD AND TIRED—AND I DON'T KNOW HOW SOON I SHALL DIE. BRING ME SOME CHOICE VENISON AND I WILL GIVE YOU THE BLESSING THAT SEALS YOUR BIRTHRIGHT.

THE NEWS REBEKAH OVERHEARS SENDS HER RUNNING THROUGH THE CAMP...

FIND JACOB! TELL HIM TO COME TO HIS MOTHER'S TENT—AT ONCE! HURRY!

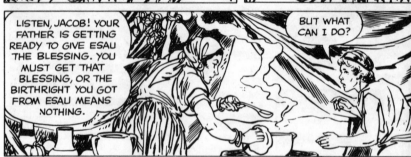

LISTEN, JACOB! YOUR FATHER IS GETTING READY TO GIVE ESAU THE BLESSING. YOU MUST GET THAT BLESSING, OR THE BIRTHRIGHT YOU GOT FROM ESAU MEANS NOTHING.

BUT WHAT CAN I DO?

BEFORE YOU AND YOUR BROTHER WERE BORN, THE LORD SPOKE TO ME AND SAID: "THE ELDER SHALL SERVE THE YOUNGER." BUT ESAU WILL SERVE YOU ONLY IF YOU ARE CHIEF OF THE TRIBE.

MY SKIN IS SMOOTH, BUT ESAU IS HAIRY. FATHER WILL TOUCH ME AND KNOW I AM NOT ESAU. WHAT CAN WE DO?

I HAVE THOUGHT OF THAT, TOO. HERE, PUT ON ESAU'S ROBE—THESE SKINS ON YOUR ARMS AND NECK WILL MAKE YOU FEEL LIKE ESAU.

BUT WHAT IF...

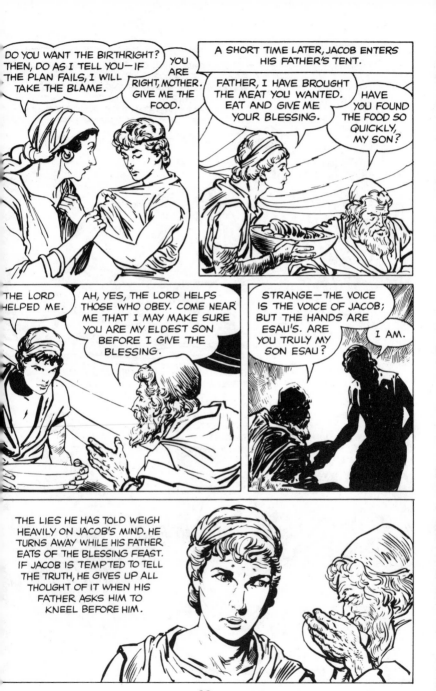

DO YOU WANT THE BIRTHRIGHT? THEN, DO AS I TELL YOU— IF THE PLAN FAILS, I WILL TAKE THE BLAME.

YOU ARE RIGHT, MOTHER. GIVE ME THE FOOD.

A SHORT TIME LATER, JACOB ENTERS HIS FATHER'S TENT.

FATHER, I HAVE BROUGHT THE MEAT YOU WANTED. EAT AND GIVE ME YOUR BLESSING.

HAVE YOU FOUND THE FOOD SO QUICKLY, MY SON?

THE LORD HELPED ME.

AH, YES, THE LORD HELPS THOSE WHO OBEY. COME NEAR ME THAT I MAY MAKE SURE YOU ARE MY ELDEST SON BEFORE I GIVE THE BLESSING.

STRANGE—THE VOICE IS THE VOICE OF JACOB; BUT THE HANDS ARE ESAU'S. ARE YOU TRULY MY SON ESAU?

I AM.

THE LIES HE HAS TOLD WEIGH HEAVILY ON JACOB'S MIND. HE TURNS AWAY WHILE HIS FATHER EATS OF THE BLESSING FEAST. IF JACOB IS TEMPTED TO TELL THE TRUTH, HE GIVES UP ALL THOUGHT OF IT WHEN HIS FATHER ASKS HIM TO KNEEL BEFORE HIM.

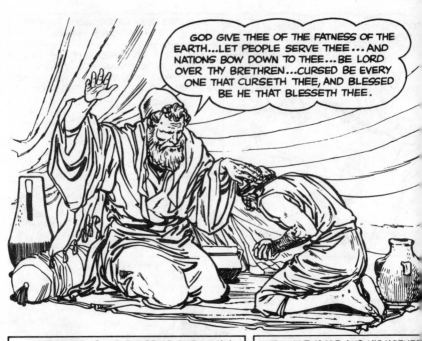

GOD GIVE THEE OF THE FATNESS OF THE EARTH...LET PEOPLE SERVE THEE...AND NATIONS BOW DOWN TO THEE...BE LORD OVER THY BRETHREN...CURSED BE EVERY ONE THAT CURSETH THEE, AND BLESSED BE HE THAT BLESSETH THEE.

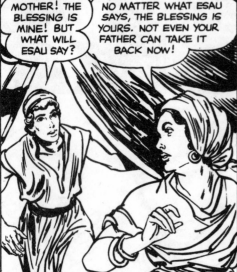

NO SOONER IS THE BLESSING GIVEN, THAN JACOB RUSHES OUT OF HIS FATHER'S TENT.

MOTHER! THE BLESSING IS MINE! BUT WHAT WILL ESAU SAY?

NO MATTER WHAT ESAU SAYS, THE BLESSING IS YOURS. NOT EVEN YOUR FATHER CAN TAKE IT BACK NOW!

BUT WHILE JACOB AND HIS MOTHER ARE REJOICING, ESAU RETURNS.

64

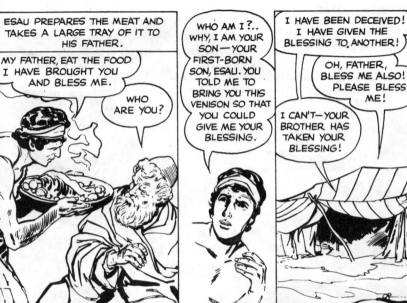

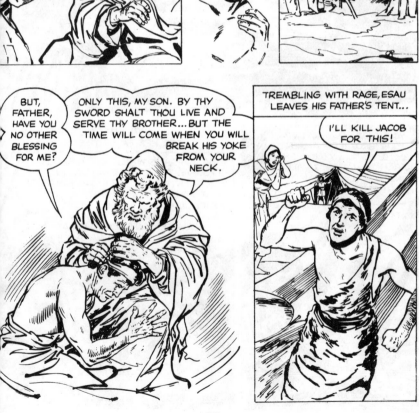

Tricked

FROM GENESIS 27: 42-46; 28; 29: 1-25

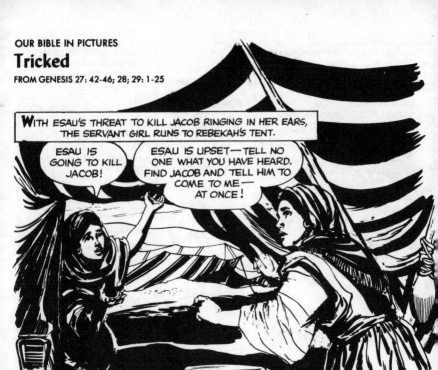

WITH ESAU'S THREAT TO KILL JACOB RINGING IN HER EARS, THE SERVANT GIRL RUNS TO REBEKAH'S TENT.

ESAU IS GOING TO KILL JACOB!

ESAU IS UPSET—TELL NO ONE WHAT YOU HAVE HEARD. FIND JACOB AND TELL HIM TO COME TO ME— AT ONCE!

YOU MUST GO AWAY UNTIL YOUR BROTHER'S ANGER COOLS. GO TO MY BROTHER, LABAN, IN HARAN. I WILL SEND FOR YOU WHEN IT IS SAFE TO RETURN.

WHAT WILL I TELL MY FATHER?

ONCE AGAIN, REBEKAH PAVES THE WAY FOR HER FAVORITE SON.

ISAAC, ESAU'S WIVES ARE A GREAT TROUBLE TO ME. LIFE WILL NOT BE WORTH LIVING FOR ME IF JACOB MARRIES A WOMAN OF THIS COUNTRY. IF ONLY HE COULD MARRY A GIRL FROM MY PEOPLE—REMEMBER HOW YOUR FATHER'S SERVANT FOUND ME AT MY FATHER'S HOUSE IN HARAN AND BROUGHT ME TO YOU?

ISAAC'S THOUGHTS GO BACK OVER THE YEARS TO THE DAY HE FIRST SAW REBEKAH. HE ALSO KNOWS THERE WILL BE TROUBLE BETWEEN HIS SONS. HE SENDS FOR JACOB.

ASHAMED, BUT FRIGHTENED BY ESAU'S ANGER, JACOB COMES TO HIS FATHER.

GO TO THY MOTHER'S BROTHER, LABAN, AND FIND A WIFE FROM AMONG HIS FAMILY. GOD BLESS YOU, MY SON.

A FEW HOURS LATER—AT THE EDGE OF CAMP...

GOOD-BY, MY SON. I'LL SEND WORD WHEN IT IS SAFE TO RETURN.

MY FATHER IS OLD—I MAY NEVER SEE HIM AGAIN. ESAU WANTS TO KILL ME. OH, MOTHER, YOU ARE THE ONLY ONE I WILL BE ABLE TO COME BACK TO!

ONE PUNISHMENT FOR THEIR DECEIT IS THAT REBEKAH AND JACOB NEVER SEE EACH OTHER AGAIN.

TRAVELING FARTHER AND FARTHER FROM HIS FAMILY AND FRIENDS, JACOB IS TORTURED BY LONELINESS. HE ESPECIALLY MISSES HIS MOTHER, WHO HAS ALWAYS PROTECTED AND ADVISED HIM. HE IS HAUNTED BY THE MEMORY OF HOW HE TRICKED HIS FATHER AND BROTHER.

AS NIGHT APPROACHES...

IT'S GETTING DARK...I'LL HAVE TO STOP HERE TONIGHT.

67

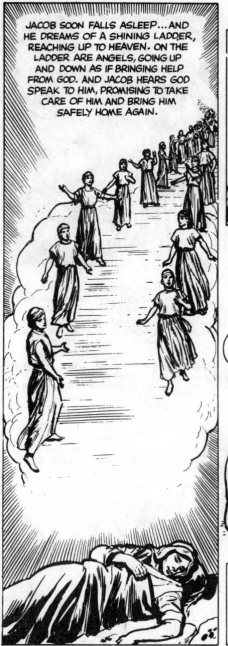

JACOB SOON FALLS ASLEEP...AND HE DREAMS OF A SHINING LADDER, REACHING UP TO HEAVEN. ON THE LADDER ARE ANGELS, GOING UP AND DOWN AS IF BRINGING HELP FROM GOD. AND JACOB HEARS GOD SPEAK TO HIM, PROMISING TO TAKE CARE OF HIM AND BRING HIM SAFELY HOME AGAIN.

THE NEXT MORNING JACOB AWAKENS, STILL AWED BY THE DREAM HE HAD.

SURELY GOD IS IN THIS PLACE—AND THIS IS THE GATE OF HEAVEN.

JACOB REALIZES THE WRONG HE HAS DONE. BUT HE KNOWS THAT GOD WILL HELP HIM IF HE OBEYS HIM. QUICKLY HE TURNS A STONE ON END FOR AN ALTAR AND WORSHIPS GOD. HE CALLS THE PLACE BETH-EL, WHICH MEANS "THE HOUSE OF GOD."

IF GOD WILL GO WITH ME, I'LL BE GOD'S MAN.

JACOB GOES ON HIS WAY A STRONGER, NOBLER YOUNG MAN BECAUSE HE HAS FOUND GOD. HE IS EAGER TO PUT BEHIND HIM THE DISHONESTY OF HIS PAST AND BECOME REALLY WORTHY OF GOD'S LOVE AND CARE.

SHEPHERDS AROUND A WELL. MAYBE THEY CAN HELP ME FIND MY UNCLE LABAN.

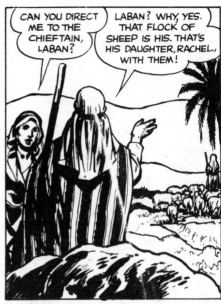

CAN YOU DIRECT ME TO THE CHIEFTAIN, LABAN?

LABAN? WHY, YES. THAT FLOCK OF SHEEP IS HIS. THAT'S HIS DAUGHTER, RACHEL, WITH THEM!

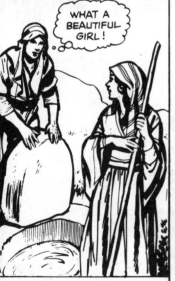

WHAT A BEAUTIFUL GIRL!

QUICKLY HE ROLLS THE STONE FROM THE WELL AND HELPS RACHEL WATER THE SHEEP. WHEN HE TELLS WHO HE IS, SHE RUNS TO TELL HER FATHER.

THAT NIGHT, LABAN HOLDS A FEAST FOR HIS NEPHEW, JACOB. LEAH, THE ELDER DAUGHTER, SERVES THE FOOD, WHILE RACHEL LISTENS TO JACOB AS HE TELLS OF HIS HOME AND LONG JOURNEY TO HARAN.

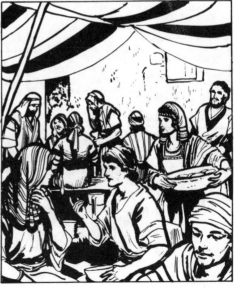

A MONTH LATER, LABAN MAKES A BARGAIN WITH JACOB.

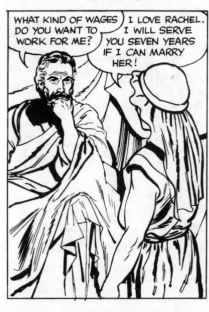

WHAT KIND OF WAGES DO YOU WANT TO WORK FOR ME?

I LOVE RACHEL. I WILL SERVE YOU SEVEN YEARS IF I CAN MARRY HER!

LABAN AGREES. FOR SEVEN YEARS JACOB TAKES CARE OF LABAN'S FLOCKS, AND BECAUSE HE LOVES RACHEL, THE YEARS SEEM BUT A FEW SWIFT DAYS. THEN AFTER SEVEN YEARS, JACOB CLAIMS HIS BRIDE...

I HAVE WORKED SEVEN YEARS FOR YOU, LABAN. NOW GIVE ME RACHEL FOR MY WIFE.

YOU HAVE SERVED ME WELL, JACOB. I'LL ARRANGE THE WEDDING FEAST AT ONCE.

THERE IS MUCH REJOICING, AND AT THE END OF THE WEDDING FEAST, LABAN BRINGS HIS DAUGHTER TO JACOB.

HERE IS YOUR BRIDE, JACOB.

RACHEL, MY DEAR! I HAVE WAITED SEVEN YEARS FOR THIS MOMENT.

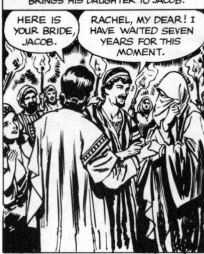

BUT, TOO LATE, JACOB DISCOVERS THAT HE HAS BEEN TRICKED!

YOU GAVE ME LEAH— NOT RACHEL— FOR MY WIFE!

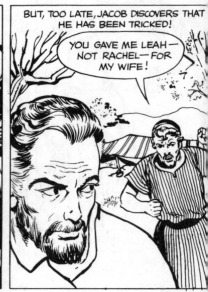

70

argain in the Desert

ACOB ACCUSES LABAN OF TRICKING HIM INTO MARRIAGE
ITH LEAH, INSTEAD OF RACHEL. BUT LABAN ONLY SMILES...

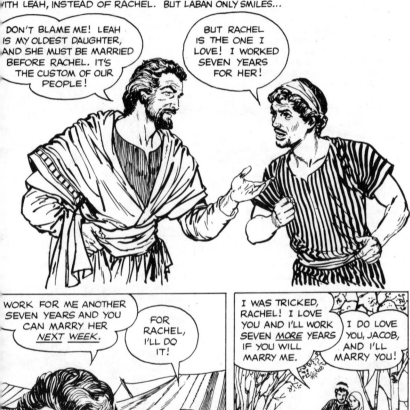

DON'T BLAME ME! LEAH IS MY OLDEST DAUGHTER, AND SHE MUST BE MARRIED BEFORE RACHEL. IT'S THE CUSTOM OF OUR PEOPLE!

BUT RACHEL IS THE ONE I LOVE! I WORKED SEVEN YEARS FOR HER!

WORK FOR ME ANOTHER SEVEN YEARS AND YOU CAN MARRY HER _NEXT WEEK_.

FOR RACHEL, I'LL DO IT!

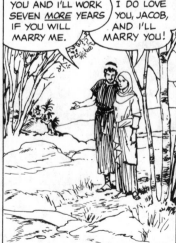

I WAS TRICKED, RACHEL! I LOVE YOU AND I'LL WORK SEVEN _MORE_ YEARS IF YOU WILL MARRY ME.

I DO LOVE YOU, JACOB, AND I'LL MARRY YOU!

SO JACOB MARRIES RACHEL AND BEGINS HIS SECOND SEVEN YEARS OF WORK FOR LABAN. UNDER JACOB'S CARE THE FLOCKS CONTINUE TO INCREASE. AT THE END OF THE SEVEN YEARS JACOB THREATENS TO LEAVE, BUT LABAN MAKES ANOTHER BARGAIN: JACOB CAN HAVE ALL OF THE SPECKLED OR SPOTTED ANIMALS. SO, JACOB STAYS; AND IN A FEW YEARS HIS FLOCKS OUTNUMBER LABAN'S. LABAN BECOMES ANGRY...

ONE DAY JACOB CALLS HIS WIVES TO HIM.

I CAN SEE THAT TROUBLE IS RISING IN THE TRIBE. IT IS BETTER IF WE LEAVE WHILE YOUR FATHER IS AWAY. HELP ME PACK, AND WE WILL GO AT ONCE.

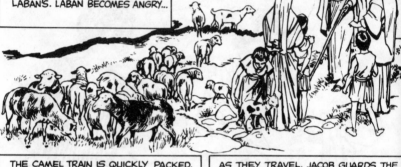

THE CAMEL TRAIN IS QUICKLY PACKED, THE FLOCKS HERDED TOGETHER; SOON THE CARAVAN IS ON ITS WAY.

LABAN MAY FOLLOW— KEEP WATCH AND TELL ME IF YOU SEE HIM COMING.

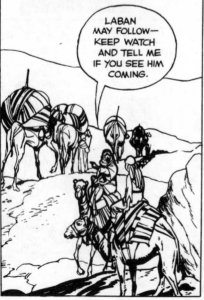

AS THEY TRAVEL, JACOB GUARDS THE CAMEL ON WHICH HIS BELOVED RACHEL AND HER ONLY SON, JOSEPH, ARE RIDING LEAH AND JACOB'S OTHER TEN SONS WATCH WITH JEALOUS EYES. WITHOUT REALIZING IT, JACOB IS SOWING SEEDS OF TROUBLE FOR THE SON HE LOVES THE BEST...

SEVERAL DAYS AFTER LEAVING LABAN...

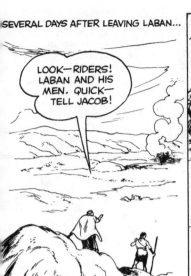

LOOK—RIDERS! LABAN AND HIS MEN. QUICK—TELL JACOB!

JACOB IS READY WHEN HIS FATHER-IN-LAW ARRIVES.

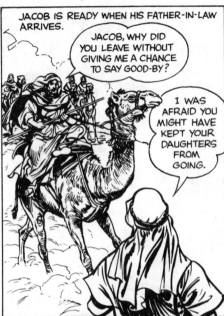

JACOB, WHY DID YOU LEAVE WITHOUT GIVING ME A CHANCE TO SAY GOOD-BY?

I WAS AFRAID YOU MIGHT HAVE KEPT YOUR DAUGHTERS FROM GOING.

I HAVE ENOUGH MEN SO I COULD TAKE REVENGE ON YOU. BUT THE GOD OF YOUR FATHERS HAS TOLD ME NOT TO HARM YOU.

SO LABAN AND JACOB SET UP A HEAP OF STONES AS A MARKER AND MAKE AN AGREEMENT NEVER TO HARM EACH OTHER.

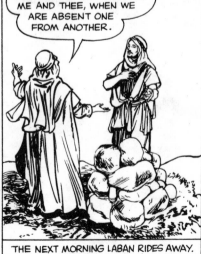

THE LORD WATCH BETWEEN ME AND THEE, WHEN WE ARE ABSENT ONE FROM ANOTHER.

THE NEXT MORNING LABAN RIDES AWAY.

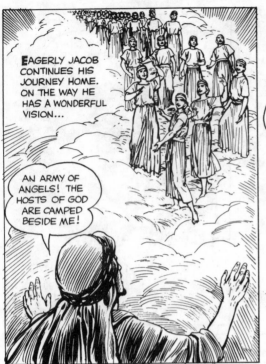

EAGERLY JACOB CONTINUES HIS JOURNEY HOME. ON THE WAY HE HAS A WONDERFUL VISION...

AN ARMY OF ANGELS! THE HOSTS OF GOD ARE CAMPED BESIDE ME!

HE IS COMFORTED BY THE ANGELS—BUT AS HE NEARS HIS HOME COUNTRY, HE BEGINS TO WORRY ABOUT HIS BROTHER, ESAU, WHO ONCE PLANNED TO MURDER HIM.

RIDE AHEAD—SEARCH OUT ESAU. TELL HIM I AM RETURNING HOME WITH MY FAMILY AND FLOCKS. TELL HIM I HOPE HE WILL FORGIVE ME.

JACOB WAITS ANXIOUSLY FOR THE RIDERS TO COME BACK. HE REMEMBERS THE TIME WHEN HE LIED TO HIS FATHER AND STOLE HIS BROTHER'S BLESSING...WHEN ESAU THREATENED TO KILL HIM...

FINALLY THE SCOUTS RETURN...

WE SAW ESAU! HE'S COMING TO MEET YOU— WITH 400 MEN!

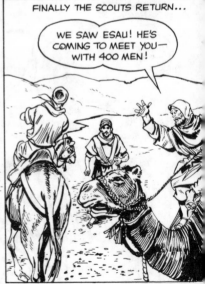

ourney to Hebron

OM GENESIS 32: 7—33; 35: 1-20

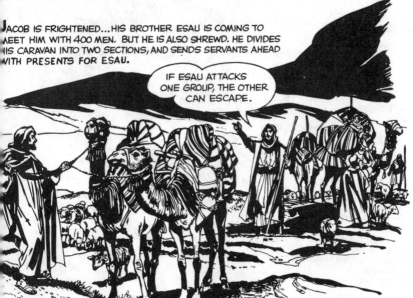

JACOB IS FRIGHTENED...HIS BROTHER ESAU IS COMING TO
MEET HIM WITH 400 MEN. BUT HE IS ALSO SHREWD. HE DIVIDES
HIS CARAVAN INTO TWO SECTIONS, AND SENDS SERVANTS AHEAD
WITH PRESENTS FOR ESAU.

IF ESAU ATTACKS ONE GROUP, THE OTHER CAN ESCAPE.

HAT NIGHT JACOB PRAYS—CONFESSING
IS SINS, ADMITTING HIS FEAR, AND
ASKING GOD'S HELP. BUT STILL HE
CANNOT SLEEP.

Y FAMILY OULD BE AFER ON HE OTHER DE OF THE RIVER.

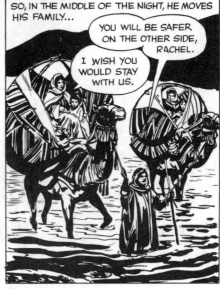

SO, IN THE MIDDLE OF THE NIGHT, HE MOVES
HIS FAMILY...

YOU WILL BE SAFER ON THE OTHER SIDE, RACHEL.

I WISH YOU WOULD STAY WITH US.

75

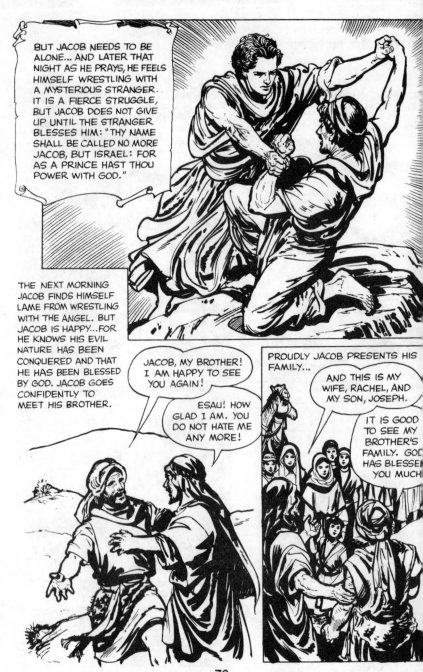

BUT JACOB NEEDS TO BE ALONE... AND LATER THAT NIGHT AS HE PRAYS, HE FEELS HIMSELF WRESTLING WITH A MYSTERIOUS STRANGER. IT IS A FIERCE STRUGGLE, BUT JACOB DOES NOT GIVE UP UNTIL THE STRANGER BLESSES HIM: "THY NAME SHALL BE CALLED NO MORE JACOB, BUT ISRAEL: FOR AS A PRINCE HAST THOU POWER WITH GOD."

THE NEXT MORNING JACOB FINDS HIMSELF LAME FROM WRESTLING WITH THE ANGEL. BUT JACOB IS HAPPY...FOR HE KNOWS HIS EVIL NATURE HAS BEEN CONQUERED AND THAT HE HAS BEEN BLESSED BY GOD. JACOB GOES CONFIDENTLY TO MEET HIS BROTHER.

JACOB, MY BROTHER! I AM HAPPY TO SEE YOU AGAIN!

ESAU! HOW GLAD I AM. YOU DO NOT HATE ME ANY MORE!

PROUDLY JACOB PRESENTS HIS FAMILY...

AND THIS IS MY WIFE, RACHEL, AND MY SON, JOSEPH.

IT IS GOOD TO SEE MY BROTHER'S FAMILY. GOD HAS BLESSED YOU MUCH

AFTER FEASTING TOGETHER, THE BROTHERS SAY GOOD-BY. JACOB HEADS TOWARD HIS FATHER'S HOME IN HEBRON.

FAREWELL, AND GREET MY FATHER FOR ME.

I WILL TELL HIM ALL IS WELL WITH YOU. GOOD-BY, AND GOD BLESS YOU, ESAU.

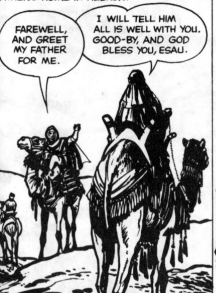

SOME TIME LATER ON THE WAY, JACOB STOPS AT BETH-EL.

THIS STONE, RACHEL, MARKS THE PLACE WHERE I SAW ANGELS COMING TO ME FROM HEAVEN, AND WHERE GOD PROMISED TO TAKE CARE OF ME. HE HAS, RACHEL... MORE THAN I DESERVE.

GOD HAS BEEN GOOD TO US, JACOB. AND I PRAY THAT HE WILL TAKE CARE OF OUR SON, JOSEPH— AND THE CHILD WHO IS SOON TO BE BORN.

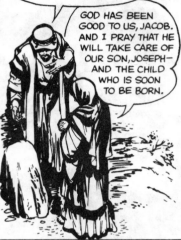

FARTHER ALONG ON THE JOURNEY— NOT FAR FROM BETHLEHEM— RACHEL'S CHILD IS BORN...

IT'S A BOY, BUT OH, MY MASTER, YOUR WIFE, RACHEL, IS DEAD!

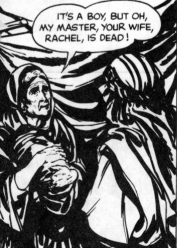

JACOB BURIES HIS BELOVED WIFE, RACHEL. THEN HE AND HIS FAMILY CONTINUE SADLY ON THEIR JOURNEY... STOPPING NOW AND THEN TO REST AND FEED THE FLOCKS. AS THEY TRAVEL ON, JACOB WONDERS...

RACHEL AND MY MOTHER ARE DEAD. WILL I GET TO MY FATHER WHILE HE IS STILL ALIVE?

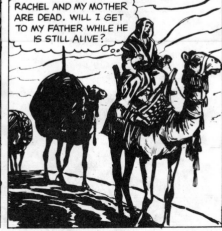

Into the Pit

FROM GENESIS 35: 27-29; 37: 1-26

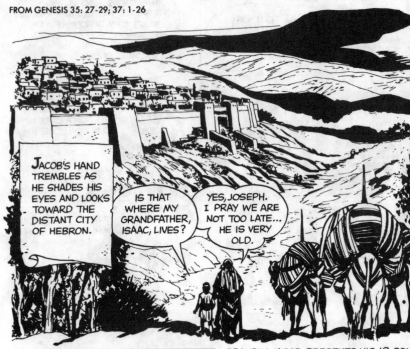

JACOB'S HAND TREMBLES AS HE SHADES HIS EYES AND LOOKS TOWARD THE DISTANT CITY OF HEBRON.

IS THAT WHERE MY GRANDFATHER, ISAAC, LIVES?

YES, JOSEPH. I PRAY WE ARE NOT TOO LATE... HE IS VERY OLD.

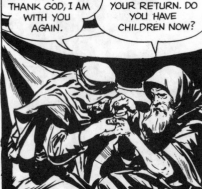

JACOB'S PRAYERS ARE ANSWERED. AT THE SIGHT OF HIS BLIND AND AGED FATHER, HE FALLS TO HIS KNEES.

O FATHER, I AM YOUR SON, JACOB— THANK GOD, I AM WITH YOU AGAIN.

JACOB, MY SON! I HAVE PRAYED FOR YOUR RETURN. DO YOU HAVE CHILDREN NOW?

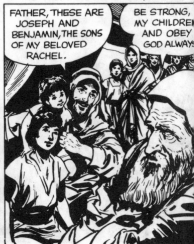

PROUDLY JACOB PRESENTS HIS 12 SONS TO THEIR GRANDFATHER, ISAAC.

FATHER, THESE ARE JOSEPH AND BENJAMIN, THE SONS OF MY BELOVED RACHEL.

BE STRONG, MY CHILDREN AND OBEY GOD ALWAYS.

78

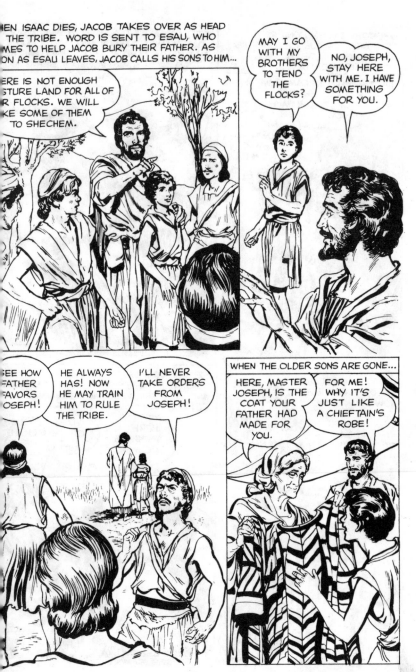

79

WHEN THE OLDER SONS RETURN, THEY ARE JEALOUS OF JOSEPH'S COAT. THEN HE TELLS THEM ABOUT HIS DREAMS...

LAST NIGHT I DREAMED WE WERE BINDING SHEAVES, AND ALL OF YOUR SHEAVES BOWED DOWN TO MINE.

BOW DOWN TO HIM? **NEVER!**

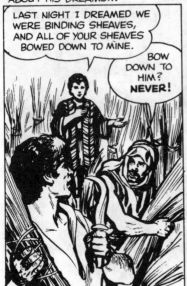

STILL LATER JOSEPH HAS ANOTHER DREAM...

I DREAMED THE SUN AND MOON AND STARS BOWED TO ME.

WHAT? SHALL YOUR PARENT AND BROTHER SERVE YOU

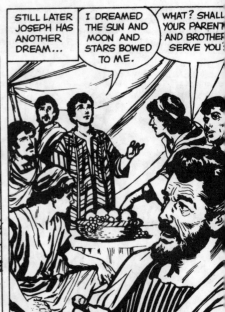

JACOB SOON FORGETS HIS OWN ANGER TOWARD JOSEPH, BUT THE SECOND DREAM WHIPS THE OLDER BROTHERS' HATRED INTO A BURNING RAGE.

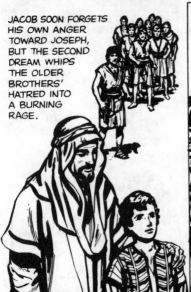

SEVERAL DAYS LATER THE BROTHERS ARE TENDING THE SHEEP SOME DISTANCE FROM CA AND JACOB SENDS JOSEPH TO SEE HOW THEY A GETTING ALONG.

HERE COMES THE DREAMER.

I'VE HAD ENOUGH OF HIS TALK. LET GET RID OF HIM

80

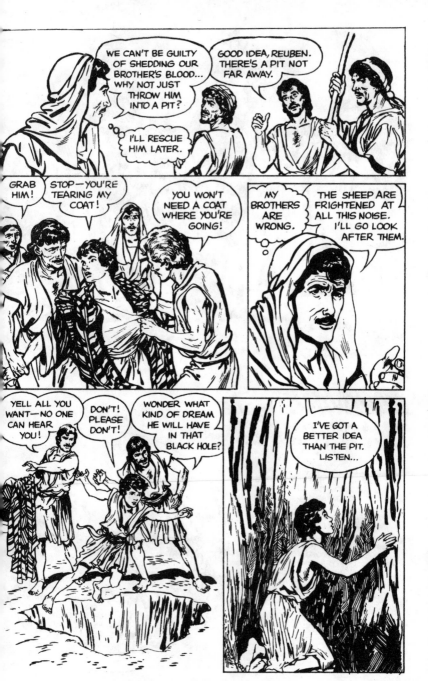

81

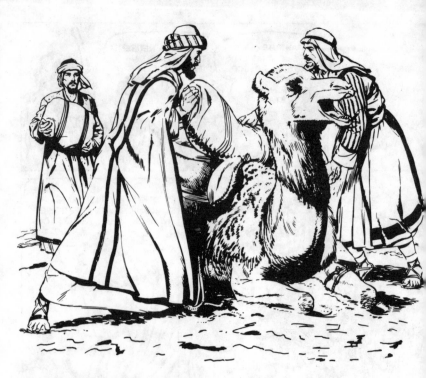

CARAVANS on the TRADE ROUTES

LONG, SLOW CARAVANS CARRYING MERCHANDISE AND TRAVELERS WERE A COMMON SIGHT IN PALESTINE BEFORE, DURING, AND AFTER JESUS' TIME. A WELL-TRAVELED CARAVAN ROUTE FROM BABYLONIA TO EGYPT RAN RIGHT THROUGH PALESTINE.

THE MOST COMMON PACK ANIMALS IN THESE CARAVANS WERE CAMELS BECAUSE THEY COULD MAKE THE LONG, HARD JOURNEYS ACROSS THE MOUNTAINS AND DESERTS IN THIS PART OF THE WORLD.

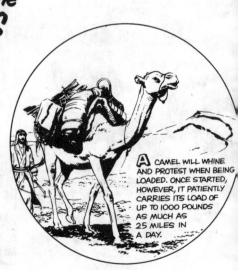

A CAMEL WILL WHINE AND PROTEST WHEN BEING LOADED. ONCE STARTED, HOWEVER, IT PATIENTLY CARRIES ITS LOAD OF UP TO 1000 POUNDS AS MUCH AS 25 MILES IN A DAY.

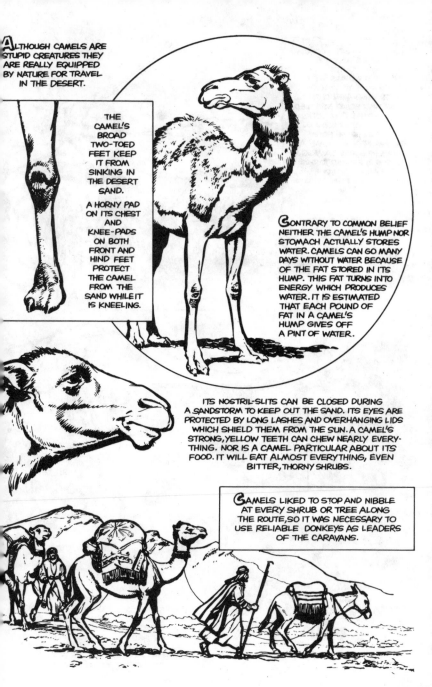

ALTHOUGH CAMELS ARE STUPID CREATURES THEY ARE REALLY EQUIPPED BY NATURE FOR TRAVEL IN THE DESERT.

THE CAMEL'S BROAD TWO-TOED FEET KEEP IT FROM SINKING IN THE DESERT SAND.

A HORNY PAD ON ITS CHEST AND KNEE-PADS ON BOTH FRONT AND HIND FEET PROTECT THE CAMEL FROM THE SAND WHILE IT IS KNEELING.

CONTRARY TO COMMON BELIEF NEITHER THE CAMEL'S HUMP NOR STOMACH ACTUALLY STORES WATER. CAMELS CAN GO MANY DAYS WITHOUT WATER BECAUSE OF THE FAT STORED IN ITS HUMP. THIS FAT TURNS INTO ENERGY WHICH PRODUCES WATER. IT IS ESTIMATED THAT EACH POUND OF FAT IN A CAMEL'S HUMP GIVES OFF A PINT OF WATER.

ITS NOSTRIL-SLITS CAN BE CLOSED DURING A SANDSTORM TO KEEP OUT THE SAND. ITS EYES ARE PROTECTED BY LONG LASHES AND OVERHANGING LIDS WHICH SHIELD THEM FROM THE SUN. A CAMEL'S STRONG, YELLOW TEETH CAN CHEW NEARLY EVERYTHING. NOR IS A CAMEL PARTICULAR ABOUT ITS FOOD. IT WILL EAT ALMOST EVERYTHING, EVEN BITTER, THORNY SHRUBS.

CAMELS LIKED TO STOP AND NIBBLE AT EVERY SHRUB OR TREE ALONG THE ROUTE, SO IT WAS NECESSARY TO USE RELIABLE DONKEYS AS LEADERS OF THE CARAVANS.

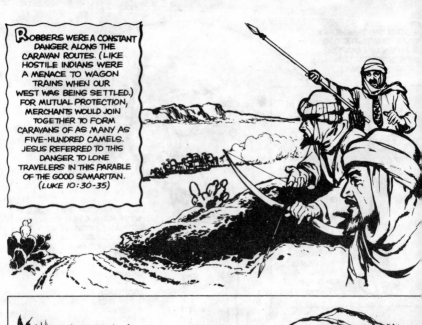

ROBBERS WERE A CONSTANT DANGER ALONG THE CARAVAN ROUTES. (LIKE HOSTILE INDIANS WERE A MENACE TO WAGON TRAINS WHEN OUR WEST WAS BEING SETTLED.) FOR MUTUAL PROTECTION, MERCHANTS WOULD JOIN TOGETHER TO FORM CARAVANS OF AS MANY AS FIVE-HUNDRED CAMELS. JESUS REFERRED TO THIS DANGER TO LONE TRAVELERS IN THIS PARABLE OF THE GOOD SAMARITAN. (LUKE 10:30-35)

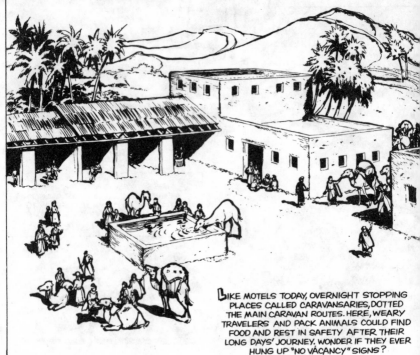

LIKE MOTELS TODAY, OVERNIGHT STOPPING PLACES CALLED CARAVANSARIES, DOTTED THE MAIN CARAVAN ROUTES. HERE, WEARY TRAVELERS AND PACK ANIMALS COULD FIND FOOD AND REST IN SAFETY AFTER THEIR LONG DAYS' JOURNEY. WONDER IF THEY EVER HUNG UP "NO VACANCY" SIGNS?

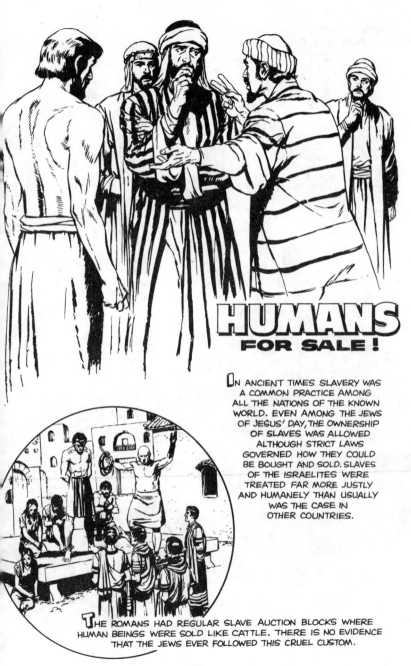

HUMANS FOR SALE!

IN ANCIENT TIMES SLAVERY WAS A COMMON PRACTICE AMONG ALL THE NATIONS OF THE KNOWN WORLD. EVEN AMONG THE JEWS OF JESUS' DAY, THE OWNERSHIP OF SLAVES WAS ALLOWED ALTHOUGH STRICT LAWS GOVERNED HOW THEY COULD BE BOUGHT AND SOLD. SLAVES OF THE ISRAELITES WERE TREATED FAR MORE JUSTLY AND HUMANELY THAN USUALLY WAS THE CASE IN OTHER COUNTRIES.

THE ROMANS HAD REGULAR SLAVE AUCTION BLOCKS WHERE HUMAN BEINGS WERE SOLD LIKE CATTLE. THERE IS NO EVIDENCE THAT THE JEWS EVER FOLLOWED THIS CRUEL CUSTOM.

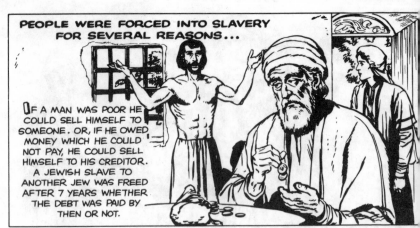

PEOPLE WERE FORCED INTO SLAVERY FOR SEVERAL REASONS...

IF A MAN WAS POOR HE COULD SELL HIMSELF TO SOMEONE. OR, IF HE OWED MONEY WHICH HE COULD NOT PAY, HE COULD SELL HIMSELF TO HIS CREDITOR. A JEWISH SLAVE TO ANOTHER JEW WAS FREED AFTER 7 YEARS WHETHER THE DEBT WAS PAID BY THEN OR NOT.

A POOR MAN, UNABLE TO SUPPORT HIS FAMILY, MIGHT SELL HIS DAUGHTER AS A FEMALE SLAVE IF SHE WAS UNDER 12 YEARS OLD. SHE COULD BE BOUND FOR NO LONGER THAN SIX YEARS.

SLAVES COULD BE REDEEMED BY FRIENDS OR RELATIVES IF THEY HAD THE MONEY TO DO SO. WHEN FREED, A SLAVE WAS ENTITLED TO A PARTING GIFT.

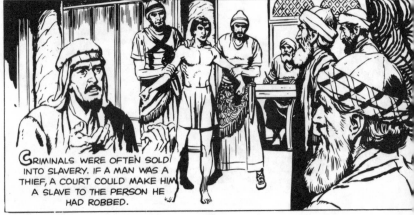

CRIMINALS WERE OFTEN SOLD INTO SLAVERY. IF A MAN WAS A THIEF, A COURT COULD MAKE HIM A SLAVE TO THE PERSON HE HAD ROBBED.

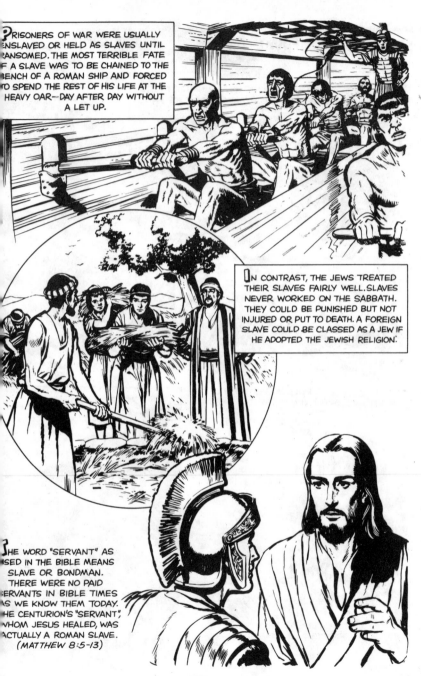

PRISONERS OF WAR WERE USUALLY ENSLAVED OR HELD AS SLAVES UNTIL RANSOMED. THE MOST TERRIBLE FATE OF A SLAVE WAS TO BE CHAINED TO THE BENCH OF A ROMAN SHIP AND FORCED TO SPEND THE REST OF HIS LIFE AT THE HEAVY OAR—DAY AFTER DAY WITHOUT A LET UP.

IN CONTRAST, THE JEWS TREATED THEIR SLAVES FAIRLY WELL. SLAVES NEVER WORKED ON THE SABBATH. THEY COULD BE PUNISHED BUT NOT INJURED OR PUT TO DEATH. A FOREIGN SLAVE COULD BE CLASSED AS A JEW IF HE ADOPTED THE JEWISH RELIGION.

THE WORD "SERVANT" AS USED IN THE BIBLE MEANS SLAVE OR BONDMAN. THERE WERE NO PAID SERVANTS IN BIBLE TIMES AS WE KNOW THEM TODAY. THE CENTURION'S "SERVANT", WHOM JESUS HEALED, WAS ACTUALLY A ROMAN SLAVE. (MATTHEW 8:5-13)

Slave Train to Egypt

FROM GENESIS 37: 27-36; 39: 1-20

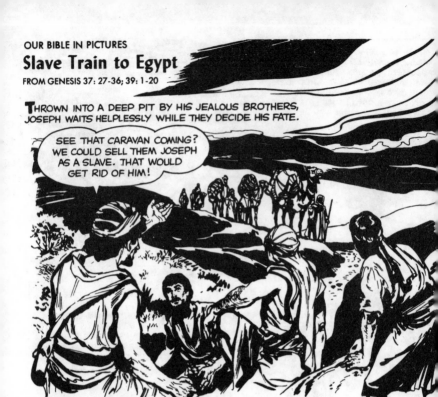

THROWN INTO A DEEP PIT BY HIS JEALOUS BROTHERS, JOSEPH WAITS HELPLESSLY WHILE THEY DECIDE HIS FATE.

SO THE BROTHERS PULL JOSEPH OUT OF THE PIT AND DRAG HIM TO THE CARAVAN.

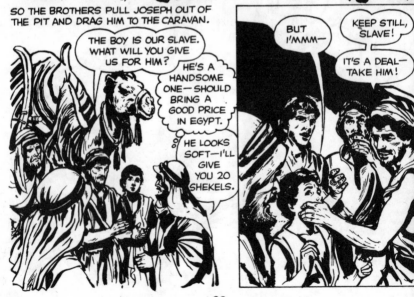

88

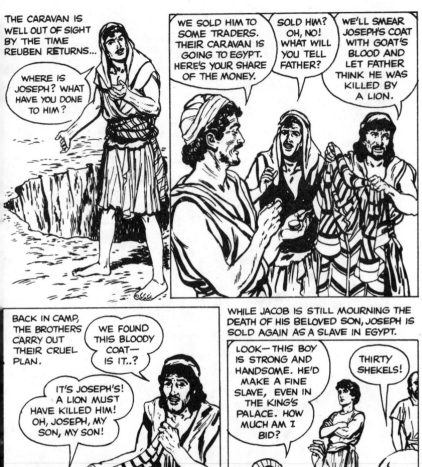

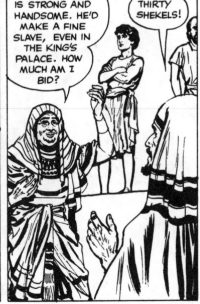

89

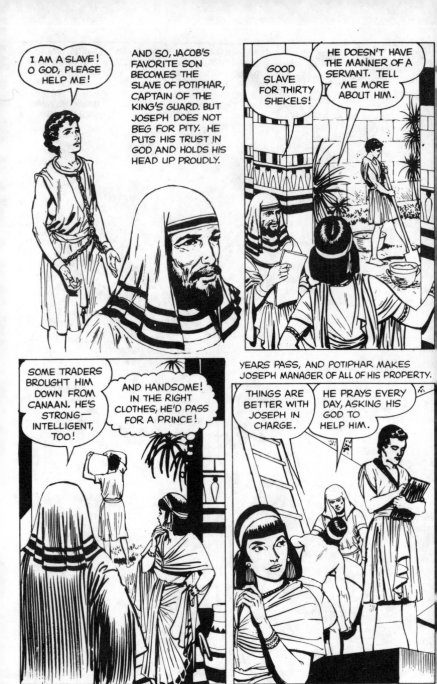

90

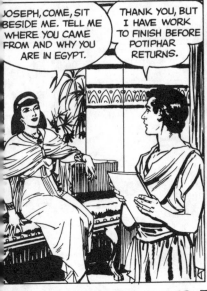

BUT JOSEPH'S SUCCESS ALSO LEADS TO TROUBLE. POTIPHAR'S WIFE FALLS IN LOVE WITH THE HANDSOME, YOUNG SLAVE. ONE DAY WHILE POTIPHAR IS AWAY...

JOSEPH, COME, SIT BESIDE ME. TELL ME WHERE YOU CAME FROM AND WHY YOU ARE IN EGYPT.

THANK YOU, BUT I HAVE WORK TO FINISH BEFORE POTIPHAR RETURNS.

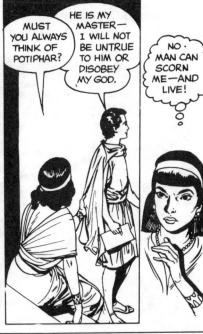

MUST YOU ALWAYS THINK OF POTIPHAR?

HE IS MY MASTER— I WILL NOT BE UNTRUE TO HIM OR DISOBEY MY GOD.

NO. MAN CAN SCORN ME—AND LIVE!

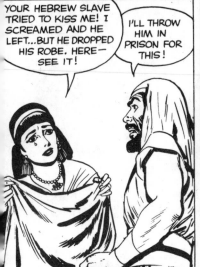

SHE BIDES HER TIME...WHEN POTIPHAR RETURNS SHE GREETS HIM WITH TEARS IN HER EYES, AND A LIE ON HER LIPS.

YOUR HEBREW SLAVE TRIED TO KISS ME! I SCREAMED AND HE LEFT...BUT HE DROPPED HIS ROBE. HERE— SEE IT!

I'LL THROW HIM IN PRISON FOR THIS!

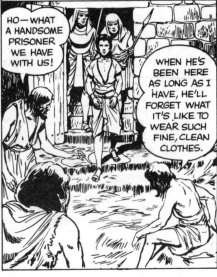

BEFORE THE SUN SETS THAT DAY, JOSEPH IS CHAINED AND THROWN INTO THE KING'S PRISON.

HO— WHAT A HANDSOME PRISONER WE HAVE WITH US!

WHEN HE'S BEEN HERE AS LONG AS I HAVE, HE'LL FORGET WHAT IT'S LIKE TO WEAR SUCH FINE, CLEAN CLOTHES.

91

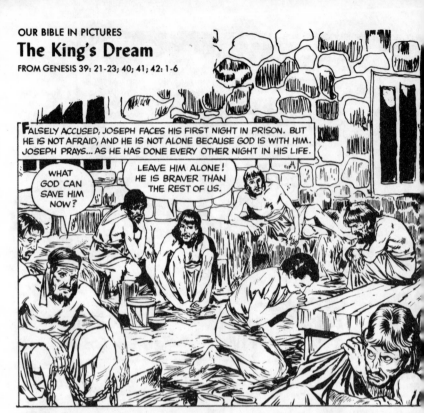

FALSELY ACCUSED, JOSEPH FACES HIS FIRST NIGHT IN PRISON. BUT HE IS NOT AFRAID, AND HE IS NOT ALONE BECAUSE GOD IS WITH HIM. JOSEPH PRAYS... AS HE HAS DONE EVERY OTHER NIGHT IN HIS LIFE.

WHAT GOD CAN SAVE HIM NOW?

LEAVE HIM ALONE! HE IS BRAVER THAN THE REST OF US.

ONE LONG, HOT DAY FOLLOWS ANOTHER. THE PRISONERS QUARREL OVER FOOD—WATER— THE BEST PLACE TO SLEEP. ONE DAY A FIGHT BREAKS OUT...

STOP IT! FIGHTING WON'T HELP US.

EVEN IN PRISON GOD IS WITH JOSEPH. WHEN THE KEEPER OF THE JAIL LEARNS JOSEPH IS A LEADER, HE PUTS JOSEPH IN CHARGE OF THE OTHER PRISONERS.

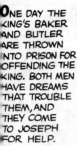

ONE DAY THE KING'S BAKER AND BUTLER ARE THROWN INTO PRISON FOR OFFENDING THE KING. BOTH MEN HAVE DREAMS THAT TROUBLE THEM, AND THEY COME TO JOSEPH FOR HELP.

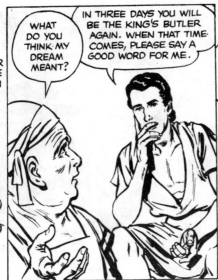

WHAT DO YOU THINK MY DREAM MEANT?

IN THREE DAYS YOU WILL BE THE KING'S BUTLER AGAIN. WHEN THAT TIME COMES, PLEASE SAY A GOOD WORD FOR ME.

NOW TELL ME WHAT MY DREAM MEANS.

I'M SORRY, BUT THE DREAM SHOWS YOU WILL BE HANGED, IN JUST THREE DAYS.

JOSEPH'S WORDS COME TRUE. THREE DAYS LATER, ONE MAN DIES, AND THE OTHER RETURNS TO SERVE THE KING. BUT HE FORGETS HIS PROMISE. TWO YEARS GO BY...

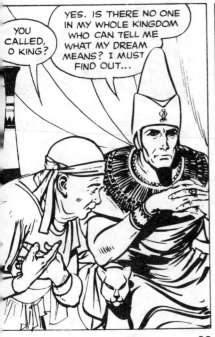

YOU CALLED, O KING?

YES. IS THERE NO ONE IN MY WHOLE KINGDOM WHO CAN TELL ME WHAT MY DREAM MEANS? I MUST FIND OUT...

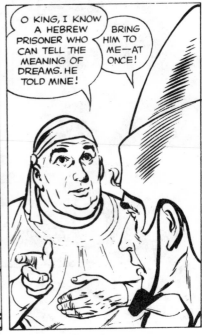

O KING, I KNOW A HEBREW PRISONER WHO CAN TELL THE MEANING OF DREAMS. HE TOLD MINE!

BRING HIM TO ME—AT ONCE!

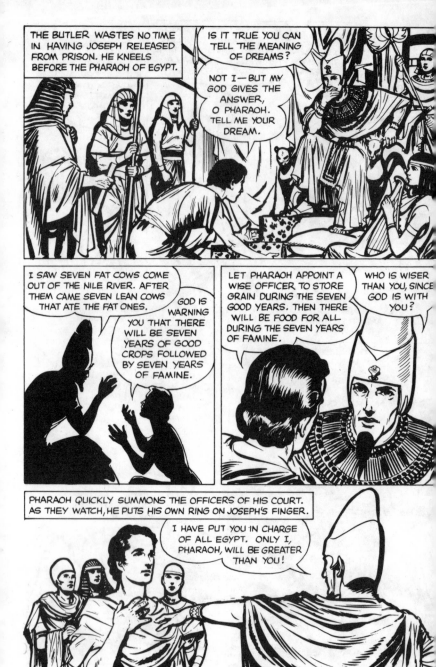

94

FROM THE THRONE ROOM, JOSEPH GOES TO HIS OWN ROOM AND KNEELS IN PRAYER, THANKING GOD FOR PROTECTION AND GUIDANCE.

JOSEPH ORDERS THE PEOPLE TO START PREPARING FOR THE FAMINE. HE BECOMES FAMOUS, AND ALL REJOICE WHEN HE MARRIES THE BEAUTIFUL DAUGHTER OF THE PRIEST OF ON.

I AM PROUD TO BE YOUR WIFE, JOSEPH. YOU HAVE DONE SO MUCH FOR OUR PEOPLE.

THERE IS MORE TO BE DONE, MY DEAR. THE YEARS OF PLENTY WILL PASS QUICKLY.

ALL TOO SOON, THE FAMINE BEGINS. AS IT CONTINUES, PEOPLE FROM OTHER COUNTRIES COME TO EGYPT SEEKING FOOD. ONE DAY TRIBESMEN FROM CANAAN ENTER JOSEPH'S CITY...

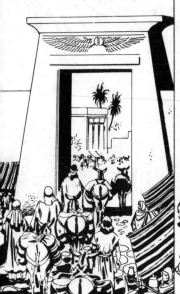

IN ORDER TO BUY GRAIN, THEY APPEAR BEFORE THE GOVERNOR OF EGYPT. THEY BOW BEFORE HIM...

MY BROTHERS! THEY DO NOT RECOGNIZE ME AFTER ALL THESE YEARS!

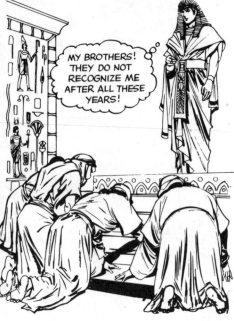

95

Trouble in Egypt

FROM GENESIS 42: 6-38

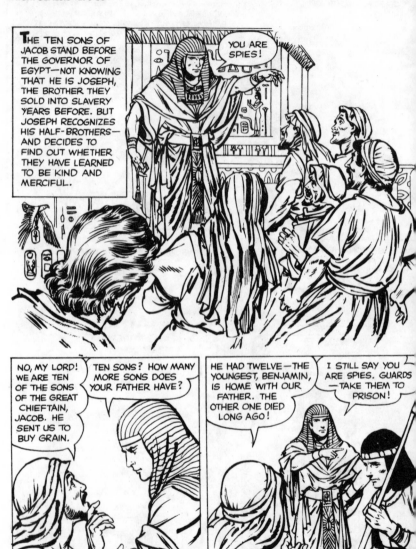

THE TEN SONS OF JACOB STAND BEFORE THE GOVERNOR OF EGYPT—NOT KNOWING THAT HE IS JOSEPH, THE BROTHER THEY SOLD INTO SLAVERY YEARS BEFORE. BUT JOSEPH RECOGNIZES HIS HALF-BROTHERS— AND DECIDES TO FIND OUT WHETHER THEY HAVE LEARNED TO BE KIND AND MERCIFUL.

YOU ARE SPIES!

NO, MY LORD! WE ARE TEN OF THE SONS OF THE GREAT CHIEFTAIN, JACOB. HE SENT US TO BUY GRAIN.

TEN SONS? HOW MANY MORE SONS DOES YOUR FATHER HAVE?

HE HAD TWELVE—THE YOUNGEST, BENJAMIN, IS HOME WITH OUR FATHER. THE OTHER ONE DIED LONG AGO!

I STILL SAY YOU ARE SPIES. GUARDS —TAKE THEM TO PRISON!

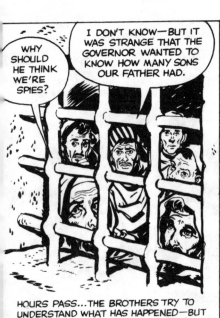

WHY SHOULD HE THINK WE'RE SPIES?

I DON'T KNOW—BUT IT WAS STRANGE THAT THE GOVERNOR WANTED TO KNOW HOW MANY SONS OUR FATHER HAD.

HOURS PASS...THE BROTHERS TRY TO UNDERSTAND WHAT HAS HAPPENED—BUT NEVER ONCE DO THEY SUSPECT THAT THEIR BROTHER JOSEPH IS THE GOVERNOR.

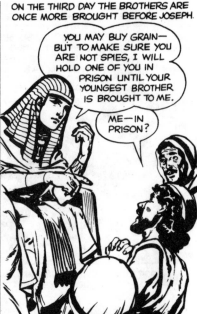

ON THE THIRD DAY THE BROTHERS ARE ONCE MORE BROUGHT BEFORE JOSEPH.

YOU MAY BUY GRAIN— BUT TO MAKE SURE YOU ARE NOT SPIES, I WILL HOLD ONE OF YOU IN PRISON UNTIL YOUR YOUNGEST BROTHER IS BROUGHT TO ME.

ME—IN PRISON?

THIS MUST BE PUNISHMENT FOR WHAT WE DID TO JOSEPH LONG AGO.

I TOLD YOU NOT TO HARM HIM!

HAS IT TAKEN YOU ALL THESE YEARS TO REGRET THE EVIL YOU DID THAT DAY?

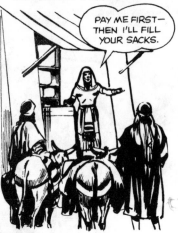

THE ONE BROTHER SIMEON IS QUICKLY BOUND AND TAKEN TO PRISON AS A HOSTAGE. FRIGHTENED AND EAGER TO LEAVE EGYPT, THE OTHER BROTHERS HURRY TO THE STOREHOUSE FOR GRAIN.

PAY ME FIRST— THEN I'LL FILL YOUR SACKS.

97

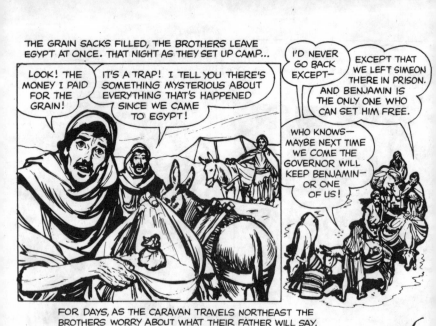

THE GRAIN SACKS FILLED, THE BROTHERS LEAVE EGYPT AT ONCE. THAT NIGHT AS THEY SET UP CAMP...

LOOK! THE MONEY I PAID FOR THE GRAIN!

IT'S A TRAP! I TELL YOU THERE'S SOMETHING MYSTERIOUS ABOUT EVERYTHING THAT'S HAPPENED SINCE WE CAME TO EGYPT!

I'D NEVER GO BACK EXCEPT—

EXCEPT THAT WE LEFT SIMEON THERE IN PRISON. AND BENJAMIN IS THE ONLY ONE WHO CAN SET HIM FREE.

WHO KNOWS— MAYBE NEXT TIME WE COME THE GOVERNOR WILL KEEP BENJAMIN— OR ONE OF US!

FOR DAYS, AS THE CARAVAN TRAVELS NORTHEAST THE BROTHERS WORRY ABOUT WHAT THEIR FATHER WILL SAY.

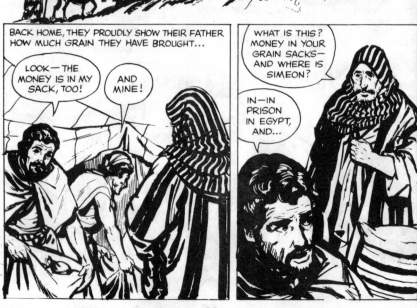

BACK HOME, THEY PROUDLY SHOW THEIR FATHER HOW MUCH GRAIN THEY HAVE BROUGHT...

LOOK— THE MONEY IS IN MY SACK, TOO!

AND MINE!

WHAT IS THIS? MONEY IN YOUR GRAIN SACKS— AND WHERE IS SIMEON?

IN—IN PRISON IN EGYPT, AND...

SIMEON IN PRISON? WHY? SPEAK UP. WHAT HAPPENED?

THE WHOLE TRIP WAS VERY STRANGE, FATHER. THE GOVERNOR SAID WE WERE SPIES. HE PUT US ALL IN PRISON, THEN HE RELEASED ALL OF US BUT SIMEON. SIMEON HAS TO STAY THERE—UNTIL WE TAKE BENJAMIN TO EGYPT.

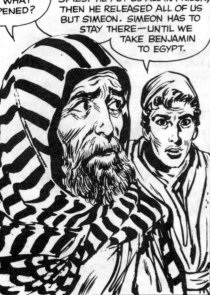

BENJAMIN TO EGYPT? NEVER! MY SON JOSEPH HAS BEEN DEAD THESE MANY YEARS—NOW SIMEON IS LOST TO ME. I WILL NOT PART WITH BENJAMIN.

BUT FATHER—WHAT ABOUT SIMEON?

YES, WHAT ABOUT SIMEON? AND WHAT ABOUT US IF THE GRAIN RUNS OUT AND WE HAVE TO GO TO EGYPT AGAIN? WE CAN'T GO WITHOUT BENJAMIN!

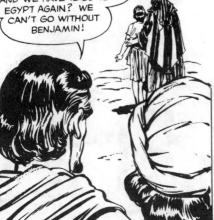

THE GRAIN IS USED SPARINGLY, BUT ONE DAY JACOB'S HUNGRY TRIBE HAS TO FACE THE TRUTH...

THE GRAIN IS ALMOST GONE—WHAT SHALL WE DO?

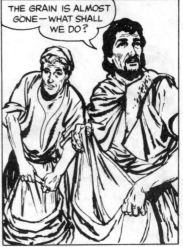

The Stolen Cup

FROM GENESIS 43: 1—44: 12

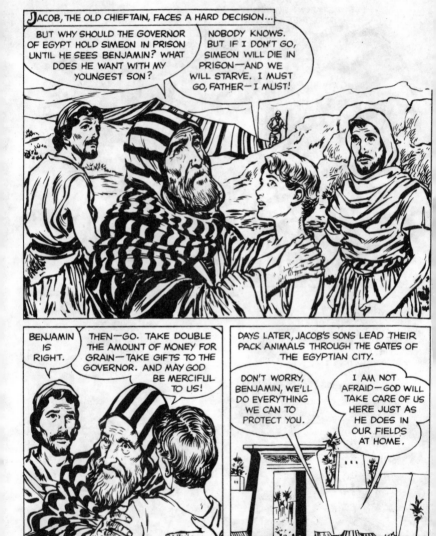

JACOB, THE OLD CHIEFTAIN, FACES A HARD DECISION...

BUT WHY SHOULD THE GOVERNOR OF EGYPT HOLD SIMEON IN PRISON UNTIL HE SEES BENJAMIN? WHAT DOES HE WANT WITH MY YOUNGEST SON?

NOBODY KNOWS. BUT IF I DON'T GO, SIMEON WILL DIE IN PRISON—AND WE WILL STARVE. I MUST GO, FATHER—I MUST!

BENJAMIN IS RIGHT.

THEN—GO. TAKE DOUBLE THE AMOUNT OF MONEY FOR GRAIN—TAKE GIFTS TO THE GOVERNOR. AND MAY GOD BE MERCIFUL TO US!

DAYS LATER, JACOB'S SONS LEAD THEIR PACK ANIMALS THROUGH THE GATES OF THE EGYPTIAN CITY.

DON'T WORRY, BENJAMIN, WE'LL DO EVERYTHING WE CAN TO PROTECT YOU.

I AM NOT AFRAID—GOD WILL TAKE CARE OF US HERE JUST AS HE DOES IN OUR FIELDS AT HOME.

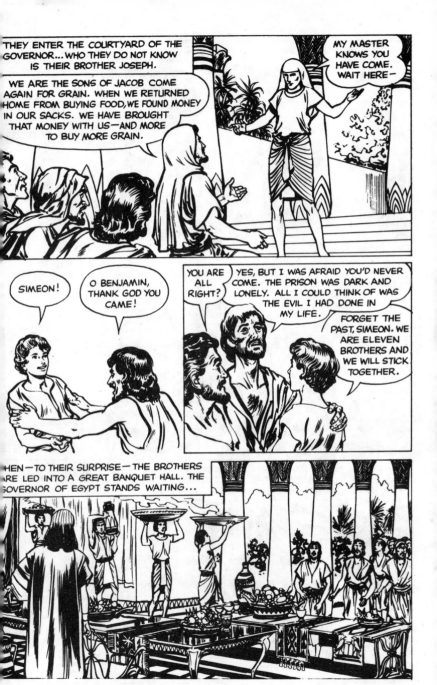

101

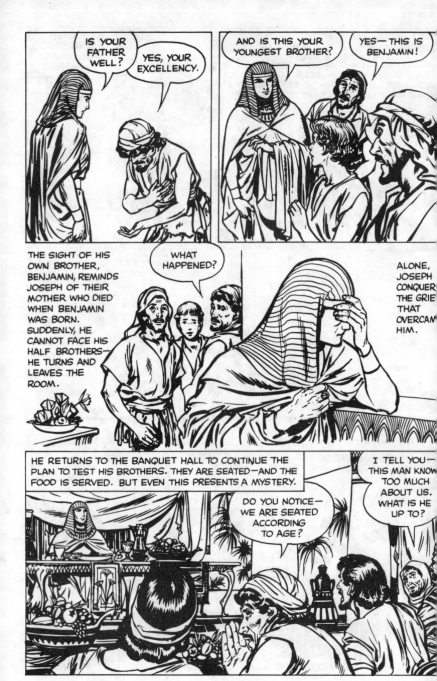

IS YOUR FATHER WELL?

YES, YOUR EXCELLENCY.

AND IS THIS YOUR YOUNGEST BROTHER?

YES—THIS IS BENJAMIN!

THE SIGHT OF HIS OWN BROTHER, BENJAMIN, REMINDS JOSEPH OF THEIR MOTHER WHO DIED WHEN BENJAMIN WAS BORN. SUDDENLY, HE CANNOT FACE HIS HALF BROTHERS— HE TURNS AND LEAVES THE ROOM.

WHAT HAPPENED?

ALONE, JOSEPH CONQUER THE GRIE THAT OVERCAM HIM.

HE RETURNS TO THE BANQUET HALL TO CONTINUE THE PLAN TO TEST HIS BROTHERS. THEY ARE SEATED—AND THE FOOD IS SERVED. BUT EVEN THIS PRESENTS A MYSTERY.

DO YOU NOTICE— WE ARE SEATED ACCORDING TO AGE?

I TELL YOU— THIS MAN KNOW TOO MUCH ABOUT US. WHAT IS HE UP TO?

BUT EVEN AS THEY WONDER, THE GOVERNOR HAS THE BROTHERS SERVED — GIVING THE LARGEST PORTION TO BENJAMIN. IT IS A SIGN OF GREAT HONOR.

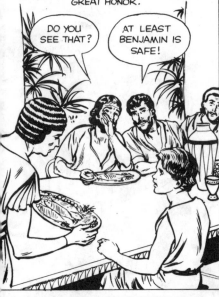

DO YOU SEE THAT?

AT LEAST BENJAMIN IS SAFE!

THE BANQUET ENDS; THE NEXT MORNING THE BROTHERS BUY THEIR GRAIN AND LEAVE. BUT THEY ARE HARDLY OUT OF THE CITY BEFORE A CHARIOT OVERTAKES THEM.

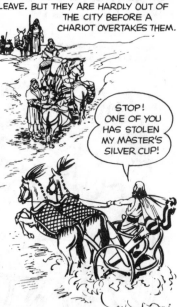

STOP! ONE OF YOU HAS STOLEN MY MASTER'S SILVER CUP!

YOUR MASTER'S CUP? WE ARE INNOCENT! SEARCH US IF YOU WILL.

IF THE CUP IS FOUND, THE MAN IN WHOSE SACK IT IS HIDDEN SHALL BECOME MY MASTER'S SLAVE!

ONE BY ONE THE SACKS ARE SEARCHED... AT LAST THE OFFICER OPENS BENJAMIN'S...

THE CUP!

Joseph's Secret

FROM GENESIS 44: 13—45: 26

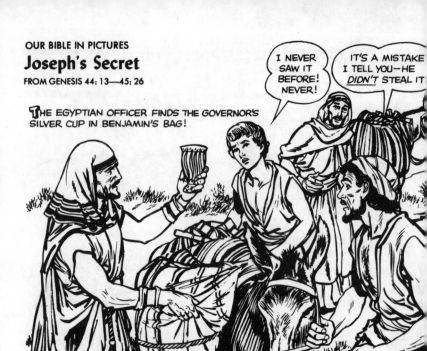

THE EGYPTIAN OFFICER FINDS THE GOVERNOR'S SILVER CUP IN BENJAMIN'S BAG!

I NEVER SAW IT BEFORE! NEVER!

IT'S A MISTAKE I TELL YOU—HE *DIDN'T* STEAL IT

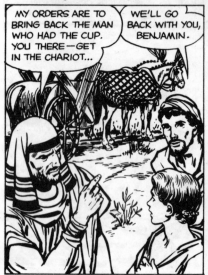

MY ORDERS ARE TO BRING BACK THE MAN WHO HAD THE CUP. YOU THERE—GET IN THE CHARIOT...

WE'LL GO BACK WITH YOU, BENJAMIN.

BACK IN THE CITY, THEY FACE THE ANGRY GOVERNOR OF EGYPT.

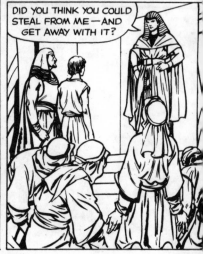

DID YOU THINK YOU COULD STEAL FROM ME—AND GET AWAY WITH IT?

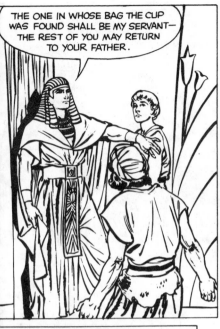

THE ONE IN WHOSE BAG THE CUP WAS FOUND SHALL BE MY SERVANT— THE REST OF YOU MAY RETURN TO YOUR FATHER.

IF BENJAMIN DOES NOT RETURN HOME, OUR FATHER WILL DIE OF GRIEF. LET ME BE YOUR SLAVE INSTEAD OF BENJAMIN.

FOR A MOMENT THERE IS SILENCE. THEN THE GOVERNOR TURNS TO HIS GUARDS.

GO! LEAVE ME ALONE WITH THESE MEN.

THE FRIGHTENED BROTHERS WAIT. FINALLY JOSEPH SPEAKS...

I CAN'T KEEP THE SECRET ANY LONGER— I AM YOUR BROTHER, JOSEPH! YOU SOLD ME AS A SLAVE MANY YEARS AGO. GOD HAS BLESSED ME RICHLY...NOW WE ARE TOGETHER AGAIN.

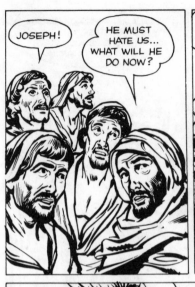

JOSEPH!

HE MUST HATE US... WHAT WILL HE DO NOW?

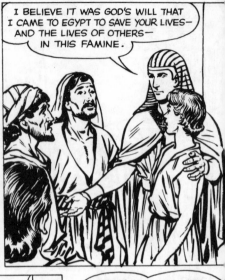

I BELIEVE IT WAS GOD'S WILL THAT I CAME TO EGYPT TO SAVE YOUR LIVES— AND THE LIVES OF OTHERS— IN THIS FAMINE.

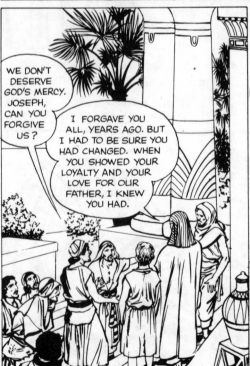

WE DON'T DESERVE GOD'S MERCY. JOSEPH, CAN YOU FORGIVE US?

I FORGAVE YOU ALL, YEARS AGO. BUT I HAD TO BE SURE YOU HAD CHANGED. WHEN YOU SHOWED YOUR LOYALTY AND YOUR LOVE FOR OUR FATHER, I KNEW YOU HAD.

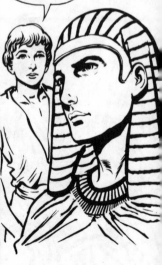

THE FAMINE WILL LAST FIVE YEARS MORE—GO BACK HOME AND BRING OUR FATHER TO BE NEAR ME, AND I WILL PROVIDE FOR ALL OF YOU.

THANK GOD FOR A BROTHER LIKE YOU.

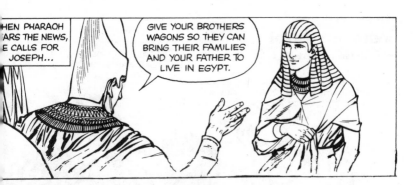

...HEN PHARAOH [HE]ARS THE NEWS, [H]E CALLS FOR JOSEPH...

GIVE YOUR BROTHERS WAGONS SO THEY CAN BRING THEIR FAMILIES AND YOUR FATHER TO LIVE IN EGYPT.

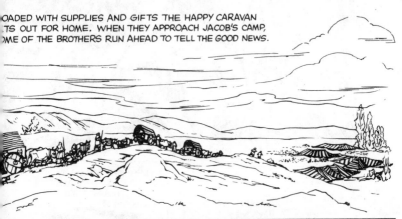

[L]OADED WITH SUPPLIES AND GIFTS THE HAPPY CARAVAN [SE]TS OUT FOR HOME. WHEN THEY APPROACH JACOB'S CAMP, [SO]ME OF THE BROTHERS RUN AHEAD TO TELL THE GOOD NEWS.

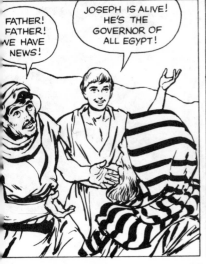

FATHER! FATHER! WE HAVE NEWS!

JOSEPH IS ALIVE! HE'S THE GOVERNOR OF ALL EGYPT!

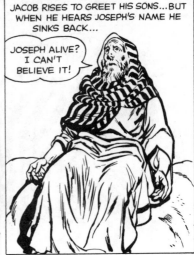

JACOB RISES TO GREET HIS SONS...BUT WHEN HE HEARS JOSEPH'S NAME HE SINKS BACK...

JOSEPH ALIVE? I CAN'T BELIEVE IT!

107

South into Egypt

FROM GENESIS 45: 27, 28; 47; 48; 50: 1-15

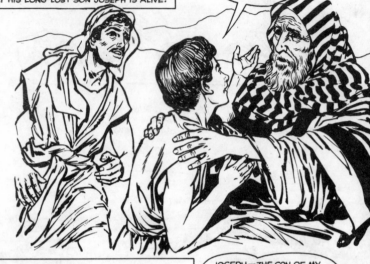

JACOB CANNOT BELIEVE THE AMAZING NEWS THAT HIS LONG-LOST SON JOSEPH IS ALIVE.

BUT, FATHER, WE ALL _SAW_ HIM! AND HE WANTS YOU TO COME TO EGYPT TO SEE HIM.

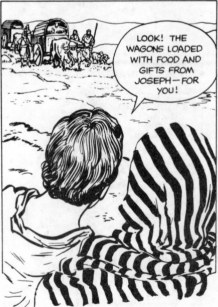

LOOK! THE WAGONS LOADED WITH FOOD AND GIFTS FROM JOSEPH—FOR YOU!

JOSEPH—THE SON OF MY BELOVED RACHEL—IS ALIVE! O GOD, I THANK THEE, I THANK THEE!

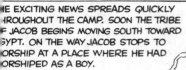

THE EXCITING NEWS SPREADS QUICKLY THROUGHOUT THE CAMP. SOON THE TRIBE OF JACOB BEGINS MOVING SOUTH TOWARD EGYPT. ON THE WAY JACOB STOPS TO WORSHIP AT A PLACE WHERE HE HAD WORSHIPED AS A BOY.

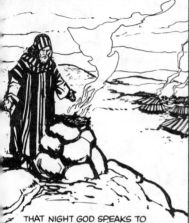

THAT NIGHT GOD SPEAKS TO HIM IN A VISION:"FEAR NOT TO GO DOWN INTO EGYPT, FOR I WILL GO WITH THEE."

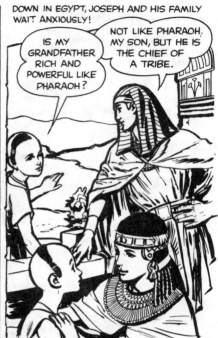

DOWN IN EGYPT, JOSEPH AND HIS FAMILY WAIT ANXIOUSLY!

IS MY GRANDFATHER RICH AND POWERFUL LIKE PHARAOH?

NOT LIKE PHARAOH, MY SON, BUT HE IS THE CHIEF OF A TRIBE.

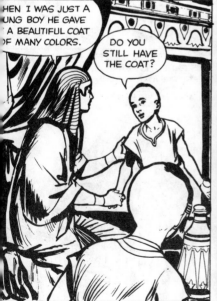

WHEN I WAS JUST A YOUNG BOY HE GAVE A BEAUTIFUL COAT OF MANY COLORS.

DO YOU STILL HAVE THE COAT?

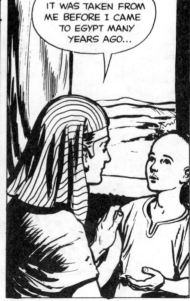

IT WAS TAKEN FROM ME BEFORE I CAME TO EGYPT MANY YEARS AGO...

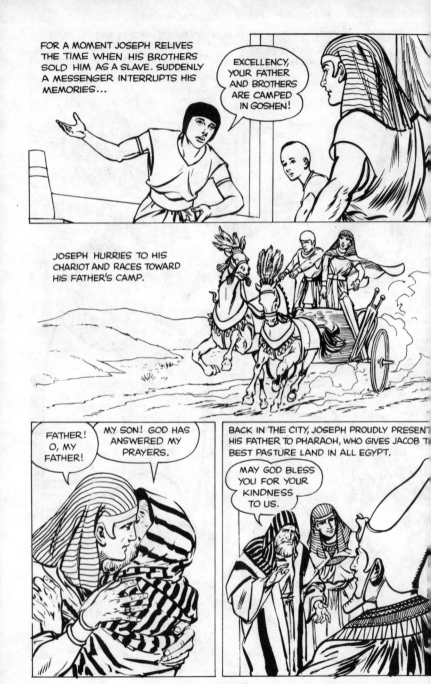

110

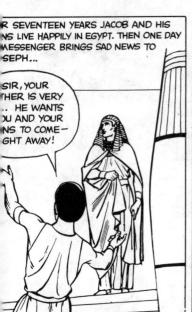

FOR SEVENTEEN YEARS JACOB AND HIS SONS LIVE HAPPILY IN EGYPT. THEN ONE DAY A MESSENGER BRINGS SAD NEWS TO JOSEPH...

SIR, YOUR FATHER IS VERY ILL... HE WANTS YOU AND YOUR SONS TO COME — RIGHT AWAY!

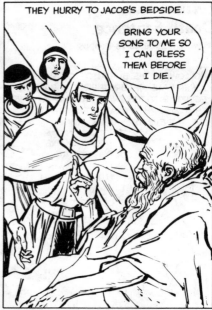

THEY HURRY TO JACOB'S BEDSIDE.

BRING YOUR SONS TO ME SO I CAN BLESS THEM BEFORE I DIE.

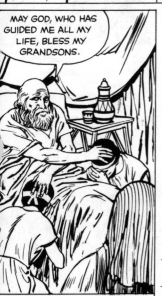

MAY GOD, WHO HAS GUIDED ME ALL MY LIFE, BLESS MY GRANDSONS.

THEN JACOB CALLS ALL OF HIS SONS TO HIM AND BLESSES THEM. JACOB DIES AND HIS SONS CARRY THE OLD CHIEFTAIN'S BODY BACK TO HIS HOMELAND OF CANAAN.

BECAUSE OF THE WICKEDNESS OF HIS OLDER SONS, JACOB GIVES THE FAMILY BIRTHRIGHT TO JOSEPH AND HIS SONS.

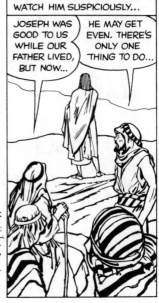

AFTER JACOB'S FUNERAL, JOSEPH WALKS AWAY FROM THE CAMP ALONE. HIS BROTHERS WATCH HIM SUSPICIOUSLY...

JOSEPH WAS GOOD TO US WHILE OUR FATHER LIVED, BUT NOW...

HE MAY GET EVEN. THERE'S ONLY ONE THING TO DO...

111

Death Sentence

FROM GENESIS 50: 15-26; EXODUS 1: 1—2: 2

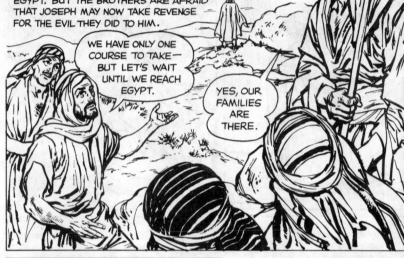

FOLLOWING THE BURIAL OF THEIR FATHER, JOSEPH AND HIS BROTHERS GO BACK TO EGYPT. BUT THE BROTHERS ARE AFRAID THAT JOSEPH MAY NOW TAKE REVENGE FOR THE EVIL THEY DID TO HIM.

WE HAVE ONLY ONE COURSE TO TAKE— BUT LET'S WAIT UNTIL WE REACH EGYPT.

YES, OUR FAMILIES ARE THERE.

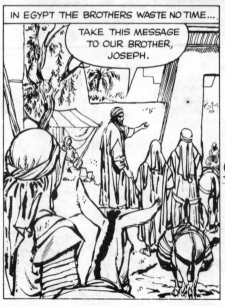

IN EGYPT THE BROTHERS WASTE NO TIME....

TAKE THIS MESSAGE TO OUR BROTHER, JOSEPH.

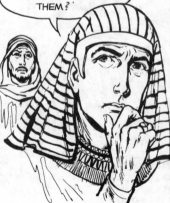

JOSEPH WEEPS WHEN HE HEARS TH[E] WORDS OF THE MESSENGER.

BRING MY BROTHERS TO ME— IS IT POSSIBLE THAT EVEN YET THEY HAVE NOT LEARNED THAT I HAVE FORGIVEN THEM?

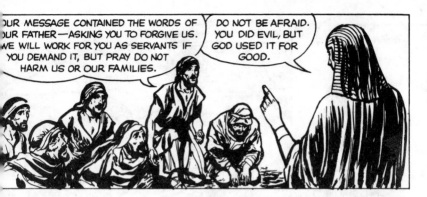

OUR MESSAGE CONTAINED THE WORDS OF OUR FATHER—ASKING YOU TO FORGIVE US. WE WILL WORK FOR YOU AS SERVANTS IF YOU DEMAND IT, BUT PRAY DO NOT HARM US OR OUR FAMILIES.

DO NOT BE AFRAID. YOU DID EVIL, BUT GOD USED IT FOR GOOD.

FOR YEARS THE SONS OF JACOB LIVE HAPPILY IN EGYPT.

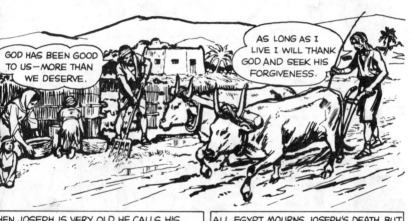

GOD HAS BEEN GOOD TO US—MORE THAN WE DESERVE.

AS LONG AS I LIVE I WILL THANK GOD AND SEEK HIS FORGIVENESS.

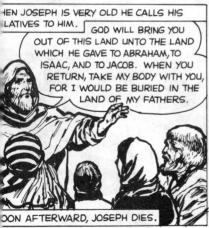

WHEN JOSEPH IS VERY OLD HE CALLS HIS RELATIVES TO HIM.

GOD WILL BRING YOU OUT OF THIS LAND UNTO THE LAND WHICH HE GAVE TO ABRAHAM, TO ISAAC, AND TO JACOB. WHEN YOU RETURN, TAKE MY BODY WITH YOU, FOR I WOULD BE BURIED IN THE LAND OF MY FATHERS.

SOON AFTERWARD, JOSEPH DIES.

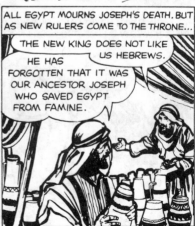

ALL EGYPT MOURNS JOSEPH'S DEATH. BUT AS NEW RULERS COME TO THE THRONE...

THE NEW KING DOES NOT LIKE US HEBREWS. HE HAS FORGOTTEN THAT IT WAS OUR ANCESTOR JOSEPH WHO SAVED EGYPT FROM FAMINE.

113

THIS COULD MEAN TROUBLE FOR US.

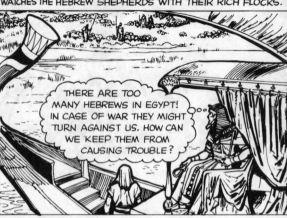

FROM HIS ROYAL YACHT ON THE NILE, THE KING FROWNS AS HE WATCHES THE HEBREW SHEPHERDS WITH THEIR RICH FLOCKS.

THERE ARE TOO MANY HEBREWS IN EGYPT! IN CASE OF WAR THEY MIGHT TURN AGAINST US. HOW CAN WE KEEP THEM FROM CAUSING TROUBLE?

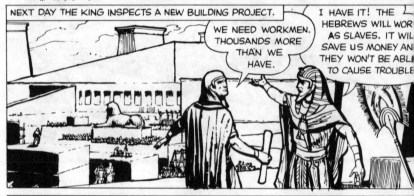

NEXT DAY THE KING INSPECTS A NEW BUILDING PROJECT.

WE NEED WORKMEN. THOUSANDS MORE THAN WE HAVE.

I HAVE IT! THE HEBREWS WILL WORK AS SLAVES. IT WILL SAVE US MONEY AND THEY WON'T BE ABLE TO CAUSE TROUBLE.

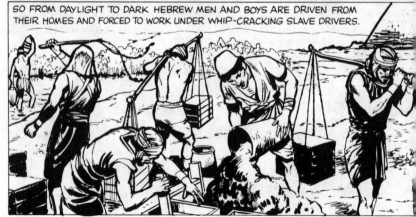

SO FROM DAYLIGHT TO DARK HEBREW MEN AND BOYS ARE DRIVEN FROM THEIR HOMES AND FORCED TO WORK UNDER WHIP-CRACKING SLAVE DRIVERS.

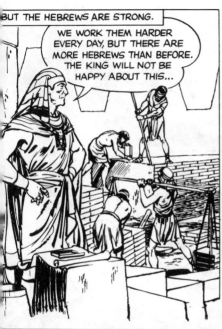

BUT THE HEBREWS ARE STRONG.

WE WORK THEM HARDER EVERY DAY, BUT THERE ARE MORE HEBREWS THAN BEFORE. THE KING WILL NOT BE HAPPY ABOUT THIS...

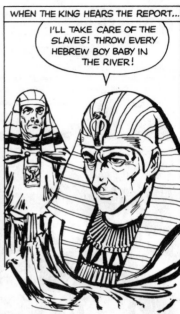

WHEN THE KING HEARS THE REPORT...

I'LL TAKE CARE OF THE SLAVES! THROW EVERY HEBREW BOY BABY IN THE RIVER!

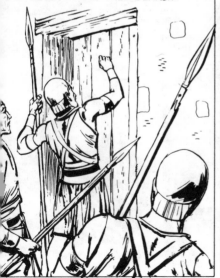

THE CRUEL ORDER IS CARRIED OUT. HEBREW MOTHERS AND FATHERS RISK THEIR LIVES TO PROTECT THEIR SONS...BUT THE KING'S MEN NEVER GIVE UP THEIR SEARCH.

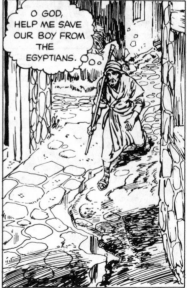

NIGHT AFTER NIGHT ONE HEBREW FATHER HURRIES HOME FROM WORK—AFRAID THAT THE SOLDIERS HAVE VISITED HIS HOME.

O GOD, HELP ME SAVE OUR BOY FROM THE EGYPTIANS.

Cry of a Slave

FROM EXODUS 2: 3-11

EGYPTIAN SOLDIERS ARE SEARCHING ALL HOUSES. PHARAOH HAS ORDERED HIS TROOPS TO FIND—AND KILL—EVERY HEBREW BABY BOY. ONE EVENING A HEBREW FATHER RETURNS TO HIS HOME...

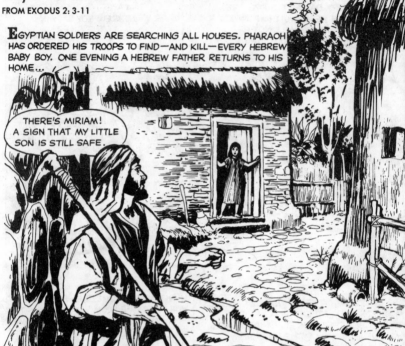

THERE'S MIRIAM! A SIGN THAT MY LITTLE SON IS STILL SAFE.

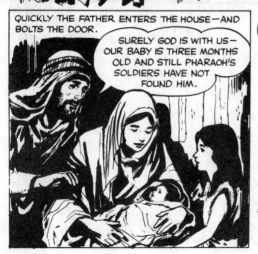

QUICKLY THE FATHER ENTERS THE HOUSE—AND BOLTS THE DOOR.

SURELY GOD IS WITH US—OUR BABY IS THREE MONTHS OLD AND STILL PHARAOH'S SOLDIERS HAVE NOT FOUND HIM.

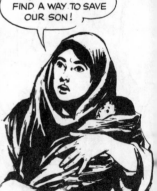

GOD WILL HELP ME FIND A WAY TO SAVE OUR SON!

NEXT DAY THE MOTHER SETS ABOUT PREPARING A LITTLE BASKET.

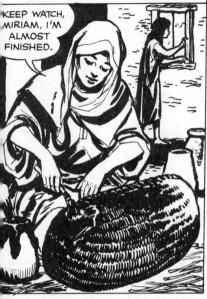

KEEP WATCH, MIRIAM, I'M ALMOST FINISHED.

THEN, CAREFULLY AVOIDING THE EGYPTIAN SOLDIERS, SHE TAKES THE BASKET AND HER TINY SON TO THE RIVER.

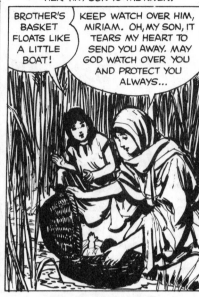

BROTHER'S BASKET FLOATS LIKE A LITTLE BOAT!

KEEP WATCH OVER HIM, MIRIAM. OH, MY SON, IT TEARS MY HEART TO SEND YOU AWAY. MAY GOD WATCH OVER YOU AND PROTECT YOU ALWAYS...

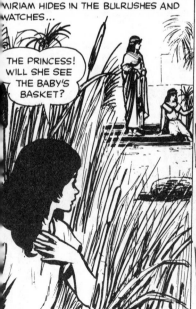

MIRIAM HIDES IN THE BULRUSHES AND WATCHES...

THE PRINCESS! WILL SHE SEE THE BABY'S BASKET?

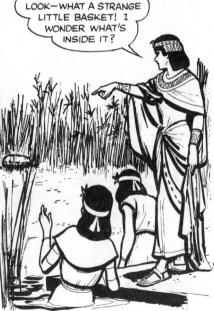

LOOK—WHAT A STRANGE LITTLE BASKET! I WONDER WHAT'S INSIDE IT?

117

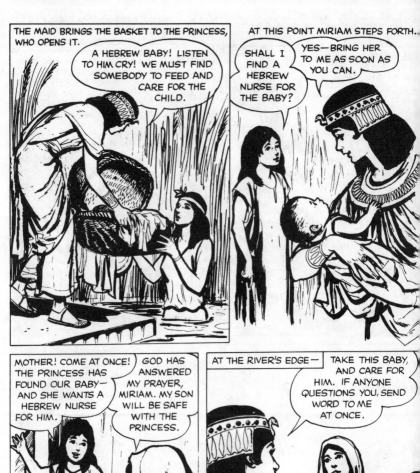

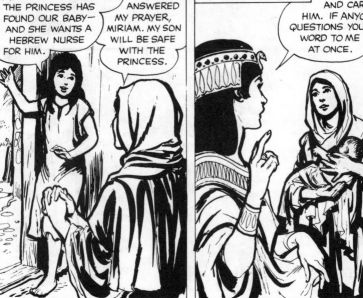

118

THE HEBREW BABY IS RETURNED TO HIS OWN HOME BUT NOW UNDER THE PROTECTION OF THE KING'S DAUGHTER. THAT NIGHT THE MOTHER, FATHER, MIRIAM AND YOUNG AARON KNEEL AND PRAY...

O GOD, WE THANK THEE FOR SAVING OUR LITTLE SON. HELP US TO TRAIN HIM TO SERVE THEE!

THE LITTLE BOY LIVES IN HIS HOME UNTIL HE IS ABOUT FOUR YEARS OLD. THEN HIS MOTHER TAKES HIM TO THE PALACE TO LIVE WITH THE PRINCESS WHO HAS ADOPTED HIM.

HE WILL BE MY SON. HIS NAME WILL BE MOSES BECAUSE THAT IS LIKE THE WORD THAT MEANS "TO DRAW OUT", AND I DREW HIM OUT OF THE WATER.

YEARS PASS, AND THE BOY MOSES LIVES THE LIFE OF A YOUNG PRINCE IN PHARAOH'S PALACE. HE LEARNS TO WRITE AND READ. LATER HE GOES TO COLLEGE. ONE DAY HE DRIVES THROUGH THE CITY...

...TO A PLACE WHERE HEBREW SLAVES ARE WORKING. AS HE WATCHES THE SLAVES TOIL, HE IS STARTLED BY A MAN'S SCREAM...

119

The Fiery Bush

FROM EXODUS 2: 11—3: 4

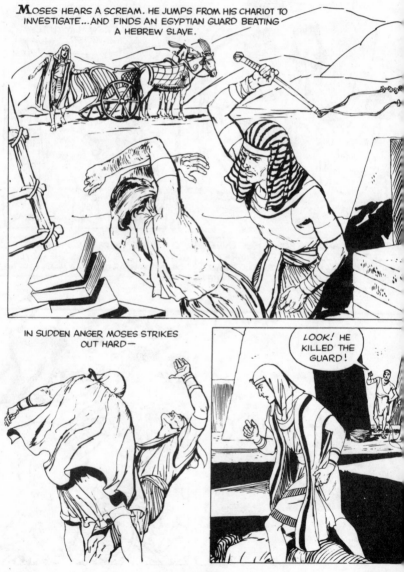

MOSES HEARS A SCREAM. HE JUMPS FROM HIS CHARIOT TO INVESTIGATE...AND FINDS AN EGYPTIAN GUARD BEATING A HEBREW SLAVE.

IN SUDDEN ANGER MOSES STRIKES OUT HARD—

LOOK! HE KILLED THE GUARD!

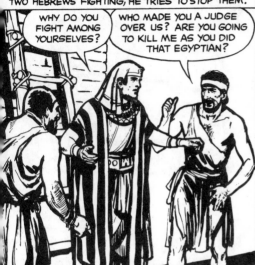

THE NEXT DAY MOSES RETURNS. WHEN HE SEES TWO HEBREWS FIGHTING, HE TRIES TO STOP THEM.

WHY DO YOU FIGHT AMONG YOURSELVES?

WHO MADE YOU A JUDGE OVER US? ARE YOU GOING TO KILL ME AS YOU DID THAT EGYPTIAN?

IF PHARAOH HEARS OF THIS HE WILL ACCUSE ME OF BEING A TRAITOR. THERE IS ONLY ONE THING FOR ME TO DO, AND I MUST DO IT NOW...

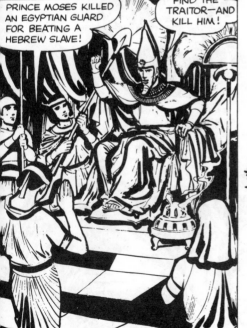

LATER THAT DAY IN THE PALACE...

PRINCE MOSES KILLED AN EGYPTIAN GUARD FOR BEATING A HEBREW SLAVE!

FIND THE TRAITOR—AND KILL HIM!

BUT PHARAOH'S ORDERS ARE TOO LATE...MOSES HAS A HEAD START ON THE SOLDIERS WHO CHASE HIM. HE ESCAPES— AND AFTER LONG, HARD RIDING REACHES THE LAND OF MIDIAN.

121

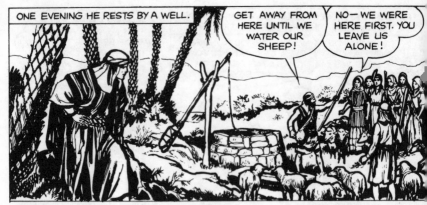

ONE EVENING HE RESTS BY A WELL.

GET AWAY FROM HERE UNTIL WE WATER OUR SHEEP!

NO—WE WERE HERE FIRST. YOU LEAVE US ALONE!

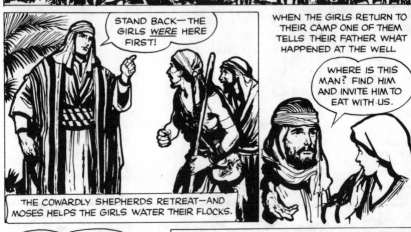

STAND BACK—THE GIRLS *WERE* HERE FIRST!

WHEN THE GIRLS RETURN TO THEIR CAMP ONE OF THEM TELLS THEIR FATHER WHAT HAPPENED AT THE WELL

WHERE IS THIS MAN? FIND HIM AND INVITE HIM TO EAT WITH US.

THE COWARDLY SHEPHERDS RETREAT—AND MOSES HELPS THE GIRLS WATER THEIR FLOCKS.

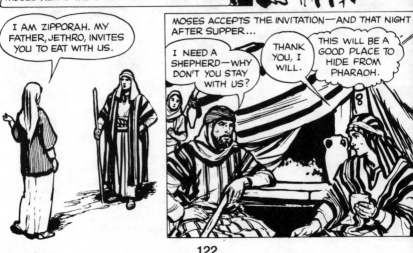

I AM ZIPPORAH. MY FATHER, JETHRO, INVITES YOU TO EAT WITH US.

MOSES ACCEPTS THE INVITATION—AND THAT NIGHT AFTER SUPPER...

I NEED A SHEPHERD—WHY DON'T YOU STAY WITH US?

THANK YOU, I WILL.

THIS WILL BE A GOOD PLACE TO HIDE FROM PHARAOH.

122

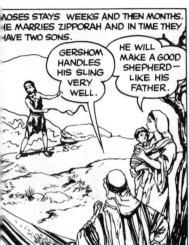

MOSES STAYS WEEKS AND THEN MONTHS. HE MARRIES ZIPPORAH AND IN TIME THEY HAVE TWO SONS.

GERSHOM HANDLES HIS SLING VERY WELL.

HE WILL MAKE A GOOD SHEPHERD— LIKE HIS FATHER.

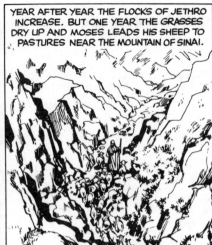

YEAR AFTER YEAR THE FLOCKS OF JETHRO INCREASE. BUT ONE YEAR THE GRASSES DRY UP AND MOSES LEADS HIS SHEEP TO PASTURES NEAR THE MOUNTAIN OF SINAI.

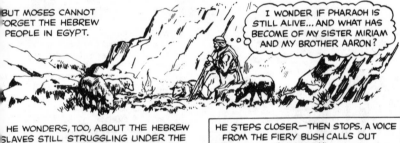

BUT MOSES CANNOT FORGET THE HEBREW PEOPLE IN EGYPT.

I WONDER IF PHARAOH IS STILL ALIVE... AND WHAT HAS BECOME OF MY SISTER MIRIAM AND MY BROTHER AARON?

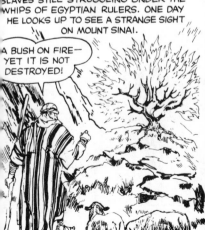

HE WONDERS, TOO, ABOUT THE HEBREW SLAVES STILL STRUGGLING UNDER THE WHIPS OF EGYPTIAN RULERS. ONE DAY HE LOOKS UP TO SEE A STRANGE SIGHT ON MOUNT SINAI.

A BUSH ON FIRE— YET IT IS NOT DESTROYED!

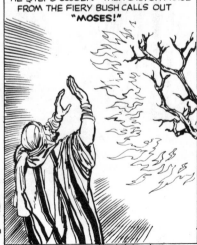

HE STEPS CLOSER—THEN STOPS. A VOICE FROM THE FIERY BUSH CALLS OUT **"MOSES!"**

Pharaoh's Revenge

FROM EXODUS 3: 4—5: 21

Moses is startled by the sight of a burning bush. Suddenly... a voice calls his name.

HERE AM I!

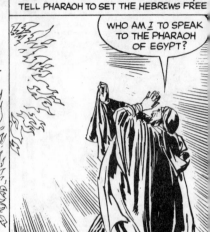

THE VOICE CONTINUES: "I AM THE GOD OF YOUR FATHERS...GO DOWN TO EGYPT, TELL PHARAOH TO SET THE HEBREWS FREE

WHO AM I TO SPEAK TO THE PHARAOH OF EGYPT?

MOSES IS AFRAID—AFRAID OF THE PHARAOH OF EGYPT, AFRAID HE CANNOT SPEAK PROPERLY— AFRAID THE HEBREW PEOPLE WILL NOT BELIEVE HIM. BUT GOD ASSURES HIM: "GO— YOUR BROTHER AARON WILL SPEAK FOR YOU. I WILL BE WITH YOU."

ONCE AGAIN MOSES STARTS TOWARD THE BUSH, BUT THE SAME VOICE WARNS HIM: "DO NOT COME NEARER... TAKE OFF YOUR SHOES, FOR THE GROUND ON WHICH YOU STAND IS HOLY GROUND."

MOSES OBEYS. HE RETURNS TO CAMP AND TELLS HIS FATHER-IN-LAW WHAT GOD HAS CALLED HIM TO DO.

GO IN PEACE. GOD WILL STRENGTHE YOU, AS HE HAS PROMISED.

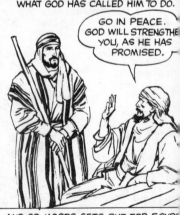

AND SO MOSES SETS OUT FOR EGYP WITH HIS WIFE AND SONS.

MEANTIME...IN THE SLAVE HUTS OF EGYPT, THE HEBREWS ARE ASKING GOD TO HELP THEM.

WHILE AARON, THE BROTHER OF MOSES, IS PRAYING, GOD SPEAKS TO HIM: "GO INTO THE WILDERNESS TO MEET YOUR BROTHER."

AARON IS SURPRISED AT THE STRANGE COMMAND. BUT, LIKE MOSES, HE OBEYS. SOON HE IS ALONE IN THE WILDERNESS.

MOSES HAS BEEN GONE FROM EGYPT FOR MANY YEARS. WILL HE KNOW ME? DOES HE KNOW I'M COMING? I WONDER WHAT GOD WANTS US TO DO?

AARON'S QUESTIONS ARE SOON ANSWERED. HE MEETS HIS BROTHER AT MOUNT SINAI.

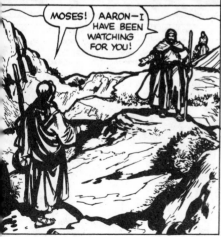

MOSES!

AARON— I HAVE BEEN WATCHING FOR YOU!

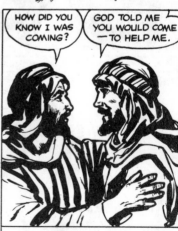

HOW DID YOU KNOW I WAS COMING?

GOD TOLD ME YOU WOULD COME —TO HELP ME.

QUICKLY, MOSES EXPLAINS THAT GOD HAS CALLED THEM TO LEAD THE HEBREWS OUT OF SLAVERY IN EGYPT.

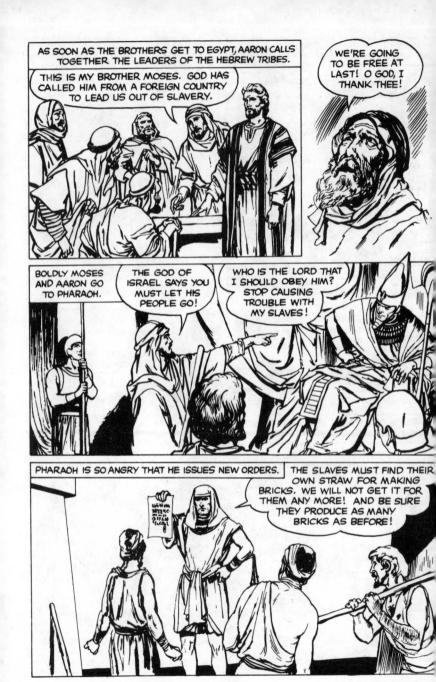

126

THE SLAVES SWEAT AND WORK LONGER, BUT THEY CANNOT DO WHAT PHARAOH DEMANDS.

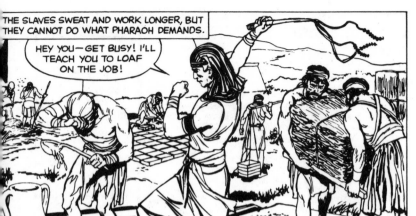

HEY YOU—GET BUSY! I'LL TEACH YOU TO LOAF ON THE JOB!

THE HEBREW FOREMEN COME BEFORE PHARAOH TO PLEAD FOR JUSTICE.

O KING, WHY ARE WE WHIPPED FOR WHAT WE CANNOT DO? IT TAKES TIME TO FIND STRAW...

YOU ARE LAZY— YOU TALK TOO MUCH ABOUT YOUR GOD. DO WHAT I TELL YOU, OR...

THE HEBREWS SADLY LEAVE PHARAOH'S PALACE...AND COME FACE TO FACE WITH MOSES AND AARON.

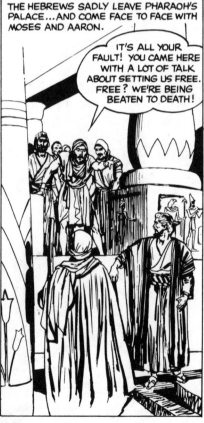

IT'S ALL YOUR FAULT! YOU CAME HERE WITH A LOT OF TALK ABOUT SETTING US FREE. FREE? WE'RE BEING BEATEN TO DEATH!

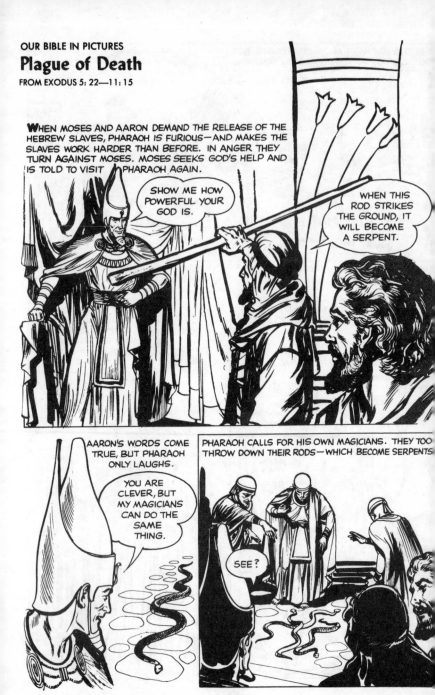

OUR BIBLE IN PICTURES

Plague of Death

FROM EXODUS 5: 22—11: 15

WHEN MOSES AND AARON DEMAND THE RELEASE OF THE HEBREW SLAVES, PHARAOH IS FURIOUS—AND MAKES THE SLAVES WORK HARDER THAN BEFORE. IN ANGER THEY TURN AGAINST MOSES. MOSES SEEKS GOD'S HELP AND IS TOLD TO VISIT PHARAOH AGAIN.

SHOW ME HOW POWERFUL YOUR GOD IS.

WHEN THIS ROD STRIKES THE GROUND, IT WILL BECOME A SERPENT.

AARON'S WORDS COME TRUE, BUT PHARAOH ONLY LAUGHS.

YOU ARE CLEVER, BUT MY MAGICIANS CAN DO THE SAME THING.

SEE?

PHARAOH CALLS FOR HIS OWN MAGICIANS. THEY TOO THROW DOWN THEIR RODS—WHICH BECOME SERPENTS.

128

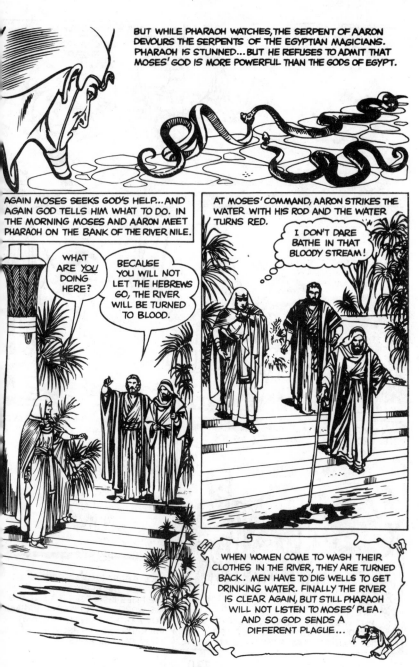

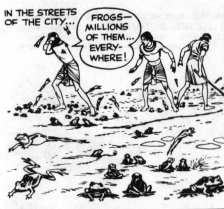

IN THE STREETS OF THE CITY...

FROGS— MILLIONS OF THEM... EVERYWHERE!

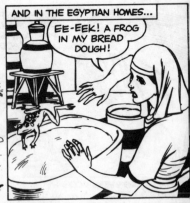

AND IN THE EGYPTIAN HOMES...

EE-EEK! A FROG IN MY BREAD DOUGH!

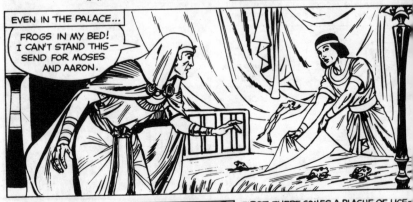

EVEN IN THE PALACE...

FROGS IN MY BED! I CAN'T STAND THIS— SEND FOR MOSES AND AARON.

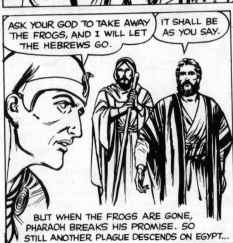

ASK YOUR GOD TO TAKE AWAY THE FROGS, AND I WILL LET THE HEBREWS GO.

IT SHALL BE AS YOU SAY.

BUT WHEN THE FROGS ARE GONE, PHARAOH BREAKS HIS PROMISE. SO STILL ANOTHER PLAGUE DESCENDS ON EGYPT...

FIRST THERE COMES A PLAGUE OF LICE— LATER GREAT SWARMS OF BITING FLIES FILL THE AIR...

ONCE AGAIN PHARAOH PROMISES TO FREE THE HEBREWS. BUT WHEN THE FLIES DISAPPEAR, HE BREAKS HIS WORD. THEN DISEASE BREAKS OUT AMONG THE CATTLE, AND PHARAOH AND HIS PEOPLE SUFFER FROM PAINFUL BOILS.

130

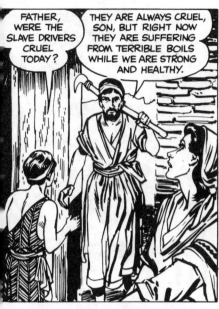

FATHER, WERE THE SLAVE DRIVERS CRUEL TODAY?

THEY ARE ALWAYS CRUEL, SON, BUT RIGHT NOW THEY ARE SUFFERING FROM TERRIBLE BOILS WHILE WE ARE STRONG AND HEALTHY.

STILL PHARAOH KEEPS THE HEBREWS IN EGYPT. SO A TERRIBLE STORM STRIKES...

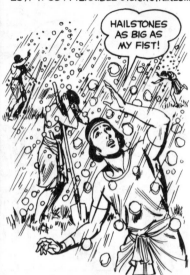

HAILSTONES AS BIG AS MY FIST!

THROUGHOUT THE LAND, THE EGYPTIAN FARMERS WATCH THE STORM WITH TERROR.

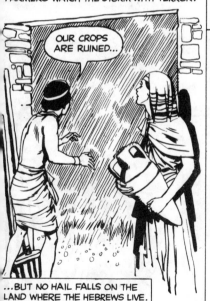

OUR CROPS ARE RUINED...

...BUT NO HAIL FALLS ON THE LAND WHERE THE HEBREWS LIVE.

LATER, MILLIONS OF LOCUSTS SWARM THROUGH THE LAND. AFTER A STRONG WIND BLOWS THEM AWAY, THE DAY BECOMES AS DARK AS NIGHT.

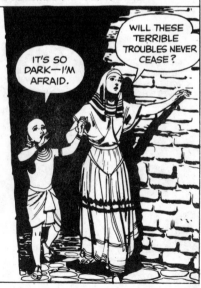

IT'S SO DARK—I'M AFRAID.

WILL THESE TERRIBLE TROUBLES NEVER CEASE?

131

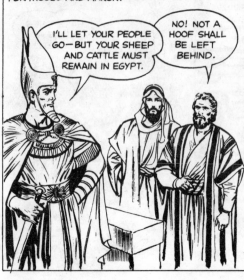

AFTER THREE DAYS OF DARKNESS PHARAOH CALLS FOR MOSES AND AARON.

I'LL LET YOUR PEOPLE GO—BUT YOUR SHEEP AND CATTLE MUST REMAIN IN EGYPT.

NO! NOT A HOOF SHALL BE LEFT BEHIND.

THEN THEY SHALL STAY! AND YOU—GET OUT OF HERE. IF I SEE YOUR FACE AGAIN, YOU'LL DIE!

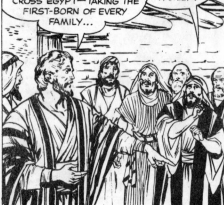

QUICKLY MOSES CALLS FOR A MEETING OF THE HEBREW LEADERS.

GOD HAS TOLD ME THAT THE ANGEL OF DEATH WILL CROSS EGYPT—TAKING THE FIRST-BORN OF EVERY FAMILY...

FIRST-BORN OF *EVERY* FAMILY?

WAIT! WE WILL BE SAVED— IF WE OBEY GOD!

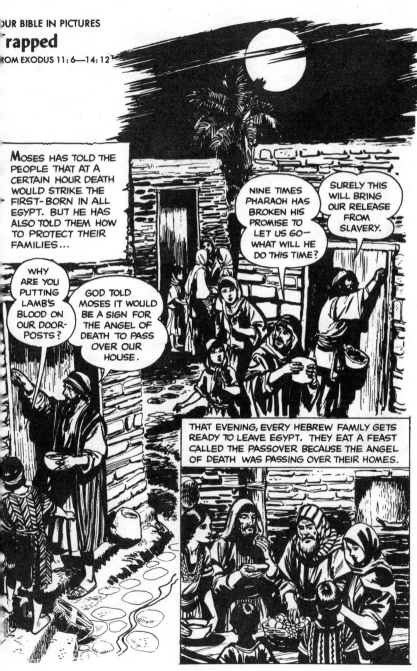

Trapped

MOSES HAS TOLD THE PEOPLE THAT AT A CERTAIN HOUR DEATH WOULD STRIKE THE FIRST-BORN IN ALL EGYPT. BUT HE HAS ALSO TOLD THEM HOW TO PROTECT THEIR FAMILIES...

NINE TIMES PHARAOH HAS BROKEN HIS PROMISE TO LET US GO—WHAT WILL HE DO THIS TIME?

SURELY THIS WILL BRING OUR RELEASE FROM SLAVERY.

WHY ARE YOU PUTTING LAMB'S BLOOD ON OUR DOOR-POSTS?

GOD TOLD MOSES IT WOULD BE A SIGN FOR THE ANGEL OF DEATH TO PASS OVER OUR HOUSE.

THAT EVENING, EVERY HEBREW FAMILY GETS READY TO LEAVE EGYPT. THEY EAT A FEAST CALLED THE PASSOVER BECAUSE THE ANGEL OF DEATH WAS PASSING OVER THEIR HOMES.

133

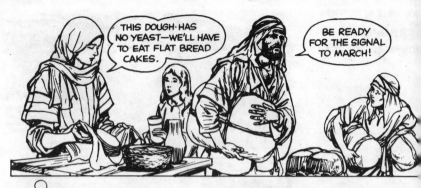

...AND AT MIDNIGHT THE ANGEL OF DEATH STRIKES ALL EGYPT.

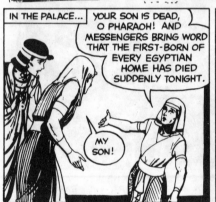

IN THE PALACE... YOUR SON IS DEAD, O PHARAOH! AND MESSENGERS BRING WORD THAT THE FIRST-BORN OF EVERY EGYPTIAN HOME HAS DIED SUDDENLY TONIGHT.

MY SON!

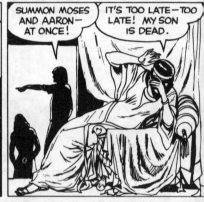

SUMMON MOSES AND AARON— AT ONCE!

IT'S TOO LATE—TOO LATE! MY SON IS DEAD.

THIS TIME PHARAOH DOES NOT BARGAIN ABOUT CATTLE OR SHEEP.

TAKE YOUR PEOPLE— TAKE YOUR CATTLE AND GET OUT OF EGYPT. SERVE YOUR GOD AS YOU HAVE SAID.

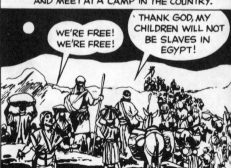

THE ORDER TO MARCH IS GIVEN ... IMMEDIATELY THE SLAVES RUSH OUT FROM THEIR SLAVE HUTS, AND MEET AT A CAMP IN THE COUNTRY.

WE'RE FREE! WE'RE FREE!

THANK GOD, MY CHILDREN WILL NOT BE SLAVES IN EGYPT!

134

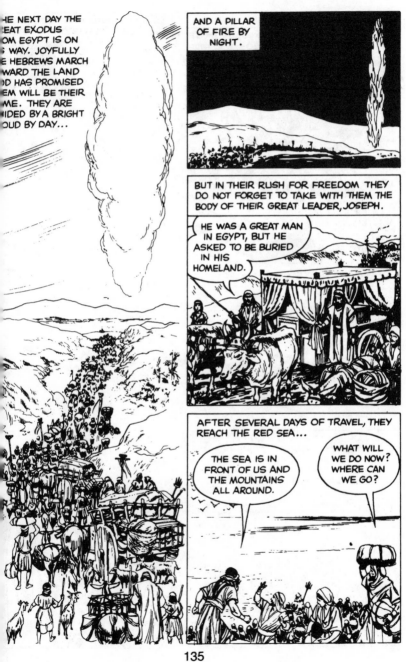

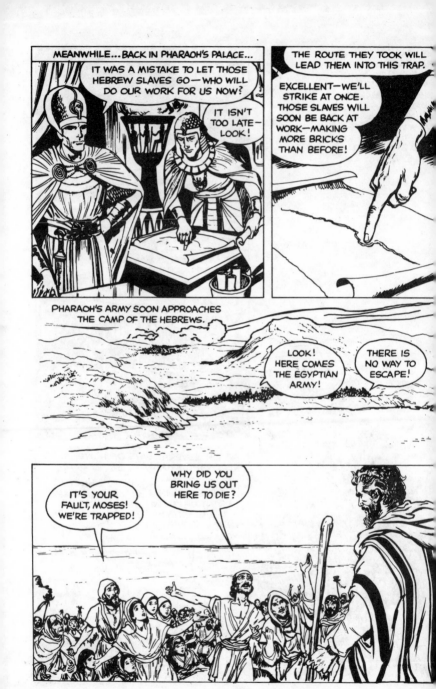

136

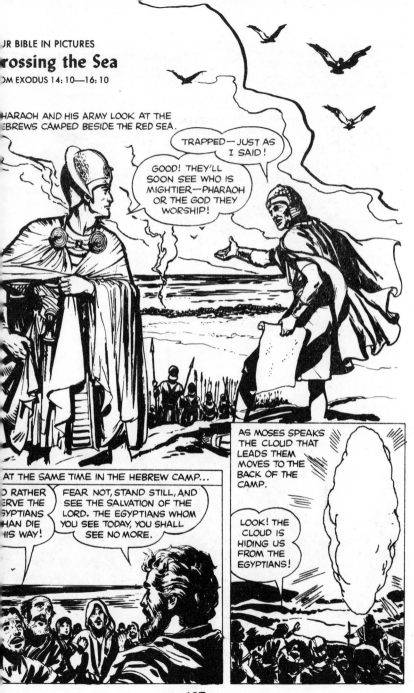

rossing the Sea

HARAOH AND HIS ARMY LOOK AT THE
EBREWS CAMPED BESIDE THE RED SEA.

TRAPPED—JUST AS I SAID!

GOOD! THEY'LL SOON SEE WHO IS MIGHTIER—PHARAOH OR THE GOD THEY WORSHIP!

AT THE SAME TIME IN THE HEBREW CAMP...

D RATHER
ERVE THE
GYPTIANS
HAN DIE
IS WAY!

FEAR NOT, STAND STILL, AND SEE THE SALVATION OF THE LORD. THE EGYPTIANS WHOM YOU SEE TODAY, YOU SHALL SEE NO MORE.

AS MOSES SPEAKS THE CLOUD THAT LEADS THEM MOVES TO THE BACK OF THE CAMP.

LOOK! THE CLOUD IS HIDING US FROM THE EGYPTIANS!

137

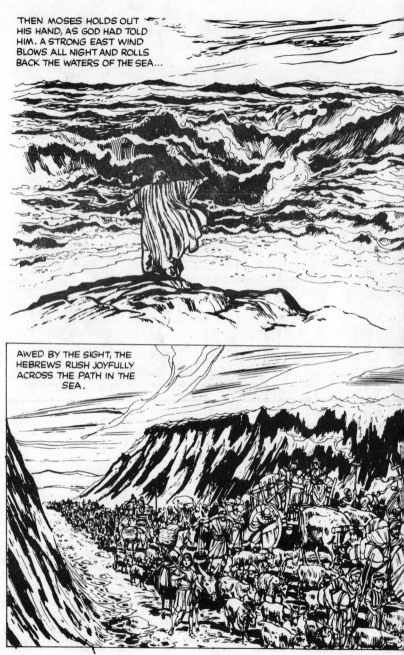

THEN MOSES HOLDS OUT HIS HAND, AS GOD HAD TOLD HIM. A STRONG EAST WIND BLOWS ALL NIGHT AND ROLLS BACK THE WATERS OF THE SEA...

AWED BY THE SIGHT, THE HEBREWS RUSH JOYFULLY ACROSS THE PATH IN THE SEA.

PHARAOH CHARGES, BUT THE HEBREW CAMP IS EMPTY! THE EGYPTIANS RACE OUT ACROSS THE SEA FLOOR, BUT SAND CLOGS THEIR CHARIOT WHEELS...

IN TERROR THEY TRY TO TURN BACK... BUT THE WIND DIES, AND THE WATERS RETURN. ALL OF PHARAOH'S MEN ARE CAUGHT IN THE RUSHING SEA.

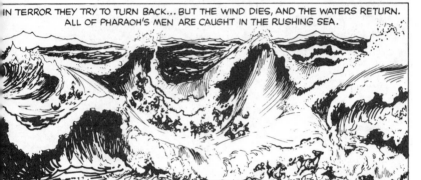

SAFE ON THE OTHER SIDE, THE HEBREWS LOOK BACK...

GOD HAS SAVED US!

I'LL NEVER AGAIN DOUBT THAT MOSES WAS SENT BY GOD TO SAVE US FROM THE EGYPTIANS.

JOYFULLY THE HEBREWS CELEBRATE GOD'S DELIVERANCE. THE TRIBES DESCENDED FROM JACOB (ISRAEL) ARE A FREE PEOPLE—READY TO FORM A NEW NATION. MIRIAM, MOSES' SISTER, LEADS THE WOMEN'S CHORUS SINGING PRAISES TO GOD.

THE LORD IS MY STRENGTH AND SONG: HE IS MY SALVATION.

SING TO THE ♪ LORD. ♫

FROM THE RED SEA, THE ISRAELITES MARCH ACROSS THE DESERT. BUT AFTER DAYS OF TRAVEL THEY FORGET WHAT GOD HAS DONE FOR THEM. AND THEY BEGIN TO COMPLAIN...

I'M THIRSTY.

THREE DAYS AND NO WATER IN SIGHT.

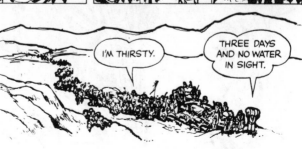

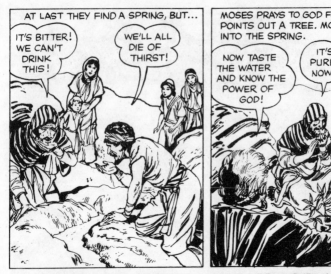

AT LAST THEY FIND A SPRING, BUT...

IT'S BITTER! WE CAN'T DRINK THIS!

WE'LL ALL DIE OF THIRST!

MOSES PRAYS TO GOD FOR HELP—AND GOD POINTS OUT A TREE. MOSES THROWS IT INTO THE SPRING.

NOW TASTE THE WATER AND KNOW THE POWER OF GOD!

IT'S PURE NOW.

...GOD HAS SAVED US AGAIN! NOW I _KNOW_ THAT GOD IS GUIDING MOSES!

WITH RENEWED FAITH, THE PEOPLE CONTINUE THEIR JOURNEY. AS THEY TRAVEL ACROSS THE HOT SANDS THEIR THOUGHTS ARE OF THE HOMELAND GOD HAS PROMISED THEM. THEY DREAM OF GREEN FIELDS...FRESH STREAMS...GREAT FLOCKS.

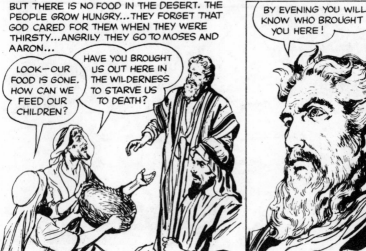

BUT THERE IS NO FOOD IN THE DESERT. THE PEOPLE GROW HUNGRY...THEY FORGET THAT GOD CARED FOR THEM WHEN THEY WERE THIRSTY...ANGRILY THEY GO TO MOSES AND AARON...

LOOK—OUR FOOD IS GONE. HOW CAN WE FEED OUR CHILDREN?

HAVE YOU BROUGHT US OUT HERE IN THE WILDERNESS TO STARVE US TO DEATH?

BY EVENING YOU WILL KNOW WHO BROUGHT YOU HERE!

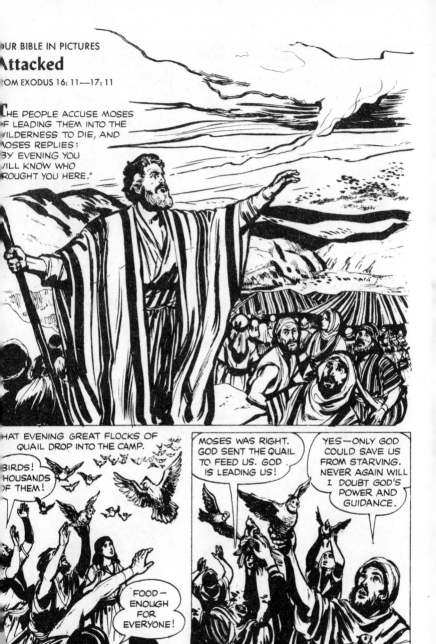

EARLY THE NEXT MORNING THE PEOPLE ARE SURPRISED TO FIND A STRANGE WHITISH COVERING ON THE GROUND.

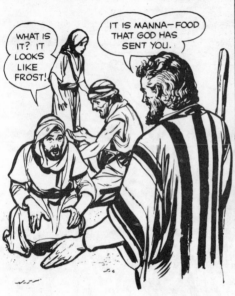

WHAT IS IT? IT LOOKS LIKE FROST!

IT IS MANNA—FOOD THAT GOD HAS SENT YOU.

HOW GOOD GOD IS TO US—

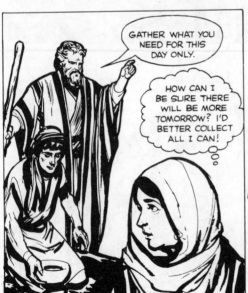

GATHER WHAT YOU NEED FOR THIS DAY ONLY.

HOW CAN I BE SURE THERE WILL BE MORE TOMORROW? I'D BETTER COLLECT ALL I CAN!

SEE—I'LL PUT THIS EXTRA ASIDE FOR TOMORROW. NO MATTER WHAT HAPPENS TO THE OTHERS, *WE* WILL NOT GO HUNGRY.

142

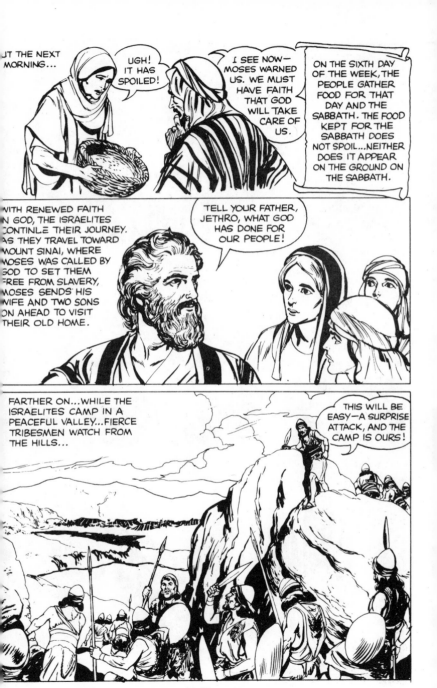

JT THE NEXT MORNING...

UGH! IT HAS SPOILED!

I SEE NOW—MOSES WARNED US. WE MUST HAVE FAITH THAT GOD WILL TAKE CARE OF US.

ON THE SIXTH DAY OF THE WEEK, THE PEOPLE GATHER FOOD FOR THAT DAY AND THE SABBATH. THE FOOD KEPT FOR THE SABBATH DOES NOT SPOIL...NEITHER DOES IT APPEAR ON THE GROUND ON THE SABBATH.

WITH RENEWED FAITH IN GOD, THE ISRAELITES CONTINUE THEIR JOURNEY. AS THEY TRAVEL TOWARD MOUNT SINAI, WHERE MOSES WAS CALLED BY GOD TO SET THEM FREE FROM SLAVERY, MOSES SENDS HIS WIFE AND TWO SONS ON AHEAD TO VISIT THEIR OLD HOME.

TELL YOUR FATHER, JETHRO, WHAT GOD HAS DONE FOR OUR PEOPLE!

FARTHER ON...WHILE THE ISRAELITES CAMP IN A PEACEFUL VALLEY...FIERCE TRIBESMEN WATCH FROM THE HILLS...

THIS WILL BE EASY—A SURPRISE ATTACK, AND THE CAMP IS OURS!

143

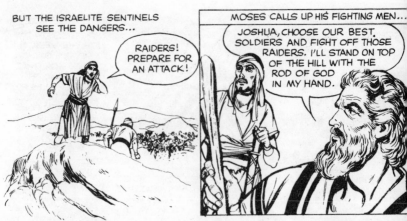

BUT THE ISRAELITE SENTINELS SEE THE DANGERS...

RAIDERS! PREPARE FOR AN ATTACK!

MOSES CALLS UP HIS FIGHTING MEN...

JOSHUA, CHOOSE OUR BEST SOLDIERS AND FIGHT OFF THOSE RAIDERS. I'LL STAND ON TOP OF THE HILL WITH THE ROD OF GOD IN MY HAND.

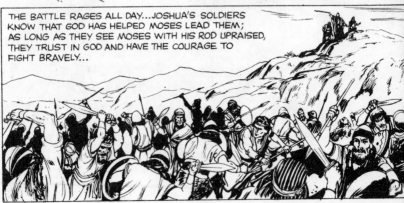

THE BATTLE RAGES ALL DAY...JOSHUA'S SOLDIERS KNOW THAT GOD HAS HELPED MOSES LEAD THEM; AS LONG AS THEY SEE MOSES WITH HIS ROD UPRAISED, THEY TRUST IN GOD AND HAVE THE COURAGE TO FIGHT BRAVELY...

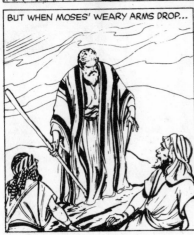

BUT WHEN MOSES' WEARY ARMS DROP...

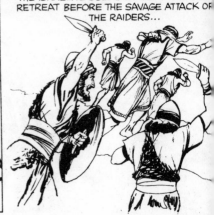

THE ISRAELITE SOLDIERS ARE AFRAID...AND RETREAT BEFORE THE SAVAGE ATTACK OF THE RAIDERS...

The Mountain Trembles

FROM EXODUS 17: 12—19: 20

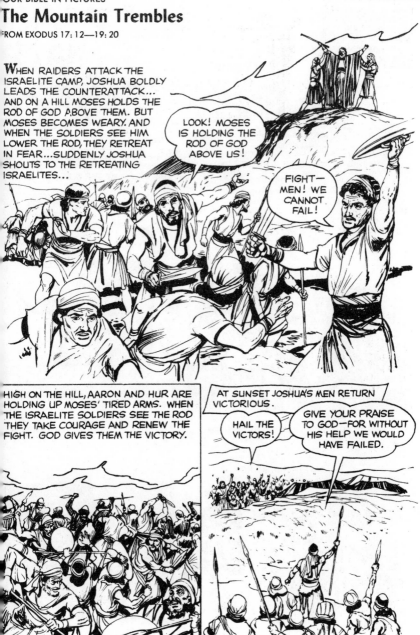

WHEN RAIDERS ATTACK THE ISRAELITE CAMP, JOSHUA BOLDLY LEADS THE COUNTERATTACK... AND ON A HILL MOSES HOLDS THE ROD OF GOD ABOVE THEM. BUT MOSES BECOMES WEARY. AND WHEN THE SOLDIERS SEE HIM LOWER THE ROD, THEY RETREAT IN FEAR...SUDDENLY JOSHUA SHOUTS TO THE RETREATING ISRAELITES...

LOOK! MOSES IS HOLDING THE ROD OF GOD ABOVE US!

FIGHT—MEN! WE CANNOT FAIL!

HIGH ON THE HILL, AARON AND HUR ARE HOLDING UP MOSES' TIRED ARMS. WHEN THE ISRAELITE SOLDIERS SEE THE ROD THEY TAKE COURAGE AND RENEW THE FIGHT. GOD GIVES THEM THE VICTORY.

AT SUNSET JOSHUA'S MEN RETURN VICTORIOUS.

HAIL THE VICTORS!

GIVE YOUR PRAISE TO GOD—FOR WITHOUT HIS HELP WE WOULD HAVE FAILED.

145

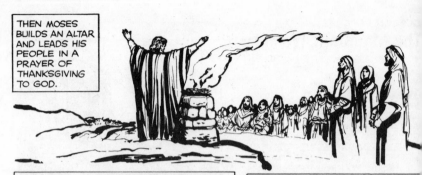

THEN MOSES BUILDS AN ALTAR AND LEADS HIS PEOPLE IN A PRAYER OF THANKSGIVING TO GOD.

FRESH FROM THEIR FIRST MILITARY VICTORY, THE ISRAELITES EAGERLY PUSH ON.

ONLY A FEW WEEKS AGO WE WERE SLAVES IN EGYPT. NOW WE ARE FREE MEN— STRONG ENOUGH TO DEFEND OURSELVES!

WHEN WE GET TO THE PROMISED LAND— WE'LL BUILD A NATION—MIGHTIER THAN ALL EGYPT!

WHEN THEY REACH THE WILDERNESS OF MOUNT SINAI, MOSES SETS UP CAMP. ONE DAY A MESSENGER BRINGS HIM GOOD NEWS...

YOUR FATHER-IN-LAW, JETHRO, YOUR WIFE AND SONS ARE ON THEIR WAY TO SEE YOU.

MOSES GOES OUT AT ONCE TO MEET THEM...

HOW GLAD I AM TO SEE YOU!

I HAVE BEEN HEARING THE WONDERFUL THINGS GOD HAS DONE FOR YOU AND YOUR PEOPLE.

PROUDLY, MOSES SHOWS JETHRO AROUND THE CAMP. AS THE DAYS GO BY, JETHRO MAKES SOME KEEN OBSERVATIONS...

THIS IS WRONG. I MUST SPEAK TO MOSES AT ONCE.

146

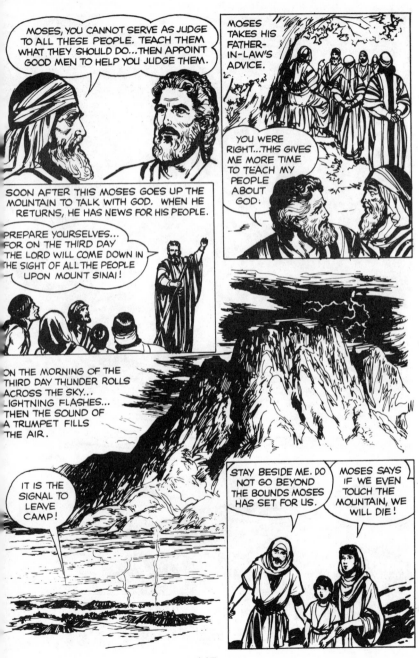

147

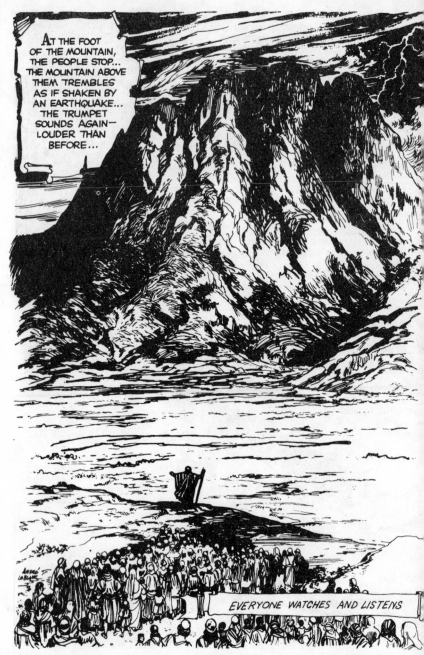

148

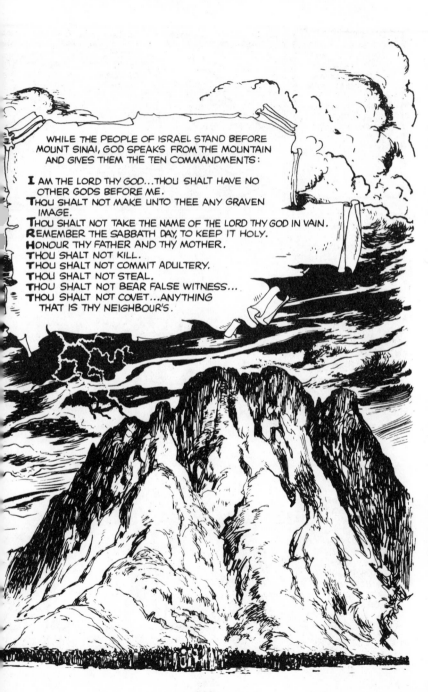

WHILE THE PEOPLE OF ISRAEL STAND BEFORE MOUNT SINAI, GOD SPEAKS FROM THE MOUNTAIN AND GIVES THEM THE TEN COMMANDMENTS:

I AM THE LORD THY GOD...THOU SHALT HAVE NO OTHER GODS BEFORE ME.
THOU SHALT NOT MAKE UNTO THEE ANY GRAVEN IMAGE.
THOU SHALT NOT TAKE THE NAME OF THE LORD THY GOD IN VAIN.
REMEMBER THE SABBATH DAY, TO KEEP IT HOLY.
HONOUR THY FATHER AND THY MOTHER.
THOU SHALT NOT KILL.
THOU SHALT NOT COMMIT ADULTERY.
THOU SHALT NOT STEAL.
THOU SHALT NOT BEAR FALSE WITNESS...
THOU SHALT NOT COVET...ANYTHING THAT IS THY NEIGHBOUR'S.

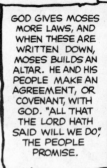

GOD GIVES MOSES MORE LAWS, AND WHEN THESE ARE WRITTEN DOWN, MOSES BUILDS AN ALTAR. HE AND HIS PEOPLE MAKE AN AGREEMENT, OR COVENANT, WITH GOD. "ALL THAT THE LORD HATH SAID WILL WE DO", THE PEOPLE PROMISE.

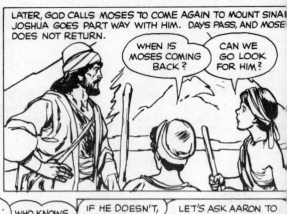

LATER, GOD CALLS MOSES TO COME AGAIN TO MOUNT SINAI. JOSHUA GOES PART WAY WITH HIM. DAYS PASS, AND MOSES DOES NOT RETURN.

WHEN IS MOSES COMING BACK?

CAN WE GO LOOK FOR HIM?

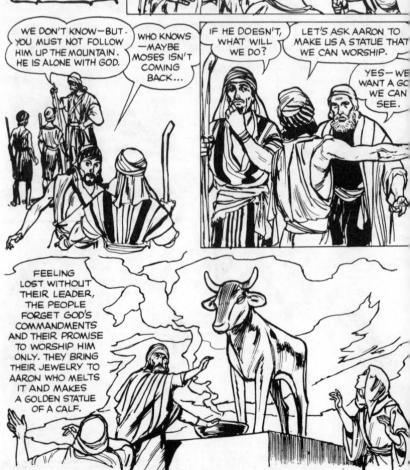

WE DON'T KNOW—BUT YOU MUST NOT FOLLOW HIM UP THE MOUNTAIN. HE IS ALONE WITH GOD.

WHO KNOWS—MAYBE MOSES ISN'T COMING BACK...

IF HE DOESN'T, WHAT WILL WE DO?

LET'S ASK AARON TO MAKE US A STATUE THAT WE CAN WORSHIP.

YES—WE WANT A GOD WE CAN SEE.

FEELING LOST WITHOUT THEIR LEADER, THE PEOPLE FORGET GOD'S COMMANDMENTS AND THEIR PROMISE TO WORSHIP HIM ONLY. THEY BRING THEIR JEWELRY TO AARON WHO MELTS IT AND MAKES A GOLDEN STATUE OF A CALF.

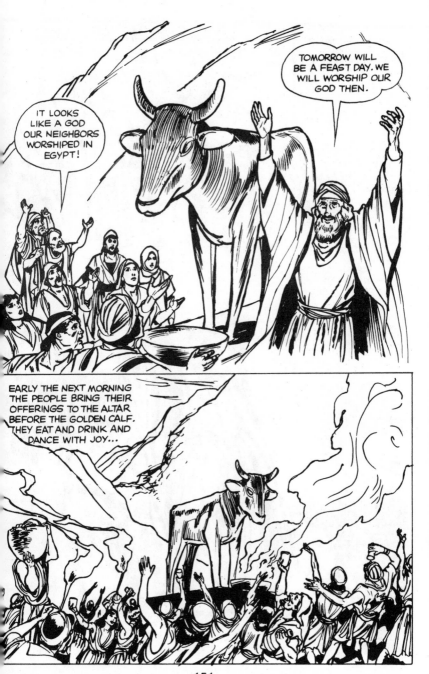

151

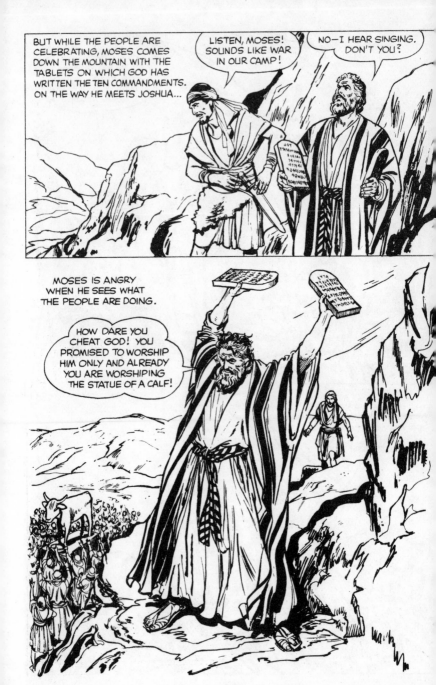

152

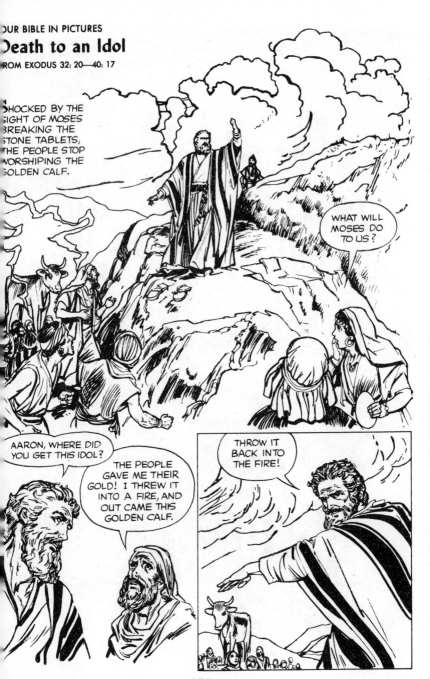

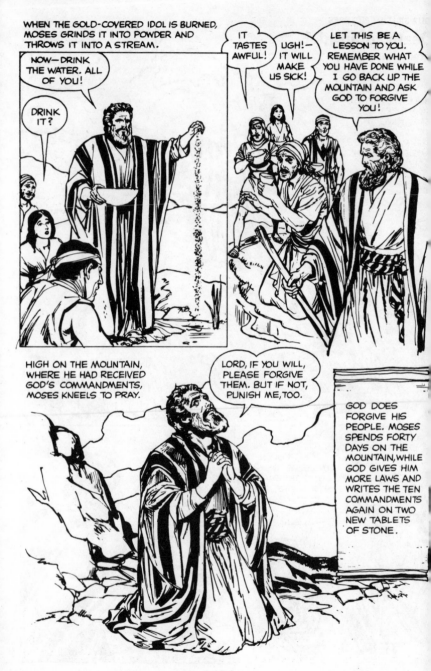

WHEN THE GOLD-COVERED IDOL IS BURNED, MOSES GRINDS IT INTO POWDER AND THROWS IT INTO A STREAM.

NOW—DRINK THE WATER. ALL OF YOU!

DRINK IT?

IT TASTES AWFUL!

UGH!— IT WILL MAKE US SICK!

LET THIS BE A LESSON TO YOU. REMEMBER WHAT YOU HAVE DONE WHILE I GO BACK UP THE MOUNTAIN AND ASK GOD TO FORGIVE YOU!

HIGH ON THE MOUNTAIN, WHERE HE HAD RECEIVED GOD'S COMMANDMENTS, MOSES KNEELS TO PRAY.

LORD, IF YOU WILL, PLEASE FORGIVE THEM. BUT IF NOT, PUNISH ME, TOO.

GOD DOES FORGIVE HIS PEOPLE. MOSES SPENDS FORTY DAYS ON THE MOUNTAIN, WHILE GOD GIVES HIM MORE LAWS AND WRITES THE TEN COMMANDMENTS AGAIN ON TWO NEW TABLETS OF STONE.

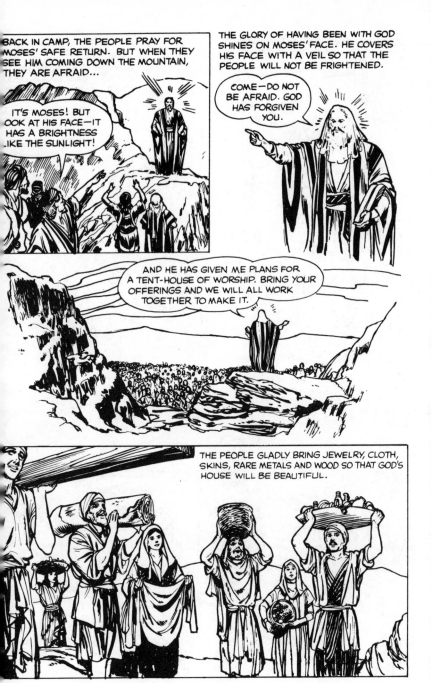

BACK IN CAMP, THE PEOPLE PRAY FOR MOSES' SAFE RETURN. BUT WHEN THEY SEE HIM COMING DOWN THE MOUNTAIN, THEY ARE AFRAID...

IT'S MOSES! BUT LOOK AT HIS FACE—IT HAS A BRIGHTNESS LIKE THE SUNLIGHT!

THE GLORY OF HAVING BEEN WITH GOD SHINES ON MOSES' FACE. HE COVERS HIS FACE WITH A VEIL SO THAT THE PEOPLE WILL NOT BE FRIGHTENED.

COME—DO NOT BE AFRAID. GOD HAS FORGIVEN YOU.

AND HE HAS GIVEN ME PLANS FOR A TENT-HOUSE OF WORSHIP. BRING YOUR OFFERINGS AND WE WILL ALL WORK TOGETHER TO MAKE IT.

THE PEOPLE GLADLY BRING JEWELRY, CLOTH, SKINS, RARE METALS AND WOOD SO THAT GOD'S HOUSE WILL BE BEAUTIFUL.

155

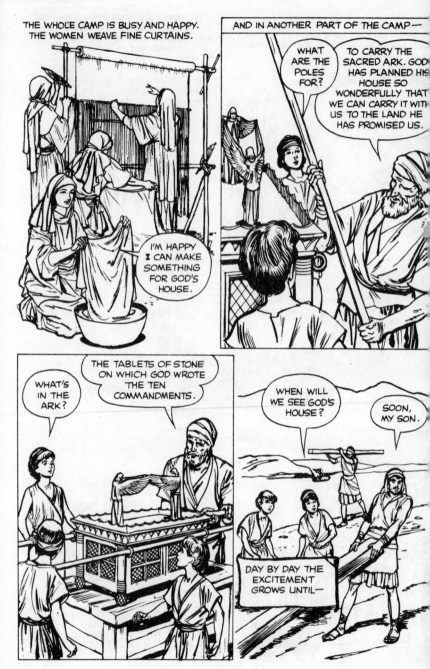

156

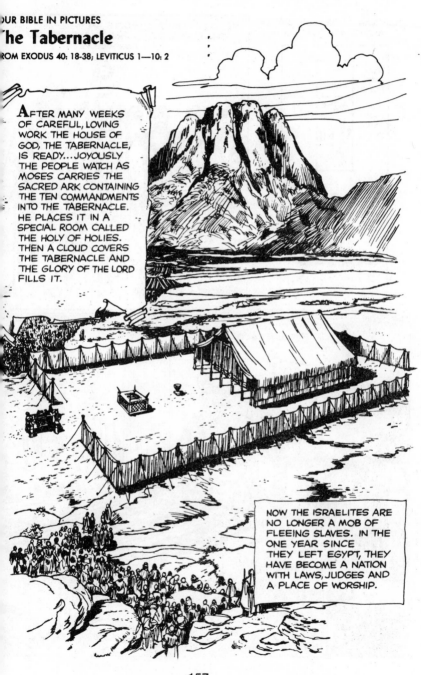

The Tabernacle

FROM EXODUS 40: 18-38; LEVITICUS 1—10: 2

AFTER MANY WEEKS OF CAREFUL, LOVING WORK THE HOUSE OF GOD, THE TABERNACLE, IS READY... JOYOUSLY THE PEOPLE WATCH AS MOSES CARRIES THE SACRED ARK CONTAINING THE TEN COMMANDMENTS INTO THE TABERNACLE. HE PLACES IT IN A SPECIAL ROOM CALLED THE HOLY OF HOLIES. THEN A CLOUD COVERS THE TABERNACLE AND THE GLORY OF THE LORD FILLS IT.

NOW THE ISRAELITES ARE NO LONGER A MOB OF FLEEING SLAVES. IN THE ONE YEAR SINCE THEY LEFT EGYPT, THEY HAVE BECOME A NATION WITH LAWS, JUDGES AND A PLACE OF WORSHIP.

157

FLOOR PLAN OF THE TABERNACLE AND ITS COURTYARD.

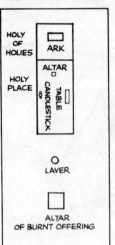

HOLY OF HOLIES — ARK

HOLY PLACE — ALTAR, TABLE, CANDLESTICK

LAVER

ALTAR OF BURNT OFFERING

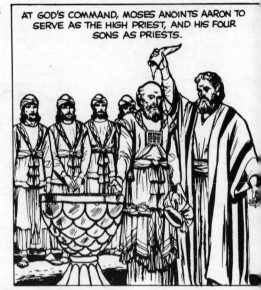

AT GOD'S COMMAND, MOSES ANOINTS AARON TO SERVE AS THE HIGH PRIEST, AND HIS FOUR SONS AS PRIESTS.

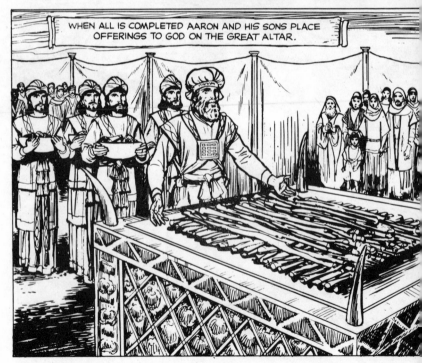

WHEN ALL IS COMPLETED AARON AND HIS SONS PLACE OFFERINGS TO GOD ON THE GREAT ALTAR.

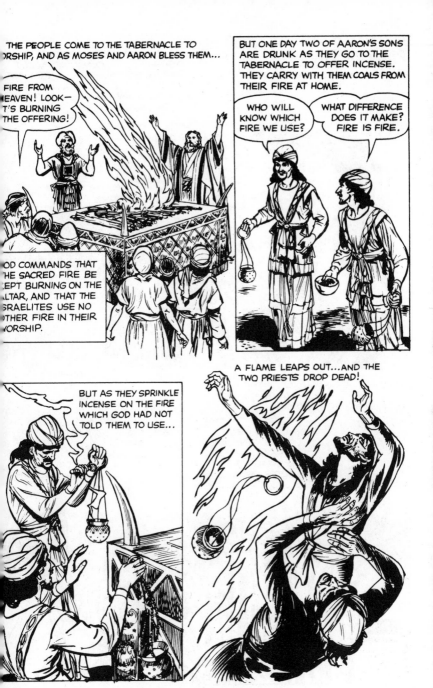

THE PEOPLE COME TO THE TABERNACLE TO WORSHIP, AND AS MOSES AND AARON BLESS THEM...

FIRE FROM HEAVEN! LOOK— IT'S BURNING THE OFFERING!

GOD COMMANDS THAT THE SACRED FIRE BE KEPT BURNING ON THE ALTAR, AND THAT THE ISRAELITES USE NO OTHER FIRE IN THEIR WORSHIP.

BUT ONE DAY TWO OF AARON'S SONS ARE DRUNK AS THEY GO TO THE TABERNACLE TO OFFER INCENSE. THEY CARRY WITH THEM COALS FROM THEIR FIRE AT HOME.

WHO WILL KNOW WHICH FIRE WE USE?

WHAT DIFFERENCE DOES IT MAKE? FIRE IS FIRE.

BUT AS THEY SPRINKLE INCENSE ON THE FIRE WHICH GOD HAD NOT TOLD THEM TO USE...

A FLAME LEAPS OUT...AND THE TWO PRIESTS DROP DEAD!

OUR BIBLE IN PICTURES

Pillar of Fire

FROM LEVITICUS 10: 3; NUMBERS 1-10

WHEN TWO OF AARON'S SONS GET DRUNK AND DISOBEY GOD'S COMMAND ABOUT WORSHIP IN THE TABERNACLE, THEY ARE STRUCK DEAD. THE WHOLE CAMP IS SHOCK ...AND MOSES WARNS AARON AND THE OTHER TWO SONS.

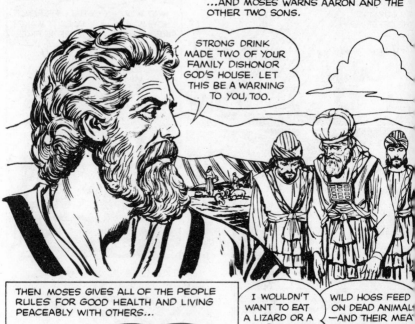

STRONG DRINK MADE TWO OF YOUR FAMILY DISHONOR GOD'S HOUSE. LET THIS BE A WARNING TO YOU, TOO.

THEN MOSES GIVES ALL OF THE PEOPLE RULES FOR GOOD HEALTH AND LIVING PEACEABLY WITH OTHERS...

DO NOT EAT BATS, OWLS, HAWKS, LIZARDS OR HOGS. SUCH FOOD IS NOT FITTING FOR GOD'S PEOPLE.

I WOULDN'T WANT TO EAT A LIZARD OR A BAT, BUT WHAT IS WRONG WITH HOGS?.

WILD HOGS FEED ON DEAD ANIMAL —AND THEIR MEA IS HEAVY WITH FAT. IT WOULD NOT BE GOOD FOR YOU IN THIS HOT COUNTRY.

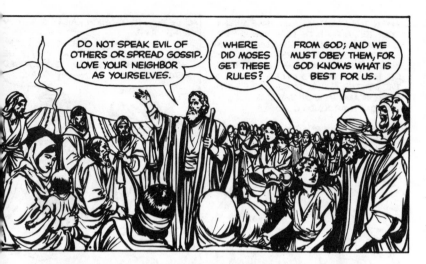

THE PEOPLE ARE DIVIDED INTO TWELVE TRIBES—BESIDES THE TRIBE OF LEVI WHICH IS SET APART FOR RELIGIOUS DUTIES. MOSES CALLS A MEETING OF THE TRIBAL LEADERS.

WHEN THE FIGHTING MEN HAVE BEEN COUNTED, A PLAN OF DEFENSE IS SET UP THAT WILL BE FOLLOWED IN CAMPING DURING THE LONG JOURNEY AHEAD. THE OUTER RIM OF THE CAMP IS MADE UP OF THE 12 TRIBES—3 ON EACH SIDE. IN THE CENTER IS THE TABERNACLE WITH PRIESTS AND MEN OF THE TRIBE OF LEVI STATIONED AROUND IT.

ABOVE THE TABERNACLE—AS A SYMBOL OF GOD'S PRESENCE—IS A CLOUD BY DAY AND A PILLAR OF FIRE BY NIGHT.

ALL OF THIS PREPARATION RAISES QUESTIONS IN THE CAMP.

DOES THIS MEAN WE'RE GETTING READY TO MOVE ON?

I HOPE SO. I CAN HARDLY WAIT TO GET TO THE PROMISED LAND.

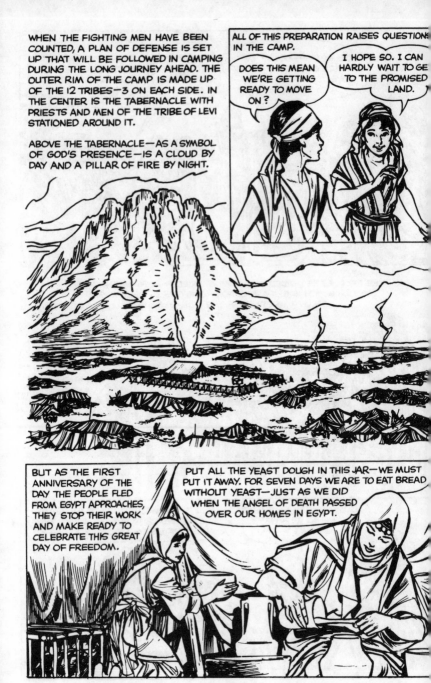

BUT AS THE FIRST ANNIVERSARY OF THE DAY THE PEOPLE FLED FROM EGYPT APPROACHES, THEY STOP THEIR WORK AND MAKE READY TO CELEBRATE THIS GREAT DAY OF FREEDOM.

PUT ALL THE YEAST DOUGH IN THIS JAR—WE MUST PUT IT AWAY. FOR SEVEN DAYS WE ARE TO EAT BREAD WITHOUT YEAST—JUST AS WE DID WHEN THE ANGEL OF DEATH PASSED OVER OUR HOMES IN EGYPT.

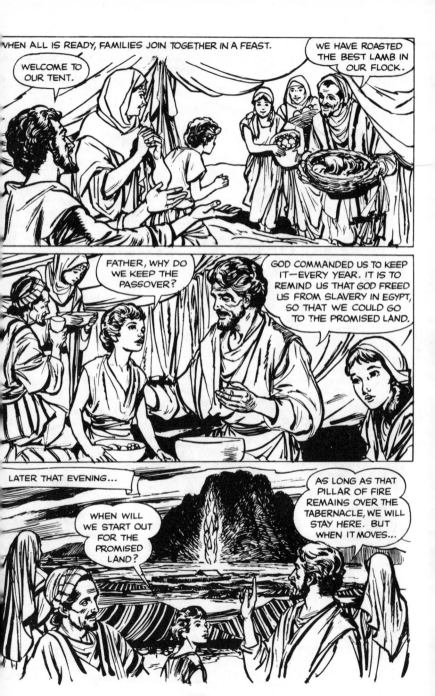

163

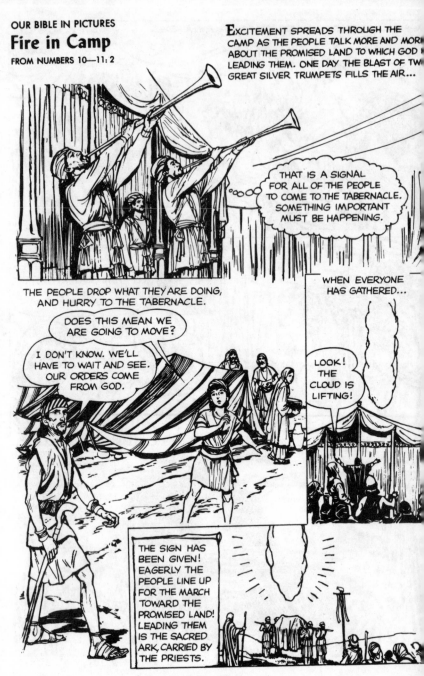

OUR BIBLE IN PICTURES
Fire in Camp
FROM NUMBERS 10—11: 2

EXCITEMENT SPREADS THROUGH THE CAMP AS THE PEOPLE TALK MORE AND MORE ABOUT THE PROMISED LAND TO WHICH GOD IS LEADING THEM. ONE DAY THE BLAST OF TWO GREAT SILVER TRUMPETS FILLS THE AIR...

THAT IS A SIGNAL FOR ALL OF THE PEOPLE TO COME TO THE TABERNACLE. SOMETHING IMPORTANT MUST BE HAPPENING.

THE PEOPLE DROP WHAT THEY ARE DOING, AND HURRY TO THE TABERNACLE.

DOES THIS MEAN WE ARE GOING TO MOVE?

I DON'T KNOW. WE'LL HAVE TO WAIT AND SEE. OUR ORDERS COME FROM GOD.

WHEN EVERYONE HAS GATHERED...

LOOK! THE CLOUD IS LIFTING!

THE SIGN HAS BEEN GIVEN! EAGERLY THE PEOPLE LINE UP FOR THE MARCH TOWARD THE PROMISED LAND! LEADING THEM IS THE SACRED ARK, CARRIED BY THE PRIESTS.

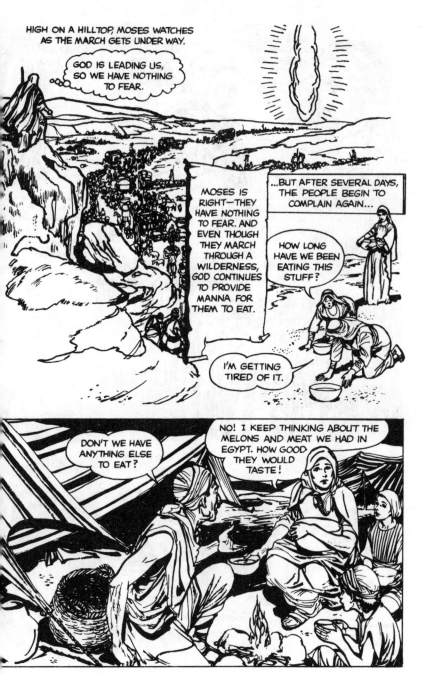

165

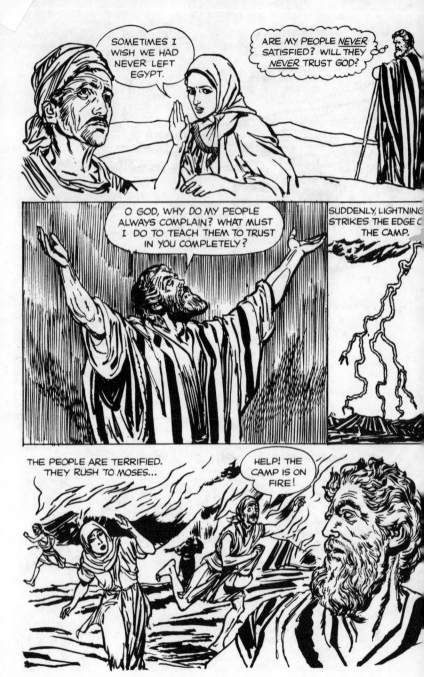

166

Family Divided

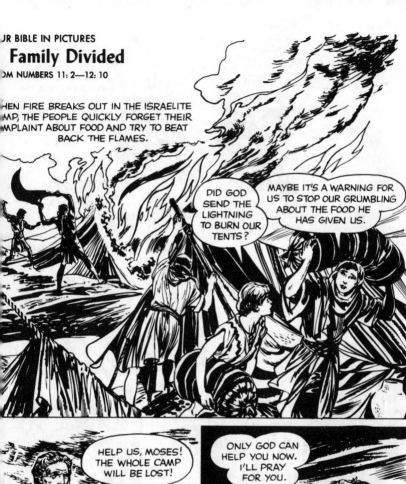

HEN FIRE BREAKS OUT IN THE ISRAELITE MP, THE PEOPLE QUICKLY FORGET THEIR MPLAINT ABOUT FOOD AND TRY TO BEAT BACK THE FLAMES.

DID GOD SEND THE LIGHTNING TO BURN OUR TENTS?

MAYBE IT'S A WARNING FOR US TO STOP OUR GRUMBLING ABOUT THE FOOD HE HAS GIVEN US.

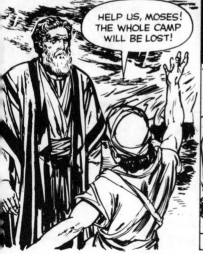

HELP US, MOSES! THE WHOLE CAMP WILL BE LOST!

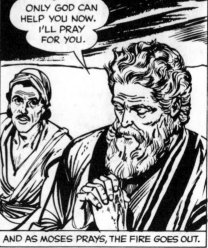

ONLY GOD CAN HELP YOU NOW. I'LL PRAY FOR YOU.

AND AS MOSES PRAYS, THE FIRE GOES OUT.

167

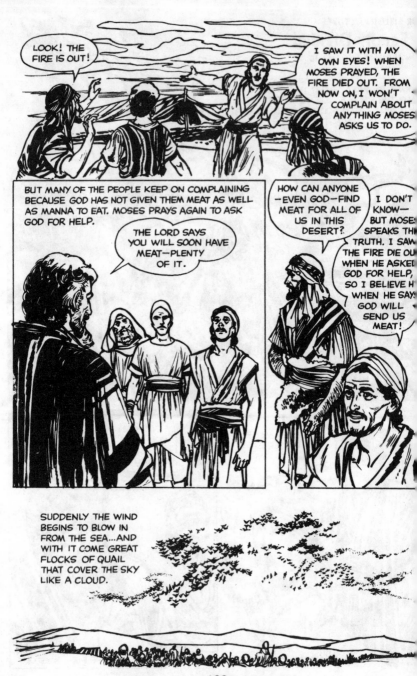

LOOK! THE FIRE IS OUT!

I SAW IT WITH MY OWN EYES! WHEN MOSES PRAYED, THE FIRE DIED OUT. FROM NOW ON, I WON'T COMPLAIN ABOUT ANYTHING MOSES ASKS US TO DO.

BUT MANY OF THE PEOPLE KEEP ON COMPLAINING BECAUSE GOD HAS NOT GIVEN THEM MEAT AS WELL AS MANNA TO EAT. MOSES PRAYS AGAIN TO ASK GOD FOR HELP.

THE LORD SAYS YOU WILL SOON HAVE MEAT—PLENTY OF IT.

HOW CAN ANYONE—EVEN GOD—FIND MEAT FOR ALL OF US IN THIS DESERT?

I DON'T KNOW—BUT MOSES SPEAKS THE TRUTH. I SAW THE FIRE DIE OUT WHEN HE ASKED GOD FOR HELP, SO I BELIEVE HIM WHEN HE SAYS GOD WILL SEND US MEAT!

SUDDENLY THE WIND BEGINS TO BLOW IN FROM THE SEA...AND WITH IT COME GREAT FLOCKS OF QUAIL THAT COVER THE SKY LIKE A CLOUD.

AS THE QUAIL LAND ON THE DESERT, THE ISRAELITES PICK UP ALL THEY CAN CARRY.

MEAT! ALL WE CAN EAT!

LET'S STORE UP ALL WE CAN TO EAT LATER ON.

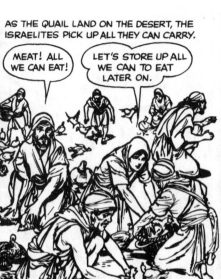

HOW MANY MORE BASKETS DO I HAVE TO GATHER?

GET AS MANY AS YOU CAN. AT LEAST _WE'LL_ HAVE ALL _WE_ NEED.

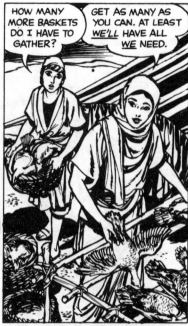

THE PEOPLE STUFF THEMSELVES UNTIL MANY ARE SICK.

IT SERVES ME RIGHT. I WAS TOO GREEDY.

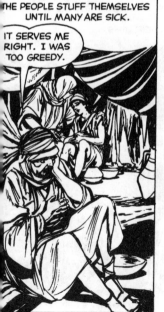

SOON AFTER THIS, THE ORDER IS GIVEN TO CONTINUE THE JOURNEY. ONCE AGAIN, A CLOUD BY DAY AND A PILLAR OF FIRE BY NIGHT LEAD THE PEOPLE...TO A CAMP SITE CLOSER TO THEIR PROMISED HOMELAND.

NO SOONER IS CAMP SET UP THAN MOSES' OWN BROTHER AND SISTER TURN AGAINST HIM.

MOSES ACTS AS IF HE IS THE ONLY SPOKESMAN FOR GOD. HE SEEMS TO FORGET, AARON, THAT YOU ARE THE HIGH PRIEST.

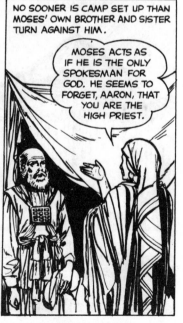

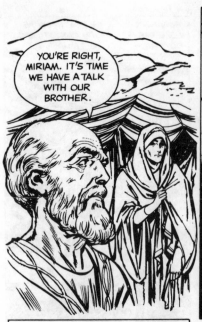

YOU'RE RIGHT, MIRIAM. IT'S TIME WE HAVE A TALK WITH OUR BROTHER.

IN ANGER, THEY GO TO MOSES...

WE'RE TIRED OF HAVING YOU RUN EVERYTHING, MOSES. DO YOU THINK YOU ARE THE ONLY ONE WHO CAN SPEAK FOR GOD? DIDN'T GOD CALL AARON TO BE THE HIGH PRIEST? AND DON'T FORGET, I AM A PROPHETESS, TOO!

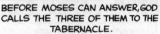

BEFORE MOSES CAN ANSWER, GOD CALLS THE THREE OF THEM TO THE TABERNACLE.

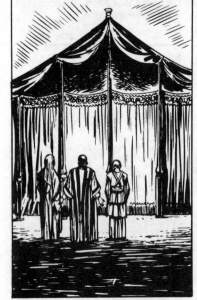

THEN GOD SPEAKS FROM A CLOUD, AND TELLS THEM THAT HE HAS CHOSEN MOSES TO LEAD THE PEOPLE OF ISRAEL. WHEN THE CLOUD DISAPPEARS, MIRIAM AND AARON GET THE SHOCK OF THEIR LIVES.

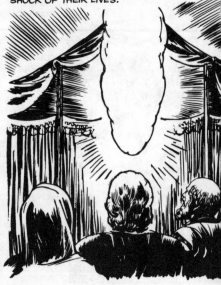

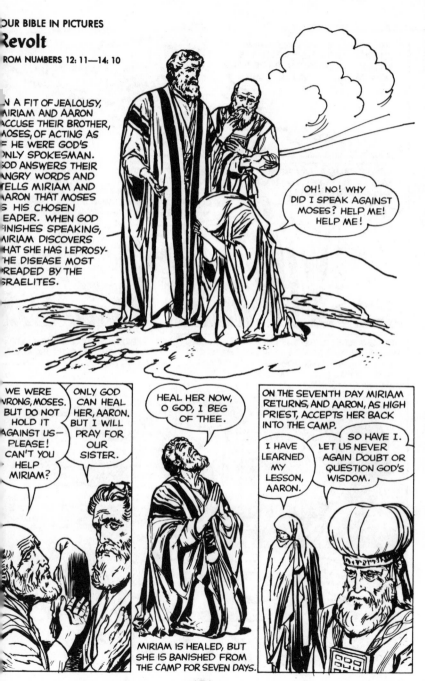

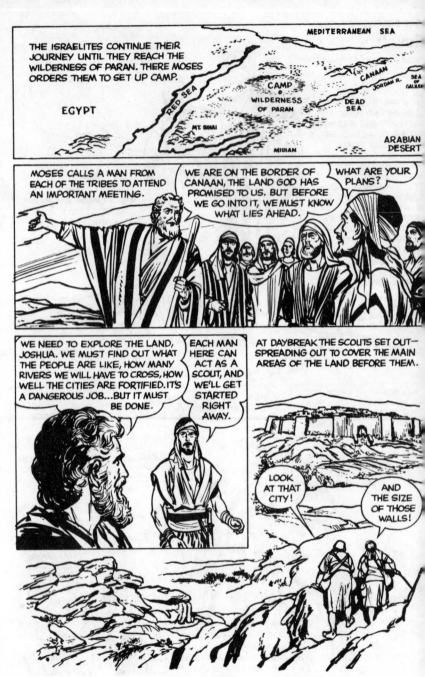

THE ISRAELITES CONTINUE THEIR JOURNEY UNTIL THEY REACH THE WILDERNESS OF PARAN. THERE MOSES ORDERS THEM TO SET UP CAMP.

MEDITERRANEAN SEA

EGYPT

RED SEA

MT. SINAI

MIDIAN

CAMP WILDERNESS OF PARAN

CANAAN

JORDAN R.

DEAD SEA

SEA OF GALILEE

ARABIAN DESERT

MOSES CALLS A MAN FROM EACH OF THE TRIBES TO ATTEND AN IMPORTANT MEETING.

WE ARE ON THE BORDER OF CANAAN, THE LAND GOD HAS PROMISED TO US. BUT BEFORE WE GO INTO IT, WE MUST KNOW WHAT LIES AHEAD.

WHAT ARE YOUR PLANS?

WE NEED TO EXPLORE THE LAND, JOSHUA. WE MUST FIND OUT WHAT THE PEOPLE ARE LIKE, HOW MANY RIVERS WE WILL HAVE TO CROSS, HOW WELL THE CITIES ARE FORTIFIED. IT'S A DANGEROUS JOB...BUT IT MUST BE DONE.

EACH MAN HERE CAN ACT AS A SCOUT, AND WE'LL GET STARTED RIGHT AWAY.

AT DAYBREAK THE SCOUTS SET OUT— SPREADING OUT TO COVER THE MAIN AREAS OF THE LAND BEFORE THEM.

LOOK AT THAT CITY!

AND THE SIZE OF THOSE WALLS!

172

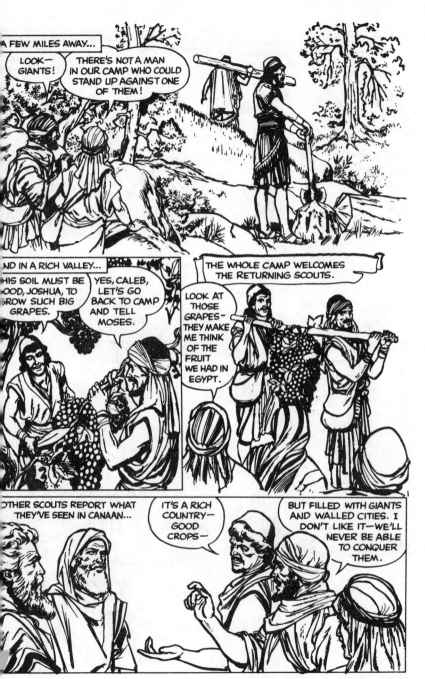

173

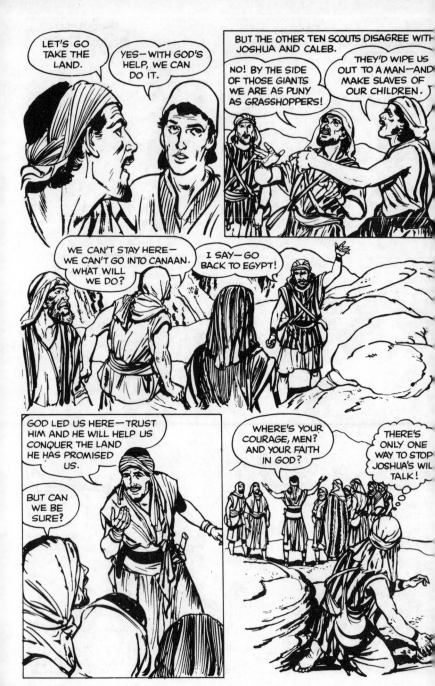

174

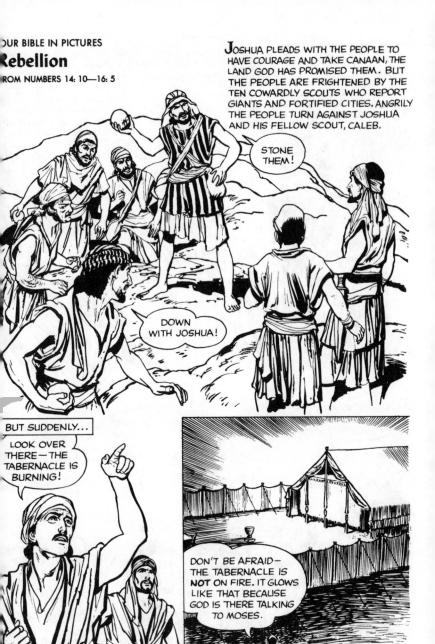

OUR BIBLE IN PICTURES
Rebellion
FROM NUMBERS 14: 10—16: 5

JOSHUA PLEADS WITH THE PEOPLE TO HAVE COURAGE AND TAKE CANAAN, THE LAND GOD HAS PROMISED THEM. BUT THE PEOPLE ARE FRIGHTENED BY THE TEN COWARDLY SCOUTS WHO REPORT GIANTS AND FORTIFIED CITIES. ANGRILY THE PEOPLE TURN AGAINST JOSHUA AND HIS FELLOW SCOUT, CALEB.

STONE THEM!

DOWN WITH JOSHUA!

BUT SUDDENLY...

LOOK OVER THERE—THE TABERNACLE IS BURNING!

DON'T BE AFRAID—THE TABERNACLE IS **NOT** ON FIRE. IT GLOWS LIKE THAT BECAUSE GOD IS THERE TALKING TO MOSES.

INSIDE THE TABERNACLE...

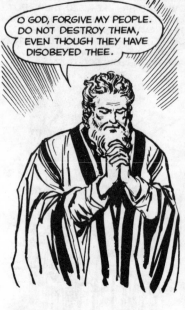

O GOD, FORGIVE MY PEOPLE. DO NOT DESTROY THEM, EVEN THOUGH THEY HAVE DISOBEYED THEE.

MOSES COMES OUT OF THE TABERNACLE AND HUSH FALLS OVER THE CROWD. HE RAISES HIS HAND...

BECAUSE YOU LACK FAITH TO ENTER THE PROMISED LAND, GOD HAS SAID YOU MUST TURN BACK TO THE WILDERNESS.

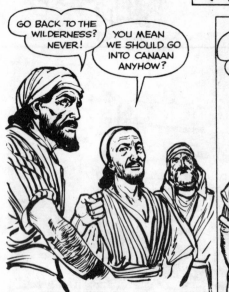

GO BACK TO THE WILDERNESS? NEVER!

YOU MEAN WE SHOULD GO INTO CANAAN ANYHOW?

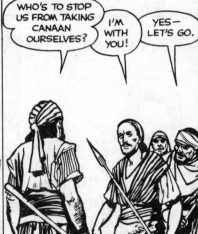

WHO'S TO STOP US FROM TAKING CANAAN OURSELVES?

I'M WITH YOU!

YES— LET'S GO.

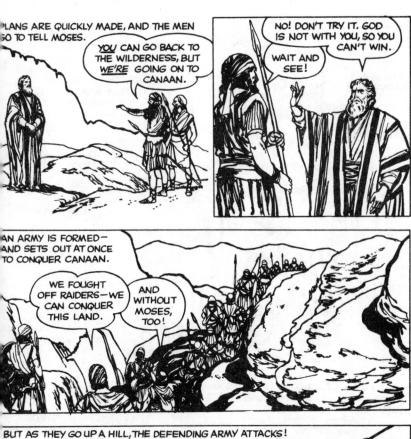

PLANS ARE QUICKLY MADE, AND THE MEN GO TO TELL MOSES.

YOU CAN GO BACK TO THE WILDERNESS, BUT *WE'RE* GOING ON TO CANAAN.

NO! DON'T TRY IT. GOD IS NOT WITH YOU, SO YOU CAN'T WIN.

WAIT AND SEE!

AN ARMY IS FORMED— AND SETS OUT AT ONCE TO CONQUER CANAAN.

WE FOUGHT OFF RAIDERS—WE CAN CONQUER THIS LAND.

AND WITHOUT MOSES, TOO!

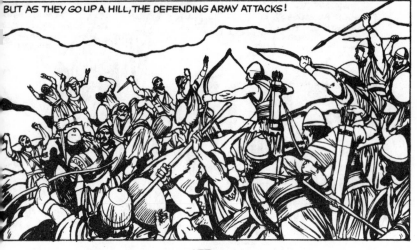

BUT AS THEY GO UP A HILL, THE DEFENDING ARMY ATTACKS!

177

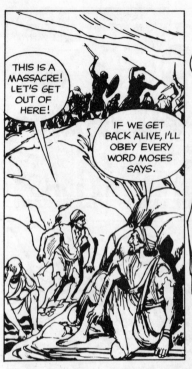

THIS IS A MASSACRE! LET'S GET OUT OF HERE!

IF WE GET BACK ALIVE, I'LL OBEY EVERY WORD MOSES SAYS.

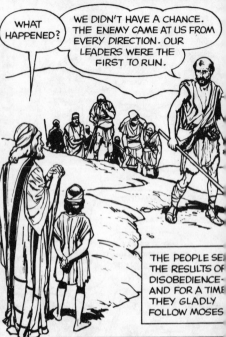

THE BATTLE IS SOON OVER—THE DEFEATED ISRAELITES LIMP BACK TO CAMP.

WHAT HAPPENED?

WE DIDN'T HAVE A CHANCE. THE ENEMY CAME AT US FROM EVERY DIRECTION. OUR LEADERS WERE THE FIRST TO RUN.

THE PEOPLE SEE THE RESULTS OF DISOBEDIENCE— AND FOR A TIME THEY GLADLY FOLLOW MOSES

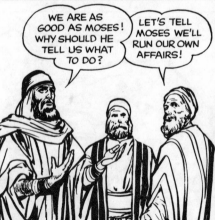

BUT THEN A MAN NAMED KORAH AND SOME OF THE OTHER HELPERS IN THE TABERNACLE GROW JEALOUS OF MOSES' LEADERSHIP.

WE ARE AS GOOD AS MOSES! WHY SHOULD HE TELL US WHAT TO DO?

LET'S TELL MOSES WE'LL RUN OUR OWN AFFAIRS!

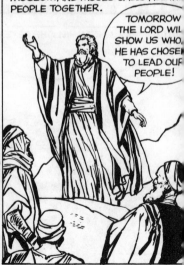

KORAH AND HIS FOLLOWERS GO TO MOSES...AND MOSES CALLS ALL THE PEOPLE TOGETHER.

TOMORROW THE LORD WILL SHOW US WHO HE HAS CHOSEN TO LEAD OUR PEOPLE!

178

Serpents in the Wilderness

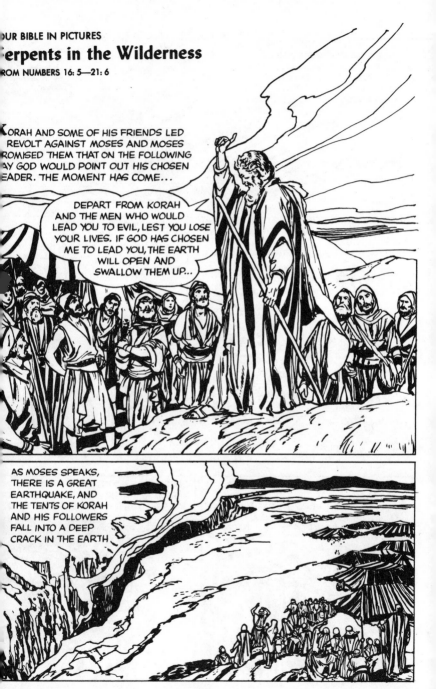

KORAH AND SOME OF HIS FRIENDS LED A REVOLT AGAINST MOSES AND MOSES PROMISED THEM THAT ON THE FOLLOWING DAY GOD WOULD POINT OUT HIS CHOSEN LEADER. THE MOMENT HAS COME...

DEPART FROM KORAH AND THE MEN WHO WOULD LEAD YOU TO EVIL, LEST YOU LOSE YOUR LIVES. IF GOD HAS CHOSEN ME TO LEAD YOU, THE EARTH WILL OPEN AND SWALLOW THEM UP...

AS MOSES SPEAKS, THERE IS A GREAT EARTHQUAKE, AND THE TENTS OF KORAH AND HIS FOLLOWERS FALL INTO A DEEP CRACK IN THE EARTH

179

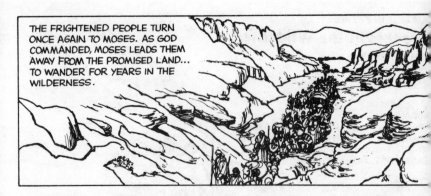

THE FRIGHTENED PEOPLE TURN ONCE AGAIN TO MOSES. AS GOD COMMANDED, MOSES LEADS THEM AWAY FROM THE PROMISED LAND... TO WANDER FOR YEARS IN THE WILDERNESS.

WHEN HARDSHIPS COME, THEY FORGET THAT IT WAS THEIR FEAR THAT KEPT THEM FROM TAKING THE GOOD LAND GOD HAD PROMISED THEM. AGAIN AND AGAIN THEY COMPLAIN...

NO WATER! NOW WHAT WILL I DO?

THE SPRING IS DRY! HOW CAN I COOK— OR WASH?

OUR TRIBAL LEADERS WILL TAKE THIS UP WITH MOSES!

WELL, MOSES, WHERE ARE WE GOING TO GET WATER?

DID YOU LEAD US OUT HERE TO DIE OF THIRST?

LET'S GO BACK TO EGYPT—AT LEAST WE HAD FOOD AND WATER THERE.

ONCE AGAIN, MOSES AND HIS BROTHER, AARON, TAKE THEIR PROBLEM TO GOD. AND GOD TELLS THEM EXACTLY WHAT TO DO.

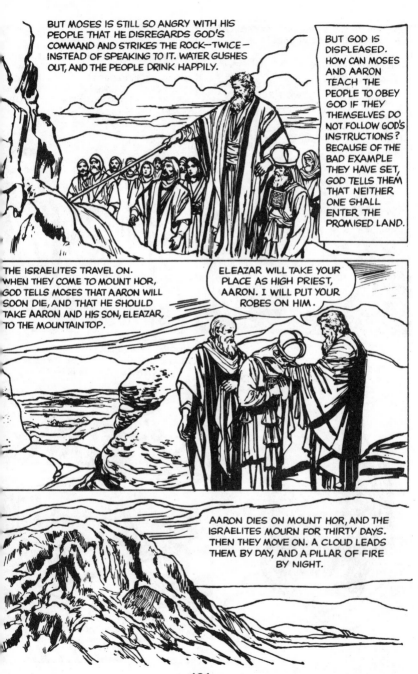

BUT MOSES IS STILL SO ANGRY WITH HIS PEOPLE THAT HE DISREGARDS GOD'S COMMAND AND STRIKES THE ROCK—TWICE—INSTEAD OF SPEAKING TO IT. WATER GUSHES OUT, AND THE PEOPLE DRINK HAPPILY.

BUT GOD IS DISPLEASED. HOW CAN MOSES AND AARON TEACH THE PEOPLE TO OBEY GOD IF THEY THEMSELVES DO NOT FOLLOW GOD'S INSTRUCTIONS? BECAUSE OF THE BAD EXAMPLE THEY HAVE SET, GOD TELLS THEM THAT NEITHER ONE SHALL ENTER THE PROMISED LAND.

THE ISRAELITES TRAVEL ON. WHEN THEY COME TO MOUNT HOR, GOD TELLS MOSES THAT AARON WILL SOON DIE, AND THAT HE SHOULD TAKE AARON AND HIS SON, ELEAZAR, TO THE MOUNTAINTOP.

ELEAZAR WILL TAKE YOUR PLACE AS HIGH PRIEST, AARON. I WILL PUT YOUR ROBES ON HIM.

AARON DIES ON MOUNT HOR, AND THE ISRAELITES MOURN FOR THIRTY DAYS. THEN THEY MOVE ON. A CLOUD LEADS THEM BY DAY, AND A PILLAR OF FIRE BY NIGHT.

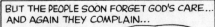

BUT THE PEOPLE SOON FORGET GOD'S CARE...
AND AGAIN THEY COMPLAIN...

THERE'S NOT ENOUGH WATER— I'M ALWAYS THIRSTY.

HAS NOT GOD ALWAYS GIVEN US WATER WHEN WE NEEDED IT?

YES, BUT—THE FOOD— I'M SICK OF THIS STUFF THAT MUST BE GATHERED EVERY DAY AND MADE INTO BREAD. I WANT FOOD LIKE WE HAD IN EGYPT— MELONS, FRUIT...

IN EGYPT YOU WERE BEATEN AND MADE TO WORK LIKE SLAVES. AND YOU CRIED FOR FREEDOM.

AND _YOU_ SAID GOD WOULD GIVE US FREEDOM! DO YOU CALL _THIS_ FREEDOM—WANDERING AROUND IN THE WILDERNESS?

SUDDENLY—AS PUNISHMENT FOR THEIR GRUMBLING—THE CAMP BECOMES ALIVE WITH POISONOUS SNAKES.

HELP! I'VE BEE[N] BITTEN

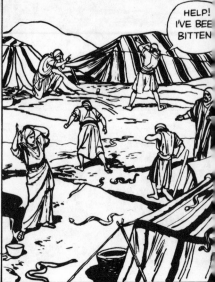

182

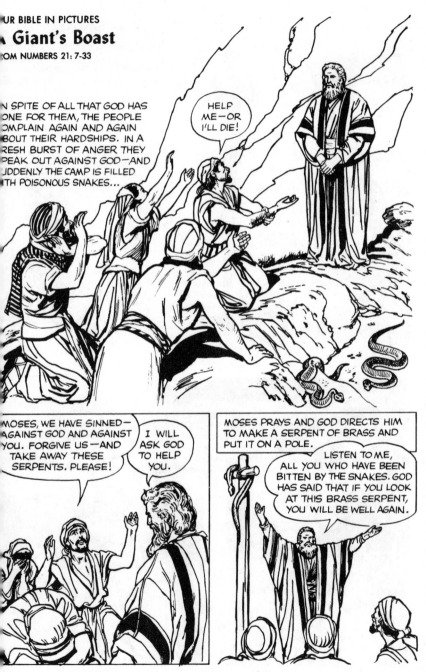

A Giant's Boast

FROM NUMBERS 21: 7-33

IN SPITE OF ALL THAT GOD HAS DONE FOR THEM, THE PEOPLE COMPLAIN AGAIN AND AGAIN ABOUT THEIR HARDSHIPS. IN A FRESH BURST OF ANGER THEY SPEAK OUT AGAINST GOD—AND SUDDENLY THE CAMP IS FILLED WITH POISONOUS SNAKES...

HELP ME—OR I'LL DIE!

MOSES, WE HAVE SINNED—AGAINST GOD AND AGAINST YOU. FORGIVE US—AND TAKE AWAY THESE SERPENTS. PLEASE!

I WILL ASK GOD TO HELP YOU.

MOSES PRAYS AND GOD DIRECTS HIM TO MAKE A SERPENT OF BRASS AND PUT IT ON A POLE.

LISTEN TO ME, ALL YOU WHO HAVE BEEN BITTEN BY THE SNAKES. GOD HAS SAID THAT IF YOU LOOK AT THIS BRASS SERPENT, YOU WILL BE WELL AGAIN.

183

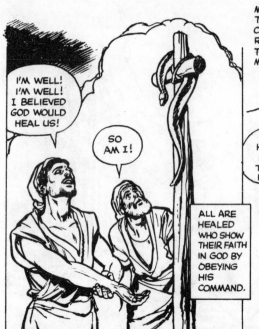

I'M WELL! I'M WELL! I BELIEVED GOD WOULD HEAL US!

SO AM I!

ALL ARE HEALED WHO SHOW THEIR FAITH IN GOD BY OBEYING HIS COMMAND.

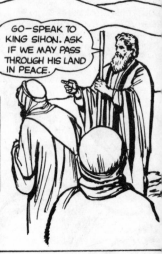

MOSES AND HIS PEOPLE CONTINUE THEIR JOURNEY— THIS TIME NO ONE COMPLAINS OR QUESTIONS MOSES' RIGHT TO LEAD. WHEN THEY REACH THE BORDER OF THE AMORITES MOSES SUMMONS TWO MESSENGERS.

GO—SPEAK TO KING SIHON. ASK IF WE MAY PASS THROUGH HIS LAND IN PEACE.

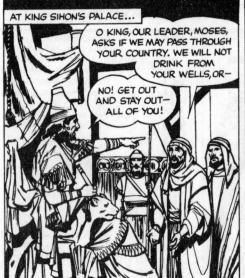

AT KING SIHON'S PALACE...

O KING, OUR LEADER, MOSES, ASKS IF WE MAY PASS THROUGH YOUR COUNTRY. WE WILL NOT DRINK FROM YOUR WELLS, OR—

NO! GET OUT AND STAY OUT— ALL OF YOU!

WHY SHOULD HE BE SO ANGRY?

I DON'T KNOW—BUT I'M SCARED. WHAT ARE WE GOING TO DO NOW?

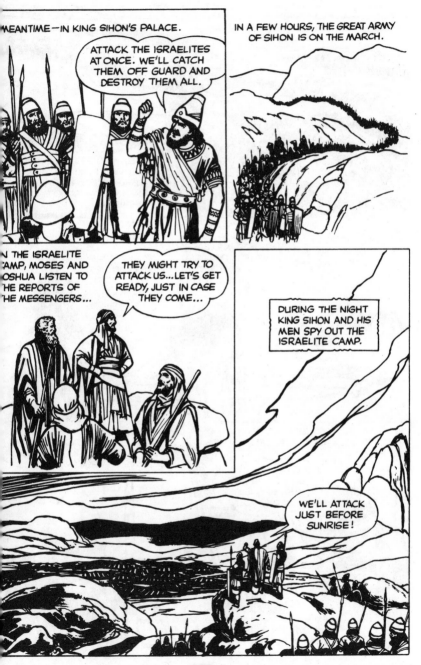

185

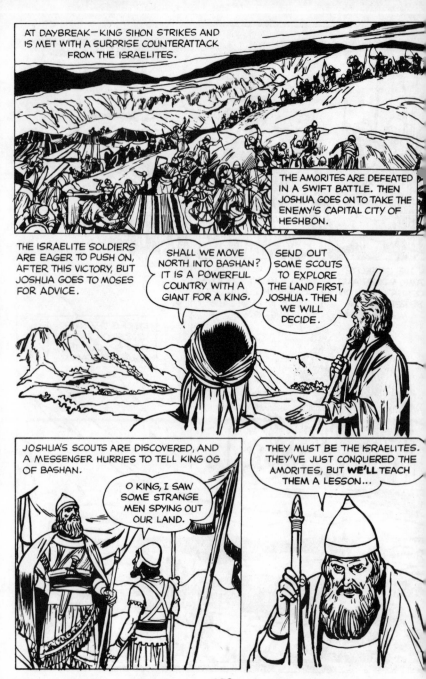

AT DAYBREAK—KING SIHON STRIKES AND IS MET WITH A SURPRISE COUNTERATTACK FROM THE ISRAELITES.

THE AMORITES ARE DEFEATED IN A SWIFT BATTLE. THEN JOSHUA GOES ON TO TAKE THE ENEMY'S CAPITAL CITY OF HESHBON.

THE ISRAELITE SOLDIERS ARE EAGER TO PUSH ON, AFTER THIS VICTORY, BUT JOSHUA GOES TO MOSES FOR ADVICE.

SHALL WE MOVE NORTH INTO BASHAN? IT IS A POWERFUL COUNTRY WITH A GIANT FOR A KING.

SEND OUT SOME SCOUTS TO EXPLORE THE LAND FIRST, JOSHUA. THEN WE WILL DECIDE.

JOSHUA'S SCOUTS ARE DISCOVERED, AND A MESSENGER HURRIES TO TELL KING OG OF BASHAN.

O KING, I SAW SOME STRANGE MEN SPYING OUT OUR LAND.

THEY MUST BE THE ISRAELITES. THEY'VE JUST CONQUERED THE AMORITES, BUT **WE'LL** TEACH THEM A LESSON...

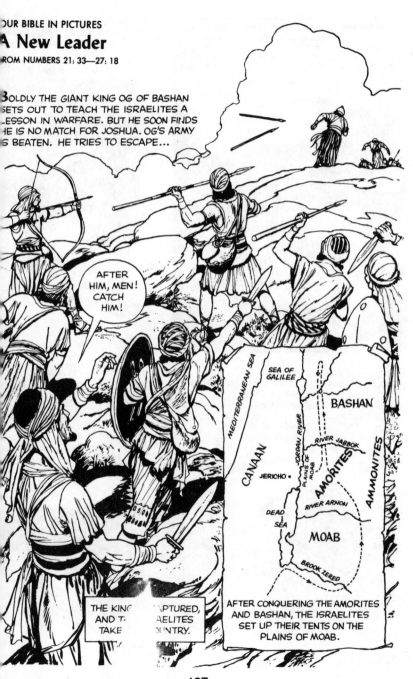

A New Leader

FROM NUMBERS 21: 33—27: 18

BOLDLY THE GIANT KING OG OF BASHAN
SETS OUT TO TEACH THE ISRAELITES A
LESSON IN WARFARE. BUT HE SOON FINDS
HE IS NO MATCH FOR JOSHUA. OG'S ARMY
IS BEATEN. HE TRIES TO ESCAPE...

AFTER HIM, MEN! CATCH HIM!

THE KING ... APTURED, AND T... AELITES TAKE ... UNTRY.

AFTER CONQUERING THE AMORITES
AND BASHAN, THE ISRAELITES
SET UP THEIR TENTS ON THE
PLAINS OF MOAB.

MEDITERRANEAN SEA

SEA OF GALILEE

BASHAN

CANAAN

JORDAN RIVER

RIVER JABBOK

JERICHO •

PLAINS OF MOAB

AMORITES

AMMONITES

DEAD SEA

RIVER ARNON

MOAB

BROOK ZERED

187

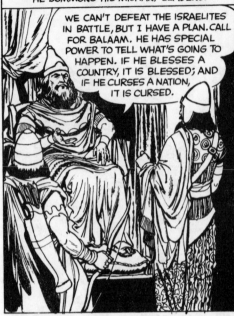

WHEN THE KING OF MOAB LEARNS OF THIS, HE SUMMONS HIS MILITARY LEADERS.

WE CAN'T DEFEAT THE ISRAELITES IN BATTLE, BUT I HAVE A PLAN. CALL FOR BALAAM. HE HAS SPECIAL POWER TO TELL WHAT'S GOING TO HAPPEN. IF HE BLESSES A COUNTRY, IT IS BLESSED; AND IF HE CURSES A NATION, IT IS CURSED.

THE KING OF MOAB CALLS BALAAM. A FIRST HE REFUSES TO COME, BUT LATE CHANGES HIS MIND. ON THE WAY TO MO

GET GOING— YOU LAZY DONKEY!

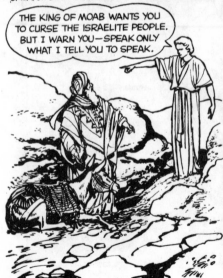

BUT THE DONKEY WON'T MOVE. SUDDENLY, BALAAM SEES AN ANGEL STANDING IN THE PATH.

THE KING OF MOAB WANTS YOU TO CURSE THE ISRAELITE PEOPLE. BUT I WARN YOU—SPEAK ONLY WHAT I TELL YOU TO SPEAK.

WHEN BALAAM GETS TO MOAB, THE KIN TAKES HIM ONTO A HIGH HILL. TOGETHER TH LOOK DOWN ON THE ISRAELITE CAMP.

THOSE ISRAELITES ARE CONQUERING ALL THE LAND AROUND HERE! PUT A CURSE ON THEM, BALAAM, SO I CAN DESTROY THEM.

I WILL ONLY SAY WHAT THE LORD TELLS ME TO SAY. WAIT WHILE I LISTEN FOR HIS INSTRUCTIONS...

188

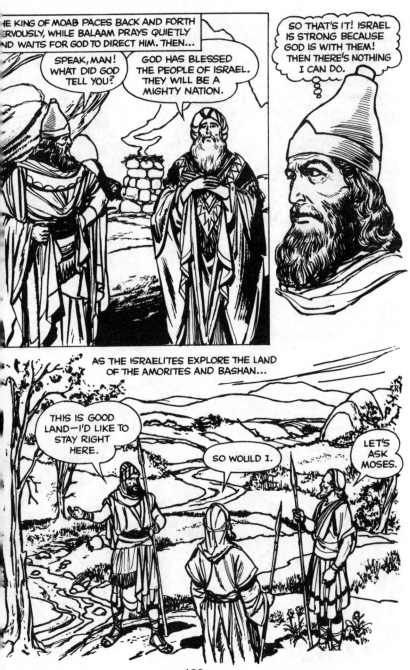

189

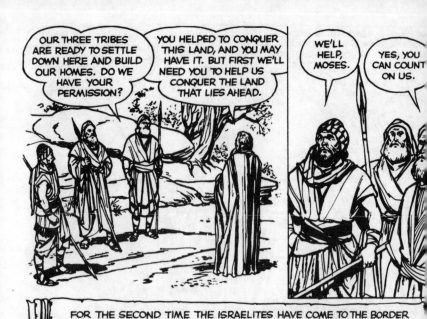

FOR THE SECOND TIME THE ISRAELITES HAVE COME TO THE BORDER OF THE PROMISED LAND. THIS TIME THEY ARE NOT AFRAID. MEN TALK OF THE FLOCKS AND HERDS THEY WILL HAVE...AND WOMEN DREAM OF PEACEFUL HOMES IN THE LAND WHICH GOD HAS PROMISED THEM.

ONE DAY MOSES CALLS JOSHUA TO AN IMPORTANT MEETING...

GOD HAS TOLD ME THAT MY WORK HERE ON EARTH IS ALMOST FINISHED, JOSHUA. A NEW LEADER WILL TAKE OUR PEOPLE INTO THE PROMISED LAND.

A NEW LEADER? OH, NO, MOSES! WHO COULD EVER TAKE YOUR PLACE?

YOU— JOSHUA!

pies in Jericho

OM NUMBERS 27: 19; DEUTERONOMY; JOSHUA 2: 1

JOSHUA IS AMAZED WHEN HE LEARNS THAT HE HAS BEEN CHOSEN TO TAKE MOSES' PLACE AS LEADER OF THE ISRAELITES.

HAVE NO FEAR, JOSHUA. GOD HAS CHOSEN YOU— AND HE WILL HELP YOU AS HE HAS HELPED ME.

I PRAY THAT I MAY BE WORTHY. WILL YOU TELL THE PEOPLE?

YES, I HAVE OTHER THINGS TO TELL THEM, TOO.

THE PEOPLE ARE SAD—AND A LITTLE FRIGHTENED—WHEN THEY LEARN THAT MOSES WILL OT GO WITH THEM INTO THE ROMISED LAND. BUT THEY ATHER EAGERLY TO HEAR VHAT HE HAS TO SAY.

FOR ALMOST FORTY YEARS I HAVE LED YOU—NOW LET ME GIVE YOU ONE LAST MESSAGE: LOVE THE LORD THY GOD WITH ALL THINE HEART.

TEACH YOUR CHILDREN TO KNOW THE LAWS OF GOD. OBEY THESE LAWS. GOD WILL LOVE YOU, AND BLESS YOU.

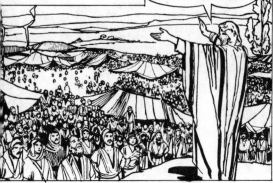

191

THEN, BEFORE ALL THE MULTITUDE OF ISRAEL, JOSHUA KNEELS BEFORE MOSES.

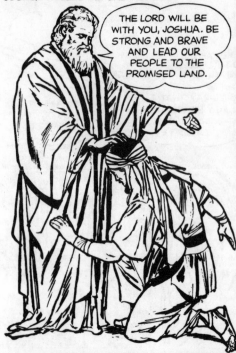

THE LORD WILL BE WITH YOU, JOSHUA. BE STRONG AND BRAVE AND LEAD OUR PEOPLE TO THE PROMISED LAND.

A FEW DAYS LATER MOSES GIVE[S] A LARGE SCROLL TO THE PRIESTS

THIS IS A COPY OF GOD'S LAWS. PUT IT WITH T[HE] HOLY ARK THAT HOLDS THE TABLETS OF STONE ON WHIC[H] THE TEN COMMANDMEN[TS] ARE WRITTEN.

MOSES AGAIN CALLS THE PEOPLE TOGETHER. THEY COME SADLY BECAUSE EVERYONE KNOWS THIS WILL BE HIS FAREWELL... HE CHANTS A SONG HE HAS WRITTEN...THEN HE RAISES HIS HAND IN BENEDICTION...

THE BLESSING OF GOD BE WITH YOU ALWAYS.

SLOWLY...MOSES TURNS AND WALKS AWAY...

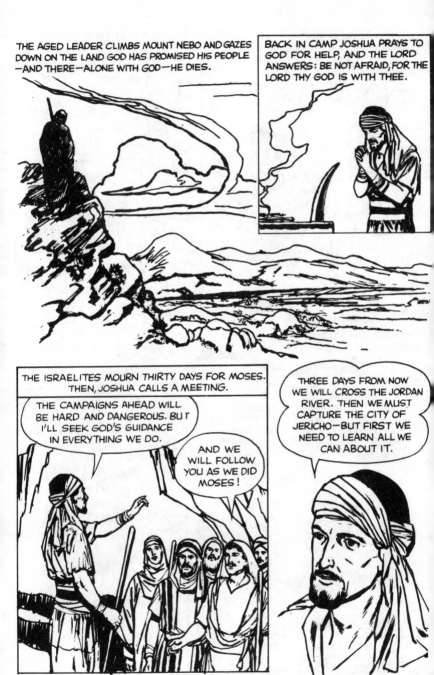

THE AGED LEADER CLIMBS MOUNT NEBO AND GAZES DOWN ON THE LAND GOD HAS PROMISED HIS PEOPLE —AND THERE—ALONE WITH GOD—HE DIES.

BACK IN CAMP JOSHUA PRAYS TO GOD FOR HELP, AND THE LORD ANSWERS: BE NOT AFRAID, FOR THE LORD THY GOD IS WITH THEE.

THE ISRAELITES MOURN THIRTY DAYS FOR MOSES. THEN, JOSHUA CALLS A MEETING.

THE CAMPAIGNS AHEAD WILL BE HARD AND DANGEROUS. BUT I'LL SEEK GOD'S GUIDANCE IN EVERYTHING WE DO.

AND WE WILL FOLLOW YOU AS WE DID MOSES!

THREE DAYS FROM NOW WE WILL CROSS THE JORDAN RIVER. THEN WE MUST CAPTURE THE CITY OF JERICHO—BUT FIRST WE NEED TO LEARN ALL WE CAN ABOUT IT.

193

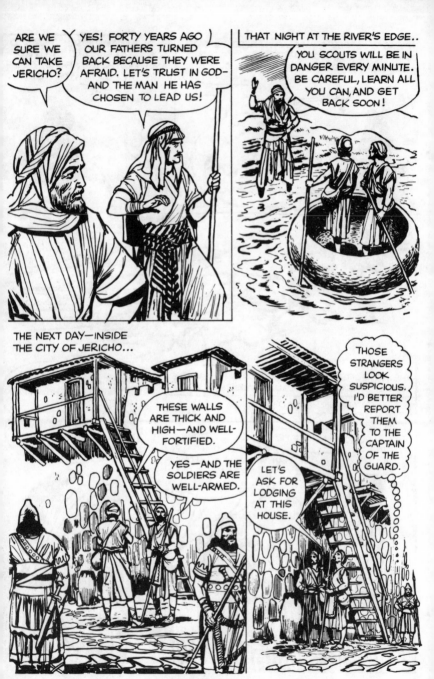

194

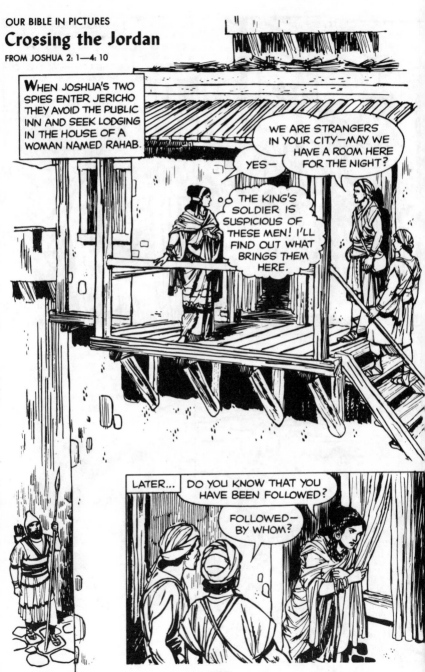

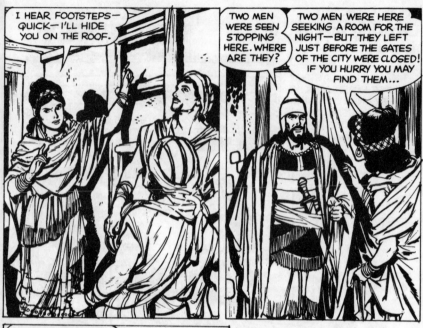

THE SPIES PROMISE SAFETY TO
RAHAB AND HER FAMILY.

196

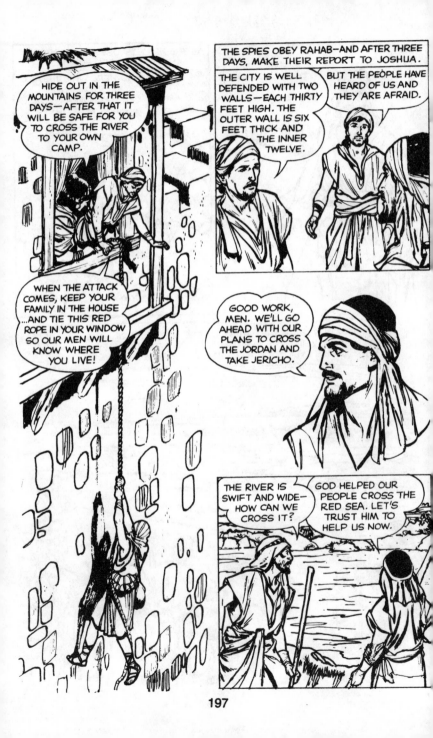

HIDE OUT IN THE MOUNTAINS FOR THREE DAYS—AFTER THAT IT WILL BE SAFE FOR YOU TO CROSS THE RIVER TO YOUR OWN CAMP.

WHEN THE ATTACK COMES, KEEP YOUR FAMILY IN THE HOUSE ...AND TIE THIS RED ROPE IN YOUR WINDOW SO OUR MEN WILL KNOW WHERE YOU LIVE!

THE SPIES OBEY RAHAB—AND AFTER THREE DAYS, MAKE THEIR REPORT TO JOSHUA.

THE CITY IS WELL DEFENDED WITH TWO WALLS—EACH THIRTY FEET HIGH. THE OUTER WALL IS SIX FEET THICK AND THE INNER TWELVE.

BUT THE PEOPLE HAVE HEARD OF US AND THEY ARE AFRAID.

GOOD WORK, MEN. WE'LL GO AHEAD WITH OUR PLANS TO CROSS THE JORDAN AND TAKE JERICHO.

THE RIVER IS SWIFT AND WIDE— HOW CAN WE CROSS IT?

GOD HELPED OUR PEOPLE CROSS THE RED SEA. LET'S TRUST HIM TO HELP US NOW.

197

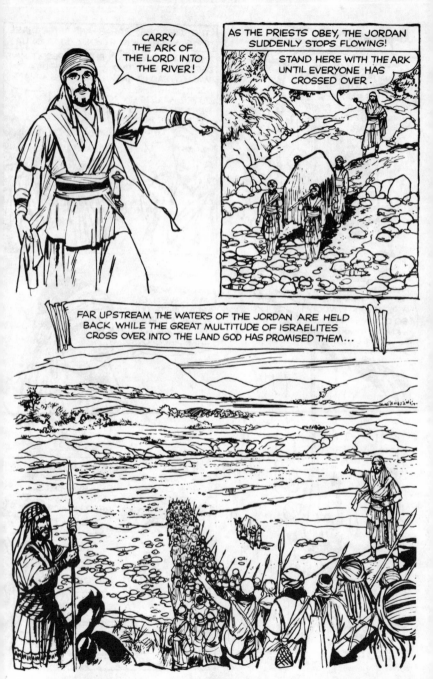

Siege of Jericho

FROM JOSHUA 4: 1—6: 20

AS IF HELD BACK BY A GIANT HAND, THE WATERS OF THE JORDAN STOP FLOWING WHILE THE ISRAELITES CROSS OVER INTO THE PROMISED LAND. WHEN ALL HAVE CROSSED, JOSHUA ORDERS A MAN FROM EACH OF THE TRIBES TO BRING A LARGE STONE FROM THE RIVER BED.

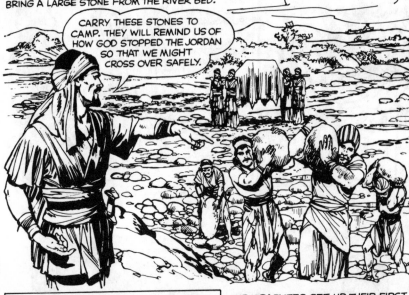

CARRY THESE STONES TO CAMP. THEY WILL REMIND US OF HOW GOD STOPPED THE JORDAN SO THAT WE MIGHT CROSS OVER SAFELY.

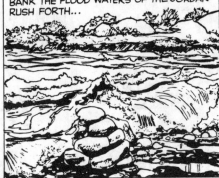

THEN JOSHUA SETS UP 12 OTHER STONES IN THE MIDDLE OF THE JORDAN—AT THE PLACE WHERE THE PRIESTS HOLD THE ARK. AFTER THAT HE COMMANDS THE PRIESTS TO CARRY THE ARK ACROSS. WHEN THEY REACH THE BANK THE FLOOD WATERS OF THE JORDAN RUSH FORTH...

THE ISRAELITES SET UP THEIR FIRST CAMP AT GILGAL—AND HERE THEY CELEBRATE THEIR FIRST PASSOVER FEAST IN THE PROMISED LAND.

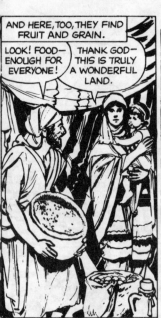

AND HERE, TOO, THEY FIND FRUIT AND GRAIN.

LOOK! FOOD—ENOUGH FOR EVERYONE!

THANK GOD—THIS IS TRULY A WONDERFUL LAND.

NOW THAT THE PEOPLE CAN FIND FOOD FOR THEMSELVES, GOD NO LONGER SENDS THE MANNA WHICH HE HAS FURNISHED THEM SINCE THEY LEFT EGYPT FORTY YEARS AGO.

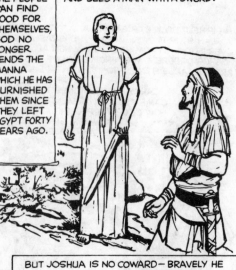

WHILE THE REST OF THE CAMP IS ENJOYING THE NEW LAND, JOSHUA SCOUTS THE AREA IN PREPARATION FOR THE ATTACK ON JERICHO. SUDDENLY HE LOOKS UP AND SEES A MAN WITH A SWORD!

IS HE GOING TO TRY TO KILL ME?

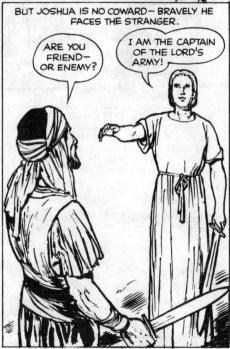

BUT JOSHUA IS NO COWARD—BRAVELY HE FACES THE STRANGER.

ARE YOU FRIEND—OR ENEMY?

I AM THE CAPTAIN OF THE LORD'S ARMY!

200

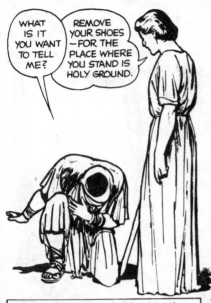

WHAT IS IT YOU WANT TO TELL ME?

REMOVE YOUR SHOES — FOR THE PLACE WHERE YOU STAND IS HOLY GROUND.

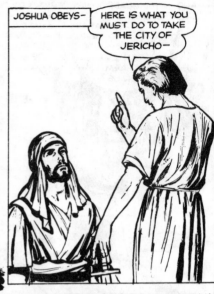

JOSHUA OBEYS —

HERE IS WHAT YOU MUST DO TO TAKE THE CITY OF JERICHO —

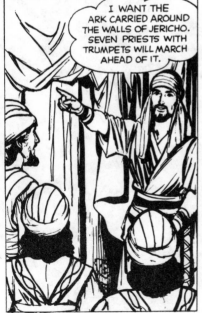

WHEN THE ANGEL LEAVES, JOSHUA RETURNS TO CAMP AND CALLS THE PRIESTS TOGETHER.

I WANT THE ARK CARRIED AROUND THE WALLS OF JERICHO. SEVEN PRIESTS WITH TRUMPETS WILL MARCH AHEAD OF IT.

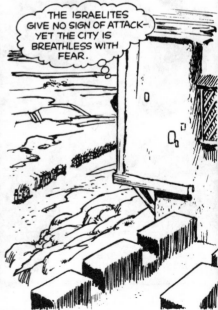

ONCE A DAY FOR SIX DAYS STRAIGHT JOSHUA MARCHES THE ISRAELITES AROUND THE CITY OF JERICHO. FROM HER HOUSE ON THE WALL RAHAB WATCHES ANXIOUSLY...

THE ISRAELITES GIVE NO SIGN OF ATTACK — YET THE CITY IS BREATHLESS WITH FEAR.

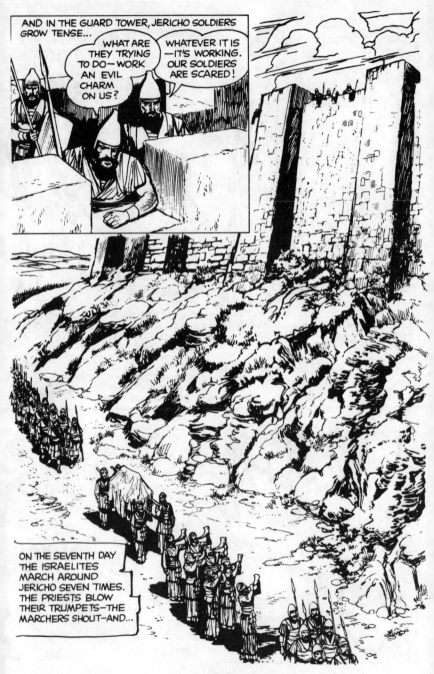

202

Attack that Failed

FROM JOSHUA 6: 20—7: 4

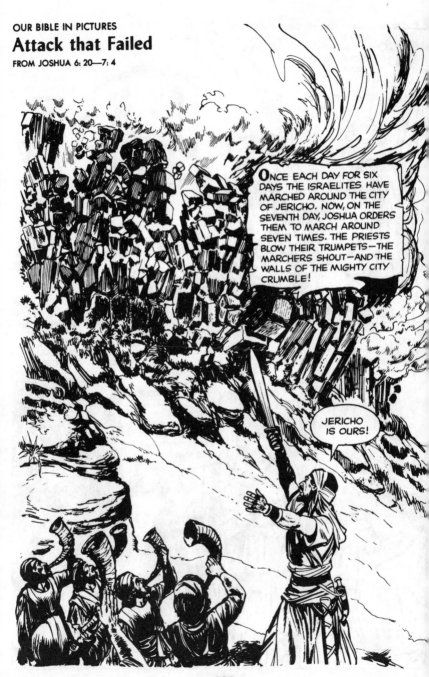

ONCE EACH DAY FOR SIX DAYS THE ISRAELITES HAVE MARCHED AROUND THE CITY OF JERICHO. NOW, ON THE SEVENTH DAY, JOSHUA ORDERS THEM TO MARCH AROUND SEVEN TIMES. THE PRIESTS BLOW THEIR TRUMPETS—THE MARCHERS SHOUT—AND THE WALLS OF THE MIGHTY CITY CRUMBLE!

JERICHO IS OURS!

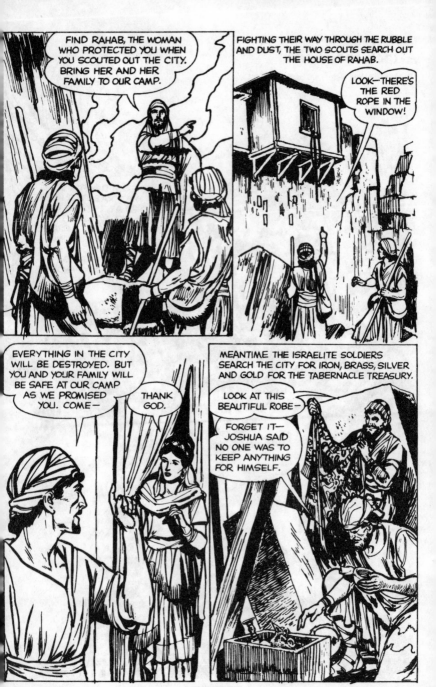

204

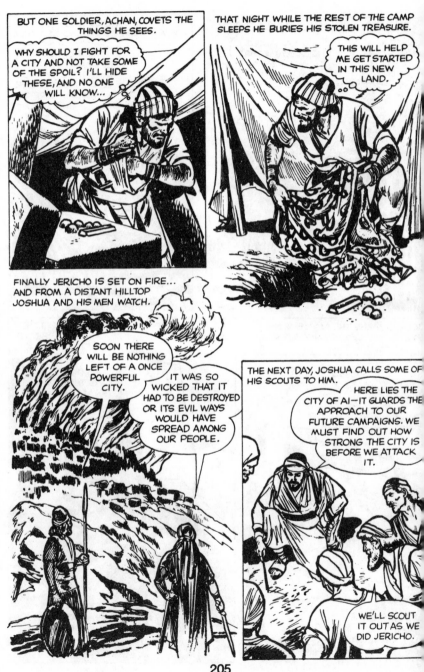

205

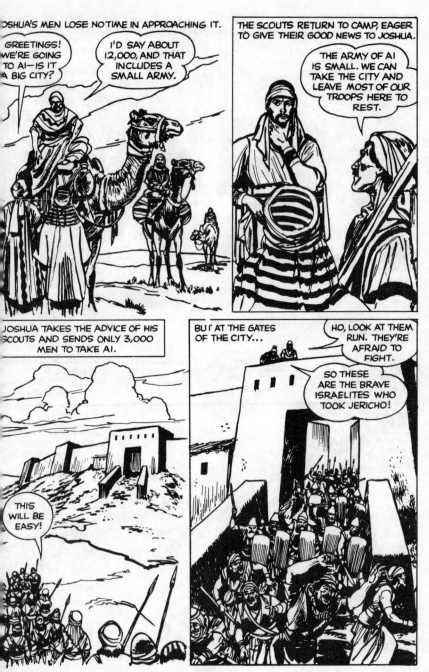

206

Tricked

FROM JOSHUA 7: 5—9: 16

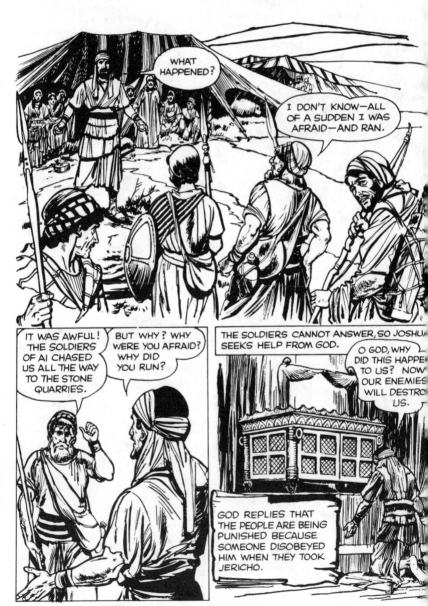

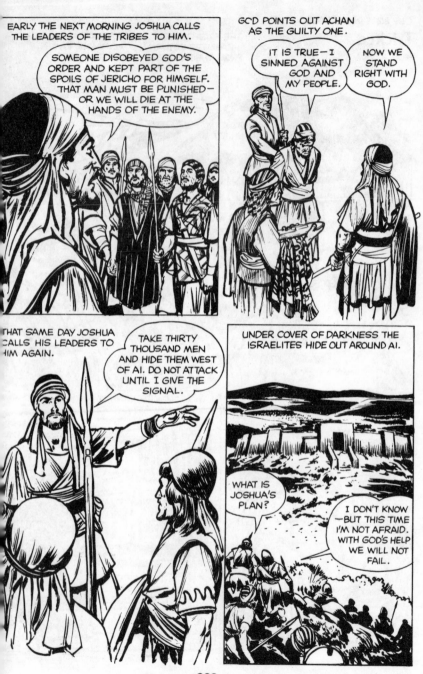

EARLY THE NEXT MORNING JOSHUA CALLS THE LEADERS OF THE TRIBES TO HIM.

SOMEONE DISOBEYED GOD'S ORDER AND KEPT PART OF THE SPOILS OF JERICHO FOR HIMSELF. THAT MAN MUST BE PUNISHED— OR WE WILL DIE AT THE HANDS OF THE ENEMY.

GOD POINTS OUT ACHAN AS THE GUILTY ONE.

IT IS TRUE—I SINNED AGAINST GOD AND MY PEOPLE.

NOW WE STAND RIGHT WITH GOD.

THAT SAME DAY JOSHUA CALLS HIS LEADERS TO HIM AGAIN.

TAKE THIRTY THOUSAND MEN AND HIDE THEM WEST OF AI. DO NOT ATTACK UNTIL I GIVE THE SIGNAL.

UNDER COVER OF DARKNESS THE ISRAELITES HIDE OUT AROUND AI.

WHAT IS JOSHUA'S PLAN?

I DON'T KNOW —BUT THIS TIME I'M NOT AFRAID. WITH GOD'S HELP WE WILL NOT FAIL.

208

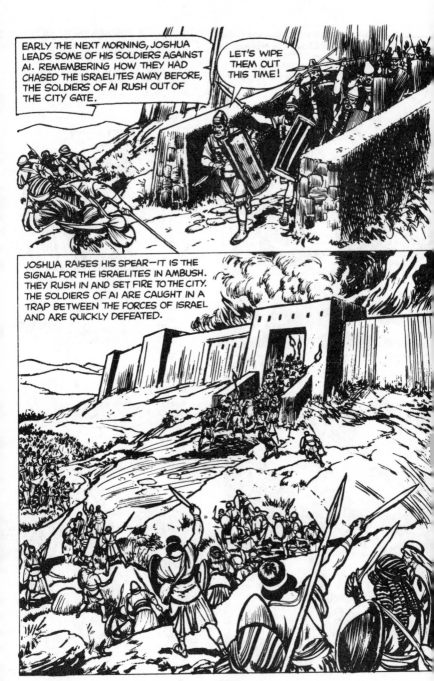

EARLY THE NEXT MORNING, JOSHUA LEADS SOME OF HIS SOLDIERS AGAINST AI. REMEMBERING HOW THEY HAD CHASED THE ISRAELITES AWAY BEFORE, THE SOLDIERS OF AI RUSH OUT OF THE CITY GATE.

LET'S WIPE THEM OUT THIS TIME!

JOSHUA RAISES HIS SPEAR—IT IS THE SIGNAL FOR THE ISRAELITES IN AMBUSH. THEY RUSH IN AND SET FIRE TO THE CITY. THE SOLDIERS OF AI ARE CAUGHT IN A TRAP BETWEEN THE FORCES OF ISRAEL AND ARE QUICKLY DEFEATED.

209

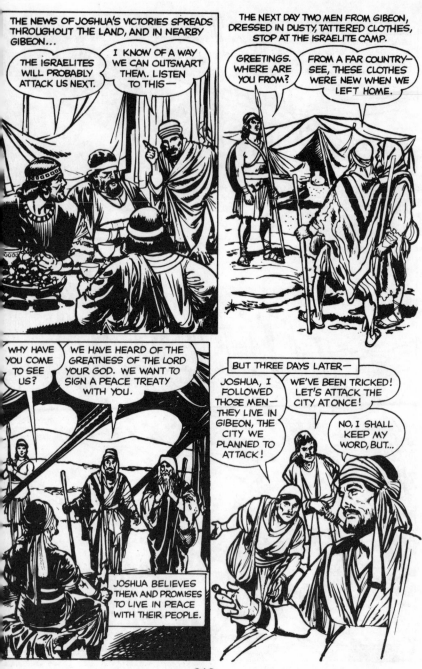

THE NEWS OF JOSHUA'S VICTORIES SPREADS THROUGHOUT THE LAND, AND IN NEARBY GIBEON...

THE ISRAELITES WILL PROBABLY ATTACK US NEXT.

I KNOW OF A WAY WE CAN OUTSMART THEM. LISTEN TO THIS—

THE NEXT DAY TWO MEN FROM GIBEON, DRESSED IN DUSTY, TATTERED CLOTHES, STOP AT THE ISRAELITE CAMP.

GREETINGS. WHERE ARE YOU FROM?

FROM A FAR COUNTRY— SEE, THESE CLOTHES WERE NEW WHEN WE LEFT HOME.

WHY HAVE YOU COME TO SEE US?

WE HAVE HEARD OF THE GREATNESS OF THE LORD YOUR GOD. WE WANT TO SIGN A PEACE TREATY WITH YOU.

JOSHUA BELIEVES THEM AND PROMISES TO LIVE IN PEACE WITH THEIR PEOPLE.

BUT THREE DAYS LATER—

JOSHUA, I FOLLOWED THOSE MEN— THEY LIVE IN GIBEON, THE CITY WE PLANNED TO ATTACK!

WE'VE BEEN TRICKED! LET'S ATTACK THE CITY AT ONCE!

NO, I SHALL KEEP MY WORD, BUT...

210

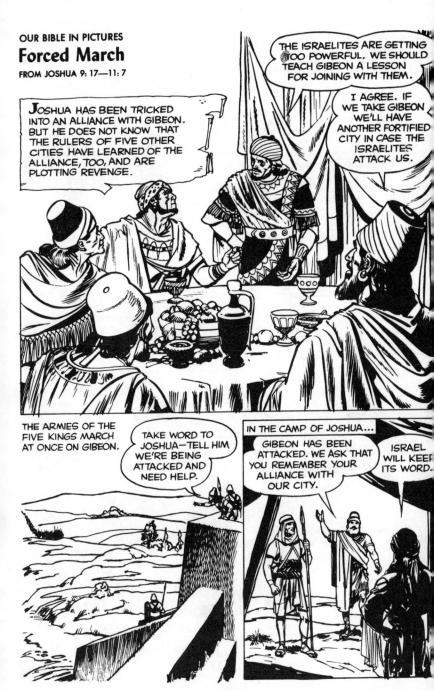

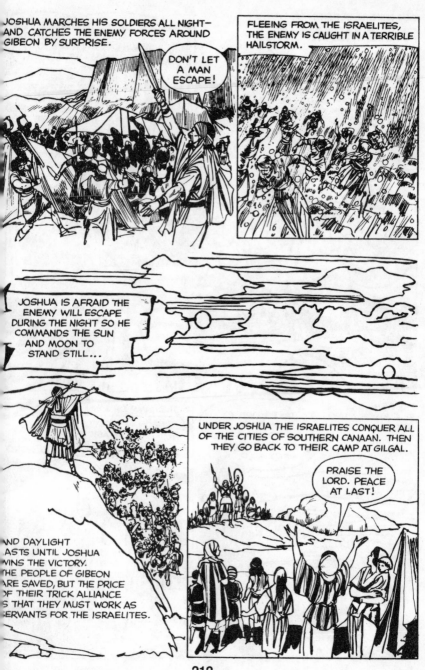

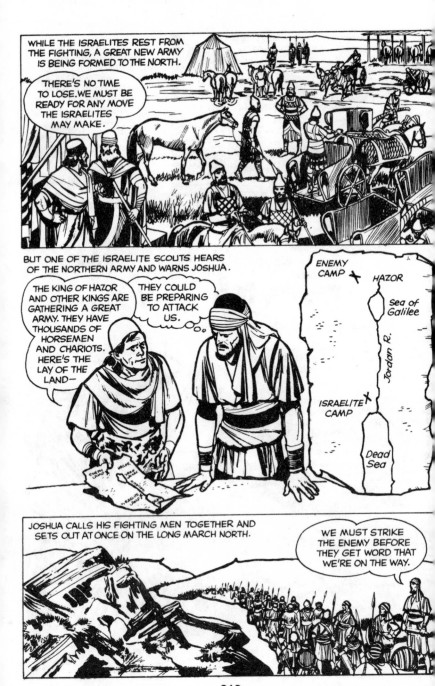

WHILE THE ISRAELITES REST FROM THE FIGHTING, A GREAT NEW ARMY IS BEING FORMED TO THE NORTH.

THERE'S NO TIME TO LOSE. WE MUST BE READY FOR ANY MOVE THE ISRAELITES MAY MAKE.

BUT ONE OF THE ISRAELITE SCOUTS HEARS OF THE NORTHERN ARMY AND WARNS JOSHUA.

THE KING OF HAZOR AND OTHER KINGS ARE GATHERING A GREAT ARMY. THEY HAVE THOUSANDS OF HORSEMEN AND CHARIOTS. HERE'S THE LAY OF THE LAND—

THEY COULD BE PREPARING TO ATTACK US.

ENEMY CAMP

HAZOR

Sea of Galilee

Jordan R.

ISRAELITE CAMP

Dead Sea

JOSHUA CALLS HIS FIGHTING MEN TOGETHER AND SETS OUT AT ONCE ON THE LONG MARCH NORTH.

WE MUST STRIKE THE ENEMY BEFORE THEY GET WORD THAT WE'RE ON THE WAY.

213

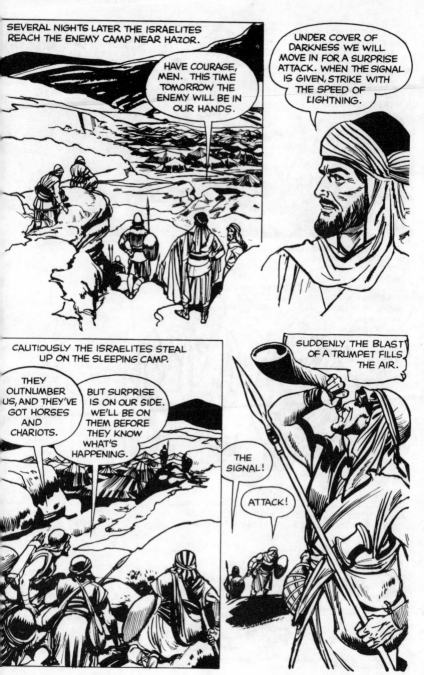

SEVERAL NIGHTS LATER THE ISRAELITES REACH THE ENEMY CAMP NEAR HAZOR.

HAVE COURAGE, MEN. THIS TIME TOMORROW THE ENEMY WILL BE IN OUR HANDS.

UNDER COVER OF DARKNESS WE WILL MOVE IN FOR A SURPRISE ATTACK. WHEN THE SIGNAL IS GIVEN, STRIKE WITH THE SPEED OF LIGHTNING.

CAUTIOUSLY THE ISRAELITES STEAL UP ON THE SLEEPING CAMP.

THEY OUTNUMBER US, AND THEY'VE GOT HORSES AND CHARIOTS.

BUT SURPRISE IS ON OUR SIDE. WE'LL BE ON THEM BEFORE THEY KNOW WHAT'S HAPPENING.

SUDDENLY THE BLAST OF A TRUMPET FILLS THE AIR.

THE SIGNAL!

ATTACK!

214

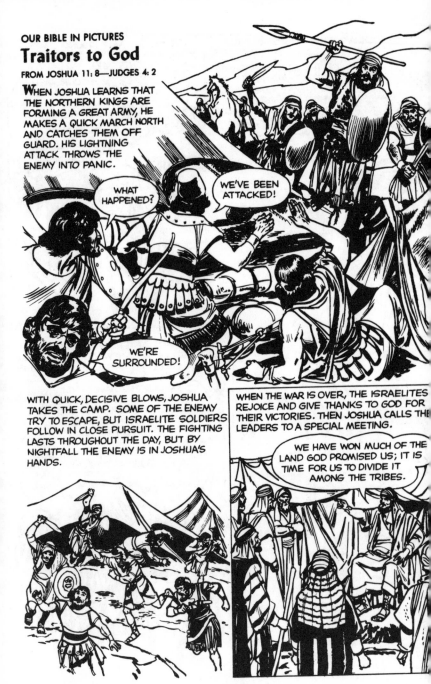

OUR BIBLE IN PICTURES

Traitors to God

FROM JOSHUA 11: 8—JUDGES 4: 2

WHEN JOSHUA LEARNS THAT THE NORTHERN KINGS ARE FORMING A GREAT ARMY, HE MAKES A QUICK MARCH NORTH AND CATCHES THEM OFF GUARD. HIS LIGHTNING ATTACK THROWS THE ENEMY INTO PANIC.

WHAT HAPPENED?

WE'VE BEEN ATTACKED!

WE'RE SURROUNDED!

WITH QUICK, DECISIVE BLOWS, JOSHUA TAKES THE CAMP. SOME OF THE ENEMY TRY TO ESCAPE, BUT ISRAELITE SOLDIERS FOLLOW IN CLOSE PURSUIT. THE FIGHTING LASTS THROUGHOUT THE DAY, BUT BY NIGHTFALL THE ENEMY IS IN JOSHUA'S HANDS.

WHEN THE WAR IS OVER, THE ISRAELITES REJOICE AND GIVE THANKS TO GOD FOR THEIR VICTORIES. THEN JOSHUA CALLS THE LEADERS TO A SPECIAL MEETING.

WE HAVE WON MUCH OF THE LAND GOD PROMISED US; IT IS TIME FOR US TO DIVIDE IT AMONG THE TRIBES.

215

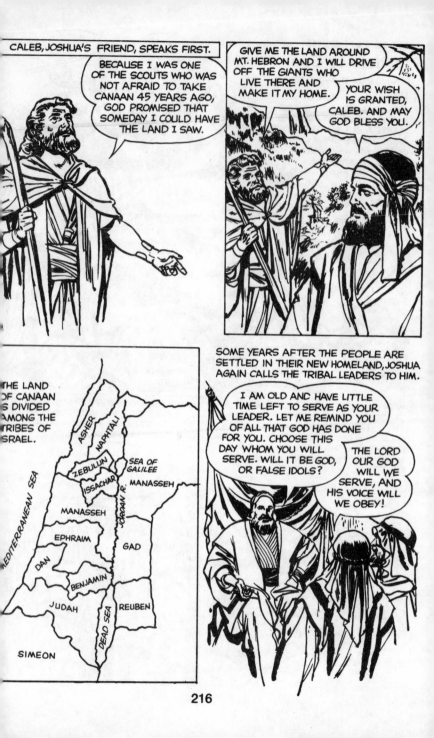

CALEB, JOSHUA'S FRIEND, SPEAKS FIRST.

BECAUSE I WAS ONE OF THE SCOUTS WHO WAS NOT AFRAID TO TAKE CANAAN 45 YEARS AGO, GOD PROMISED THAT SOMEDAY I COULD HAVE THE LAND I SAW.

GIVE ME THE LAND AROUND MT. HEBRON AND I WILL DRIVE OFF THE GIANTS WHO LIVE THERE AND MAKE IT MY HOME.

YOUR WISH IS GRANTED, CALEB. AND MAY GOD BLESS YOU.

THE LAND OF CANAAN IS DIVIDED AMONG THE TRIBES OF ISRAEL.

MEDITERRANEAN SEA

ASHER

NAPHTALI

ZEBULUN

ISSACHAR

SEA OF GALILEE

JORDAN R.

MANASSEH

MANASSEH

EPHRAIM

GAD

DAN

BENJAMIN

JUDAH

DEAD SEA

REUBEN

SIMEON

SOME YEARS AFTER THE PEOPLE ARE SETTLED IN THEIR NEW HOMELAND, JOSHUA AGAIN CALLS THE TRIBAL LEADERS TO HIM.

I AM OLD AND HAVE LITTLE TIME LEFT TO SERVE AS YOUR LEADER. LET ME REMIND YOU OF ALL THAT GOD HAS DONE FOR YOU. CHOOSE THIS DAY WHOM YOU WILL SERVE. WILL IT BE GOD, OR FALSE IDOLS?

THE LORD OUR GOD WILL WE SERVE, AND HIS VOICE WILL WE OBEY!

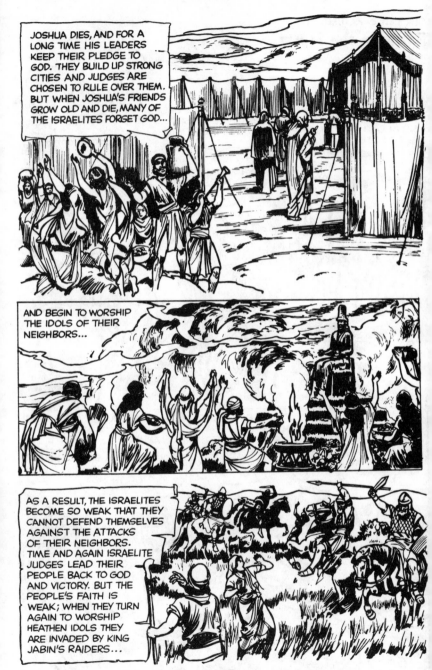

JOSHUA DIES, AND FOR A LONG TIME HIS LEADERS KEEP THEIR PLEDGE TO GOD. THEY BUILD UP STRONG CITIES AND JUDGES ARE CHOSEN TO RULE OVER THEM. BUT WHEN JOSHUA'S FRIENDS GROW OLD AND DIE, MANY OF THE ISRAELITES FORGET GOD...

AND BEGIN TO WORSHIP THE IDOLS OF THEIR NEIGHBORS...

AS A RESULT, THE ISRAELITES BECOME SO WEAK THAT THEY CANNOT DEFEND THEMSELVES AGAINST THE ATTACKS OF THEIR NEIGHBORS. TIME AND AGAIN ISRAELITE JUDGES LEAD THEIR PEOPLE BACK TO GOD AND VICTORY. BUT THE PEOPLE'S FAITH IS WEAK; WHEN THEY TURN AGAIN TO WORSHIP HEATHEN IDOLS THEY ARE INVADED BY KING JABIN'S RAIDERS...

217

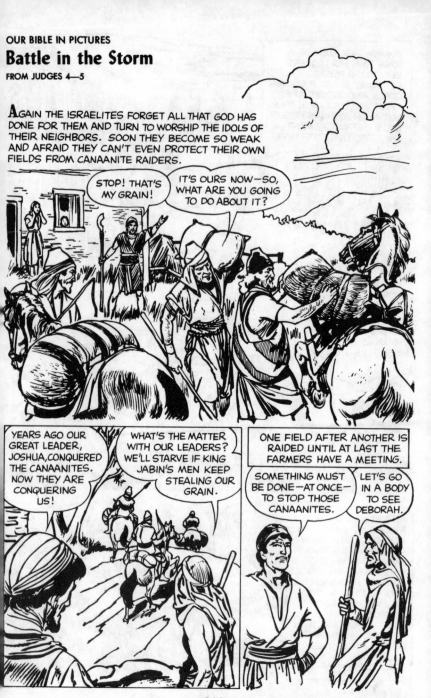

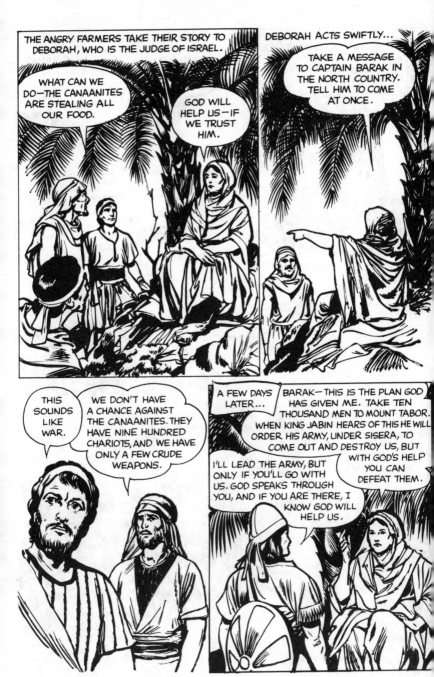

219

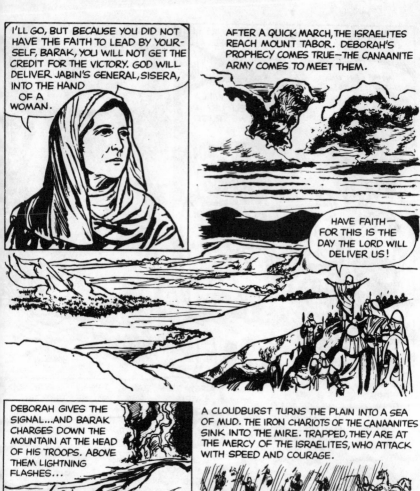

I'LL GO, BUT BECAUSE YOU DID NOT HAVE THE FAITH TO LEAD BY YOURSELF, BARAK, YOU WILL NOT GET THE CREDIT FOR THE VICTORY. GOD WILL DELIVER JABIN'S GENERAL, SISERA, INTO THE HAND OF A WOMAN.

AFTER A QUICK MARCH, THE ISRAELITES REACH MOUNT TABOR. DEBORAH'S PROPHECY COMES TRUE—THE CANAANITE ARMY COMES TO MEET THEM.

HAVE FAITH—FOR THIS IS THE DAY THE LORD WILL DELIVER US!

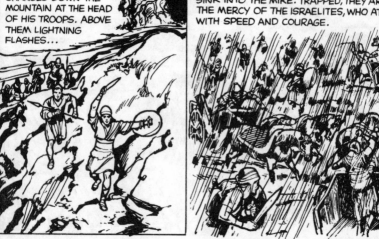

DEBORAH GIVES THE SIGNAL...AND BARAK CHARGES DOWN THE MOUNTAIN AT THE HEAD OF HIS TROOPS. ABOVE THEM LIGHTNING FLASHES...

A CLOUDBURST TURNS THE PLAIN INTO A SEA OF MUD. THE IRON CHARIOTS OF THE CANAANITES SINK INTO THE MIRE. TRAPPED, THEY ARE AT THE MERCY OF THE ISRAELITES, WHO ATTACK WITH SPEED AND COURAGE.

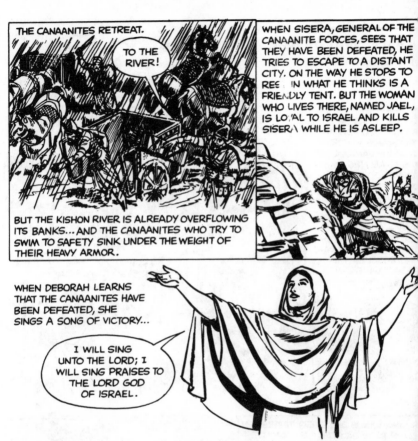

THE CANAANITES RETREAT.

TO THE RIVER!

WHEN SISERA, GENERAL OF THE CANAANITE FORCES, SEES THAT THEY HAVE BEEN DEFEATED, HE TRIES TO ESCAPE TO A DISTANT CITY. ON THE WAY HE STOPS TO RES IN WHAT HE THINKS IS A FRIENDLY TENT. BUT THE WOMAN WHO LIVES THERE, NAMED JAEL, IS LOYAL TO ISRAEL AND KILLS SISERA WHILE HE IS ASLEEP.

BUT THE KISHON RIVER IS ALREADY OVERFLOWING ITS BANKS... AND THE CANAANITES WHO TRY TO SWIM TO SAFETY SINK UNDER THE WEIGHT OF THEIR HEAVY ARMOR.

WHEN DEBORAH LEARNS THAT THE CANAANITES HAVE BEEN DEFEATED, SHE SINGS A SONG OF VICTORY...

I WILL SING UNTO THE LORD; I WILL SING PRAISES TO THE LORD GOD OF ISRAEL.

THE PEOPLE REJOICE AND SING THEIR PRAISES, TOO. AND FOR FORTY YEARS THERE IS PEACE IN ISRAEL. FAMILIES WORK IN THEIR FIELDS AND HARVEST THEIR CROPS. BUT IN TIME THEY AGAIN FORGET GOD, AND FIND THEMSELVES IN MORE TROUBLE THAN EVER BEFORE.

221

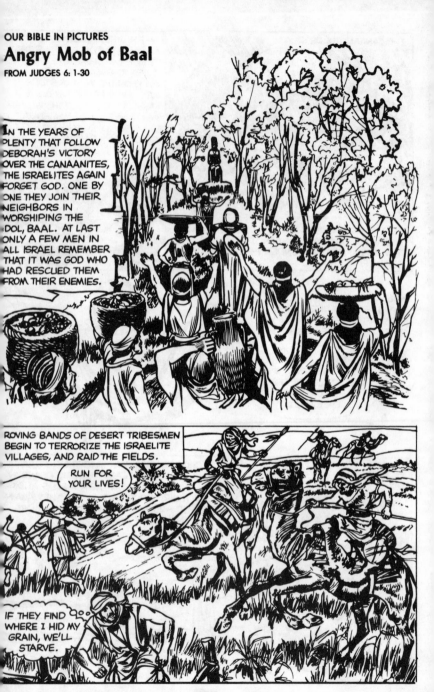

OUR BIBLE IN PICTURES
Angry Mob of Baal
FROM JUDGES 6: 1-30

IN THE YEARS OF PLENTY THAT FOLLOW DEBORAH'S VICTORY OVER THE CANAANITES, THE ISRAELITES AGAIN FORGET GOD. ONE BY ONE THEY JOIN THEIR NEIGHBORS IN WORSHIPING THE IDOL, BAAL. AT LAST ONLY A FEW MEN IN ALL ISRAEL REMEMBER THAT IT WAS GOD WHO HAD RESCUED THEM FROM THEIR ENEMIES.

ROVING BANDS OF DESERT TRIBESMEN BEGIN TO TERRORIZE THE ISRAELITE VILLAGES, AND RAID THE FIELDS.

RUN FOR YOUR LIVES!

IF THEY FIND WHERE I HID MY GRAIN, WE'LL STARVE.

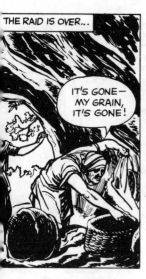

THE RAID IS OVER...

IT'S GONE— MY GRAIN, IT'S GONE!

FOR SEVEN LONG YEARS THE ISRAELITES SUFFER AT THE HANDS OF THE DESERT TRIBESMEN. THEY HIDE OUT IN CAVES, THRESH THEIR GRAIN IN SECRET PLACES...BUT ALWAYS THE RAIDERS RETURN.

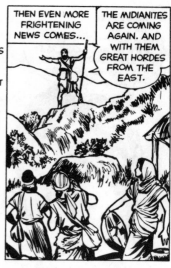

THEN EVEN MORE FRIGHTENING NEWS COMES...

THE MIDIANITES ARE COMING AGAIN. AND WITH THEM GREAT HORDES FROM THE EAST.

LIKE GRASSHOPPERS THE ENEMY SWARMS OVER THE ISRAELITE FIELDS...STEALING GRAIN, CATTLE, AND SHEEP.

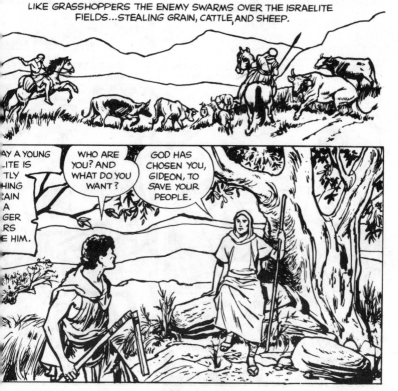

...AY A YOUNG ...LITE IS ...TLY ...HING ...RAIN ...A ...GER ...RS ...E HIM.

WHO ARE YOU? AND WHAT DO YOU WANT?

GOD HAS CHOSEN YOU, GIDEON, TO SAVE YOUR PEOPLE.

223

ME? I'M ONLY A POOR FARMER—HOW CAN I SAVE ISRAEL? GIVE ME A SIGN THAT YOU ARE THE ANGEL OF GOD.

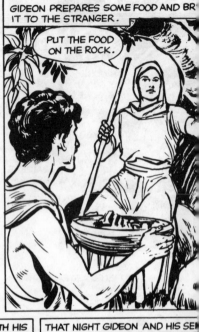

GIDEON PREPARES SOME FOOD AND BR[INGS] IT TO THE STRANGER.

PUT THE FOOD ON THE ROCK.

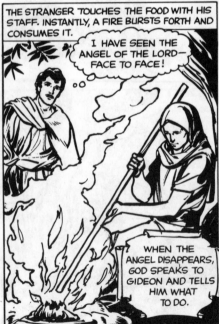

THE STRANGER TOUCHES THE FOOD WITH HIS STAFF. INSTANTLY, A FIRE BURSTS FORTH AND CONSUMES IT.

I HAVE SEEN THE ANGEL OF THE LORD— FACE TO FACE!

WHEN THE ANGEL DISAPPEARS, GOD SPEAKS TO GIDEON AND TELLS HIM WHAT TO DO.

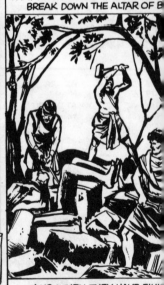

THAT NIGHT GIDEON AND HIS SE[RVANTS] BREAK DOWN THE ALTAR OF B[AAL]

AND WHEN THEY HAVE FINIS[HED] HE BUILDS AN ALTAR TO GO[D]

224

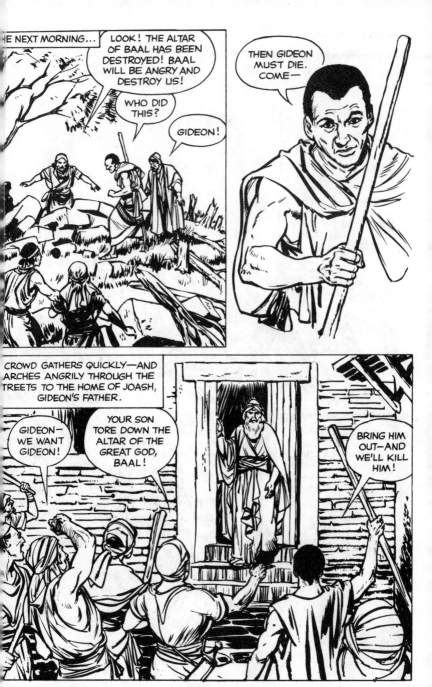

225

Courageous Three Hundred

FROM JUDGES 6: 31—7: 20

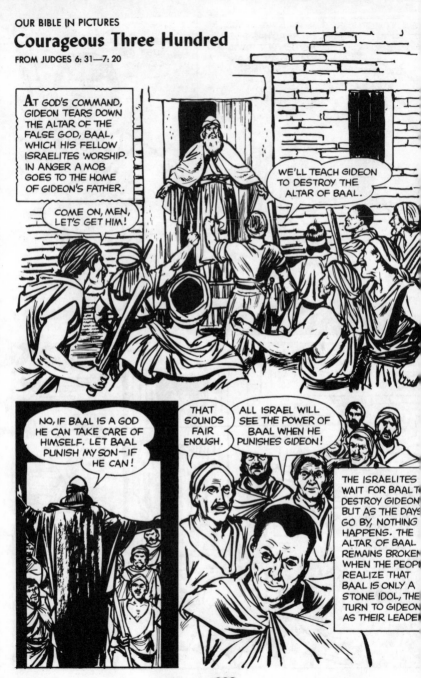

AT GOD'S COMMAND, GIDEON TEARS DOWN THE ALTAR OF THE FALSE GOD, BAAL, WHICH HIS FELLOW ISRAELITES WORSHIP. IN ANGER A MOB GOES TO THE HOME OF GIDEON'S FATHER.

COME ON, MEN, LET'S GET HIM!

WE'LL TEACH GIDEON TO DESTROY THE ALTAR OF BAAL.

NO, IF BAAL IS A GOD HE CAN TAKE CARE OF HIMSELF. LET BAAL PUNISH MY SON—IF HE CAN!

THAT SOUNDS FAIR ENOUGH.

ALL ISRAEL WILL SEE THE POWER OF BAAL WHEN HE PUNISHES GIDEON!

THE ISRAELITES WAIT FOR BAAL TO DESTROY GIDEON, BUT AS THE DAYS GO BY, NOTHING HAPPENS. THE ALTAR OF BAAL REMAINS BROKEN. WHEN THE PEOPLE REALIZE THAT BAAL IS ONLY A STONE IDOL, THEY TURN TO GIDEON AS THEIR LEADER.

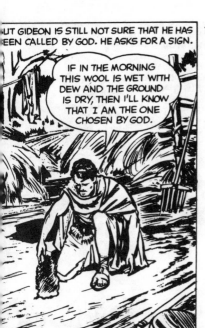

BUT GIDEON IS STILL NOT SURE THAT HE HAS BEEN CALLED BY GOD. HE ASKS FOR A SIGN.

IF IN THE MORNING THIS WOOL IS WET WITH DEW AND THE GROUND IS DRY, THEN I'LL KNOW THAT I AM THE ONE CHOSEN BY GOD.

THE NEXT MORNING GIDEON HAS HIS SIGN...

THE GROUND IS DRY— BUT THERE'S ENOUGH DEW ON THIS WOOL TO FILL A WHOLE BOWL.

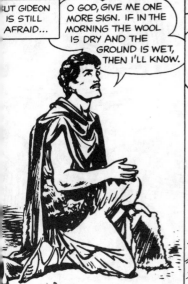

BUT GIDEON IS STILL AFRAID...

O GOD, GIVE ME ONE MORE SIGN. IF IN THE MORNING THE WOOL IS DRY AND THE GROUND IS WET, THEN I'LL KNOW.

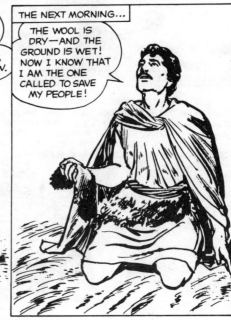

THE NEXT MORNING...

THE WOOL IS DRY—AND THE GROUND IS WET! NOW I KNOW THAT I AM THE ONE CALLED TO SAVE MY PEOPLE!

227

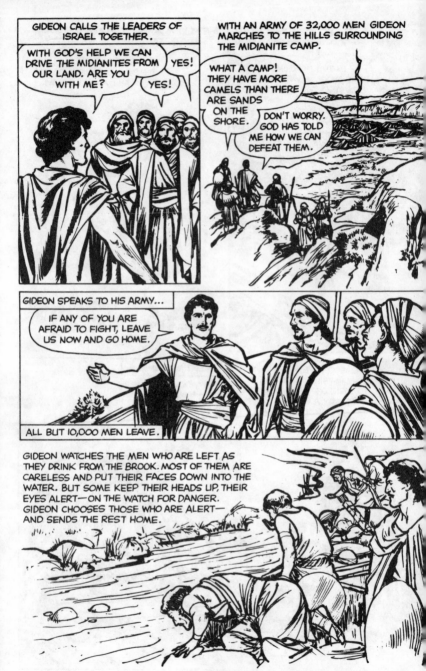

GIDEON CALLS THE LEADERS OF ISRAEL TOGETHER.

WITH GOD'S HELP WE CAN DRIVE THE MIDIANITES FROM OUR LAND. ARE YOU WITH ME?

YES!

YES!

WITH AN ARMY OF 32,000 MEN GIDEON MARCHES TO THE HILLS SURROUNDING THE MIDIANITE CAMP.

WHAT A CAMP! THEY HAVE MORE CAMELS THAN THERE ARE SANDS ON THE SHORE.

DON'T WORRY. GOD HAS TOLD ME HOW WE CAN DEFEAT THEM.

GIDEON SPEAKS TO HIS ARMY...

IF ANY OF YOU ARE AFRAID TO FIGHT, LEAVE US NOW AND GO HOME.

ALL BUT 10,000 MEN LEAVE.

GIDEON WATCHES THE MEN WHO ARE LEFT AS THEY DRINK FROM THE BROOK. MOST OF THEM ARE CARELESS AND PUT THEIR FACES DOWN INTO THE WATER. BUT SOME KEEP THEIR HEADS UP, THEIR EYES ALERT—ON THE WATCH FOR DANGER. GIDEON CHOOSES THOSE WHO ARE ALERT— AND SENDS THE REST HOME.

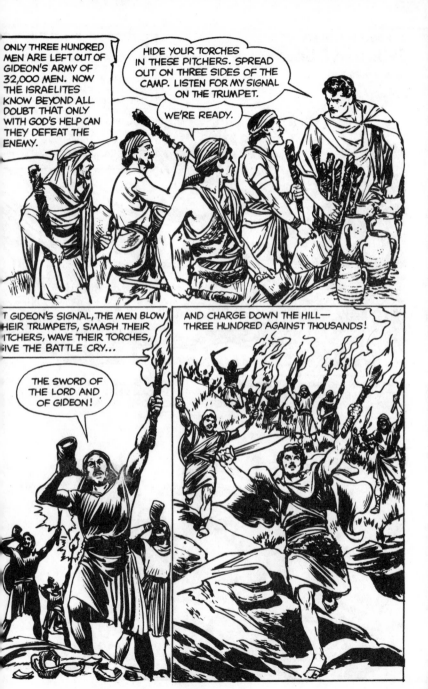

229

Philistine Raiders

FROM JUDGES 7: 22—13: 1

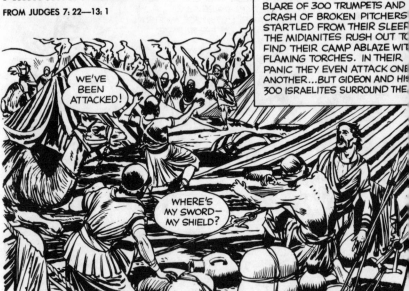

WE'VE BEEN ATTACKED!

WHERE'S MY SWORD— MY SHIELD?

THE STILLNESS OF THE NIGHT IS SUDDENLY BROKEN BY THE BLARE OF 300 TRUMPETS AND CRASH OF BROKEN PITCHERS STARTLED FROM THEIR SLEEP THE MIDIANITES RUSH OUT TO FIND THEIR CAMP ABLAZE WITH FLAMING TORCHES. IN THEIR PANIC THEY EVEN ATTACK ONE ANOTHER...BUT GIDEON AND HIS 300 ISRAELITES SURROUND THE

THE MIDIANITES THINK THEY HAVE BEEN ATTACKED BY A GIANT ARMY...AND IN TERROR MANY TRY TO ESCAPE TO THE RIVER.

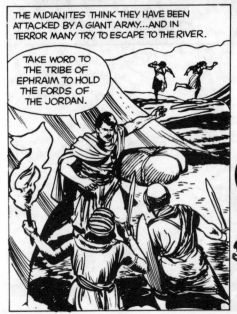

TAKE WORD TO THE TRIBE OF EPHRAIM TO HOLD THE FORDS OF THE JORDAN.

SOME OF THE MIDIANITES REACH THE JORDAN RIVER—BUT THEY ARE CAPTURED BY ISRAELITE SOLDIERS FROM EPHRAIM WAITING IN AMBUSH

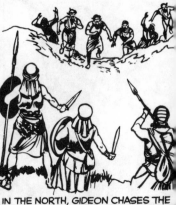

IN THE NORTH, GIDEON CHASES THE ENEMY ACROSS THE JORDAN...AND AT LAST ALL OF THE MIDIANITE FORCES ARE DEFEATED.

...TO A HIGH HILL OVERLOOKING ONE OF ABIMELECH'S CITIES, AND SHOUTS TO THE PEOPLE.

THE TREES WANTED A KING. THEY ASKED THE OLIVE AND THE FIG, BUT THEY REFUSED BECAUSE THEY WANTED TO KEEP ON BEARING GOOD FRUIT FOR GOD. FINALLY THE TREES ASKED THE BRAMBLE— AND IT ACCEPTED.

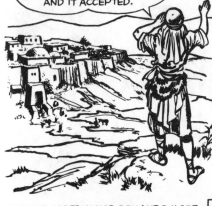

THE PEOPLE SOON LEARN THE MEANING OF JOTHAM'S FABLE. THEY FEEL THE PRICK OF THE BRAMBLE KING THEY CHOSE TO RULE OVER THEM.

ABIMELECH TAKES EVEN MY YOUNGEST SON FOR HIS ARMY—HOW CAN WE WORK THE LAND WITHOUT SONS TO HELP US?

BUT THE GREEDY KING DEMANDS MORE AND MORE UNTIL FINALLY THE PEOPLE REVOLT. ABIMELECH SENDS HIS TROOPS TO PUT DOWN THE REVOLT AND TEACH HIS SUBJECTS A LESSON.

WIPE OUT THE CITY—AND DON'T TAKE ANY PRISONERS!

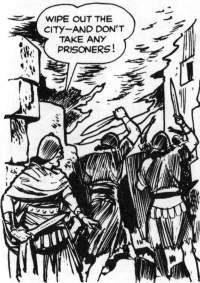

SOME OF THE PEOPLE TAKE REFUGE IN THE TOWER—SO ABIMELECH PREPARES TO SET FIRE TO THE DOOR.

BRING MORE WOOD— WE'LL BURN THEM OUT.

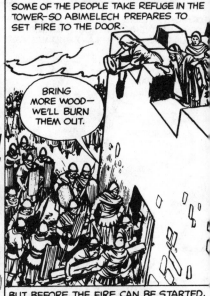

BUT BEFORE THE FIRE CAN BE STARTED, A WOMAN IN THE TOWER DROPS A MILLSTONE ON THE KING'S HEAD. HIS TROOPS TURN BACK...AND THE SIEGE IS OVER.

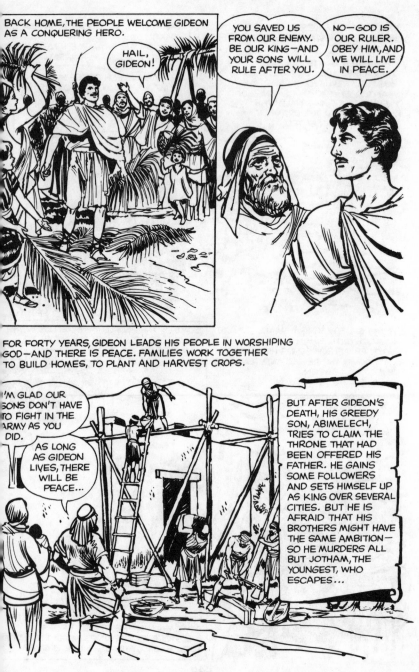

BACK HOME, THE PEOPLE WELCOME GIDEON AS A CONQUERING HERO.

HAIL, GIDEON!

YOU SAVED US FROM OUR ENEMY. BE OUR KING—AND YOUR SONS WILL RULE AFTER YOU.

NO—GOD IS OUR RULER. OBEY HIM, AND WE WILL LIVE IN PEACE.

FOR FORTY YEARS, GIDEON LEADS HIS PEOPLE IN WORSHIPING GOD—AND THERE IS PEACE. FAMILIES WORK TOGETHER TO BUILD HOMES, TO PLANT AND HARVEST CROPS.

I'M GLAD OUR SONS DON'T HAVE TO FIGHT IN THE ARMY AS YOU DID.

AS LONG AS GIDEON LIVES, THERE WILL BE PEACE...

BUT AFTER GIDEON'S DEATH, HIS GREEDY SON, ABIMELECH, TRIES TO CLAIM THE THRONE THAT HAD BEEN OFFERED HIS FATHER. HE GAINS SOME FOLLOWERS AND SETS HIMSELF UP AS KING OVER SEVERAL CITIES. BUT HE IS AFRAID THAT HIS BROTHERS MIGHT HAVE THE SAME AMBITION— SO HE MURDERS ALL BUT JOTHAM, THE YOUNGEST, WHO ESCAPES...

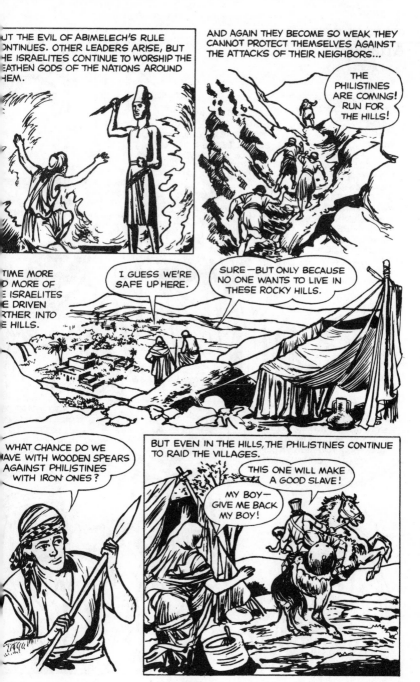

Attacked by a Lion

FROM JUDGES 13: 2—14: 5

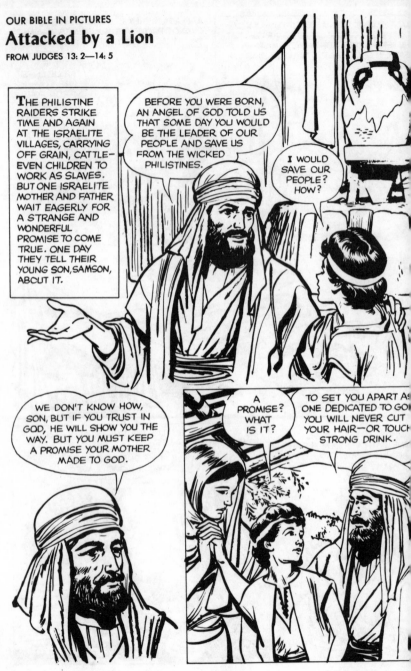

THE PHILISTINE RAIDERS STRIKE TIME AND AGAIN AT THE ISRAELITE VILLAGES, CARRYING OFF GRAIN, CATTLE— EVEN CHILDREN TO WORK AS SLAVES. BUT ONE ISRAELITE MOTHER AND FATHER WAIT EAGERLY FOR A STRANGE AND WONDERFUL PROMISE TO COME TRUE. ONE DAY THEY TELL THEIR YOUNG SON, SAMSON, ABOUT IT.

BEFORE YOU WERE BORN, AN ANGEL OF GOD TOLD US THAT SOME DAY YOU WOULD BE THE LEADER OF OUR PEOPLE AND SAVE US FROM THE WICKED PHILISTINES.

I WOULD SAVE OUR PEOPLE? HOW?

WE DON'T KNOW HOW, SON, BUT IF YOU TRUST IN GOD, HE WILL SHOW YOU THE WAY. BUT YOU MUST KEEP A PROMISE YOUR MOTHER MADE TO GOD.

A PROMISE? WHAT IS IT?

TO SET YOU APART AS ONE DEDICATED TO GOD YOU WILL NEVER CUT YOUR HAIR—OR TOUCH STRONG DRINK.

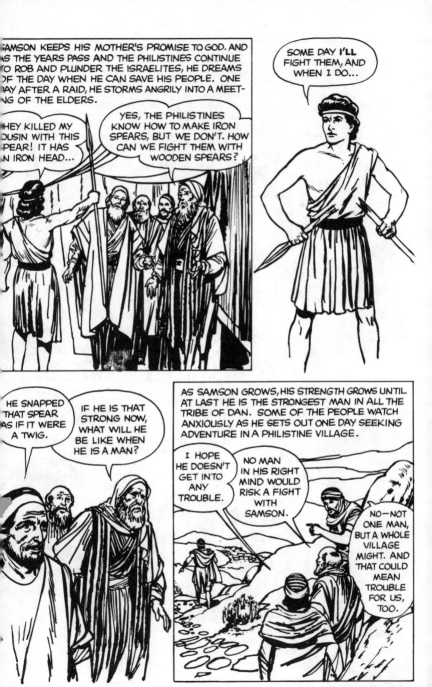

235

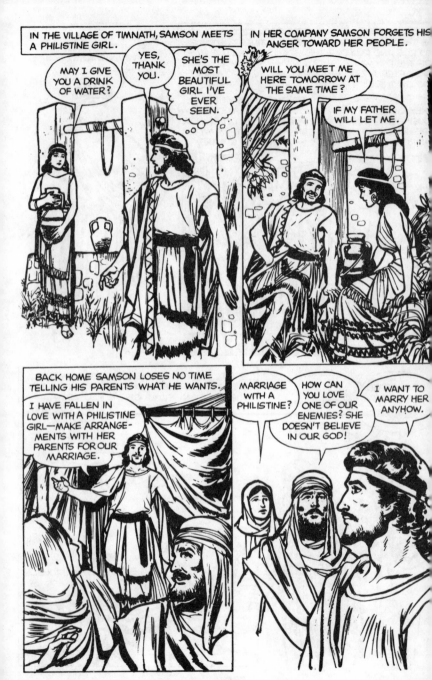

236

SAMSON'S MOTHER AND FATHER TRY TO TALK HIM OUT OF HIS MARRIAGE PLANS, BUT HE WILL NOT LISTEN. AT LAST THEY SET OUT FOR THE VILLAGE OF TIMNATH.

WHY COULDN'T HE HAVE FOUND A GIRL FROM AMONG **OUR** PEOPLE?

HE DIDN'T— AND THERE'S NOTHING WE CAN DO ABOUT IT NOW.

SAMSON IS SO HAPPY AT THE THOUGHT OF SEEING THE GIRL HE LOVES THAT HE FORGETS TO WATCH OUT FOR DANGER...

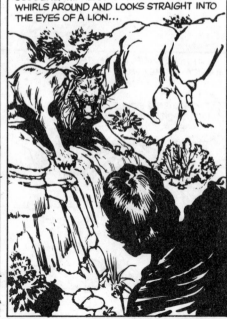

SUDDENLY HE HEARS AN ANGRY ROAR...HE WHIRLS AROUND AND LOOKS STRAIGHT INTO THE EYES OF A LION...

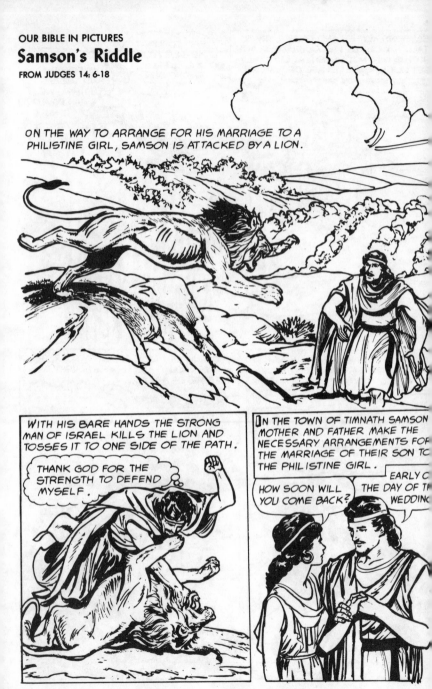

OUR BIBLE IN PICTURES
Samson's Riddle
FROM JUDGES 14: 6-18

ON THE WAY TO ARRANGE FOR HIS MARRIAGE TO A PHILISTINE GIRL, SAMSON IS ATTACKED BY A LION.

WITH HIS BARE HANDS THE STRONG MAN OF ISRAEL KILLS THE LION AND TOSSES IT TO ONE SIDE OF THE PATH.

THANK GOD FOR THE STRENGTH TO DEFEND MYSELF.

IN THE TOWN OF TIMNATH SAMSON MOTHER AND FATHER MAKE THE NECESSARY ARRANGEMENTS FOR THE MARRIAGE OF THEIR SON TO THE PHILISTINE GIRL.

HOW SOON WILL YOU COME BACK?

EARLY O THE DAY OF TH WEDDING

238

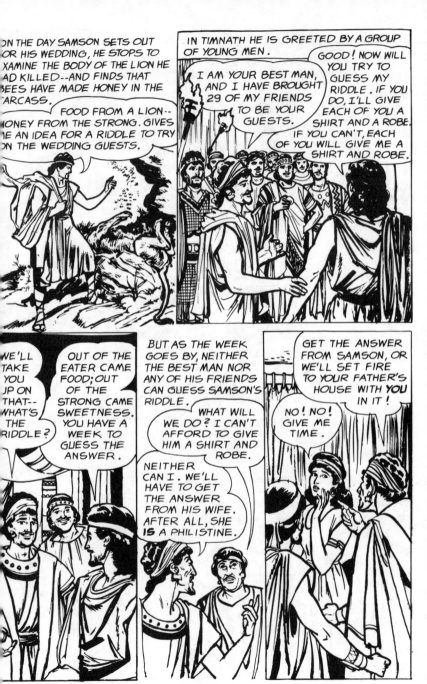

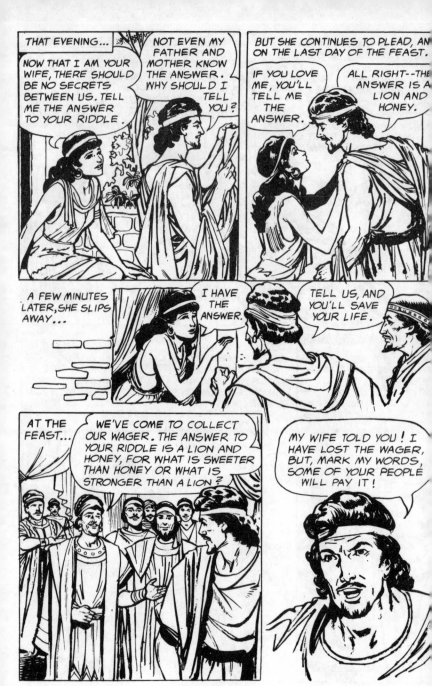

240

Samson's Revenge

FROM JUDGES 14: 19—15: 12

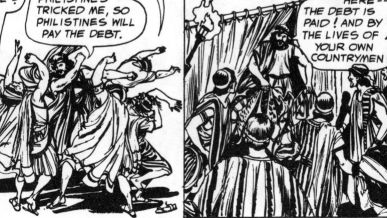

SAMSON IS FURIOUS! HE HAS LOST THE WAGER OF THIRTY ROBES TO THE PHILISTINES WHO FORCED HIS WIFE TO TELL THEM THE ANSWER TO HIS RIDDLE. HE LEAVES HIS WEDDING FEAST AND ENTERS ANOTHER CITY...

AH! ENOUGH PHILISTINES TO PAY MY DEBT--AND ALL OF THEM HANDSOMELY DRESSED, TOO.

WHO HIT ME?

WHAT'S HAPPENING?

PHILISTINES TRICKED ME, SO PHILISTINES WILL PAY THE DEBT.

STILL IN A RAGE, SAMSON RETURNS TO THE WEDDING FEAST...

HERE-- THE DEBT IS PAID! AND BY THE LIVES OF YOUR OWN COUNTRYMEN!

BACK HOME AS SAMSON'S ANGER COOLS, HE THINKS OF HIS WIFE WAITING FOR HIM.

IT WASN'T HER FAULT. THEY FORCED HER TO TELL THE ANSWER. I'LL GO TO HER AND TELL HER I'M SORRY.

IN THE PHILISTINE CITY HE GOES STRAIGHT TO THE HOME OF HIS WIFE'S FATHER.

I'VE COME TO SEE MY WIFE.

YOUR WIFE? WE THOUGHT YOU HATED HER. SHE IS NOW MARRIED TO YOUR BEST MAN.

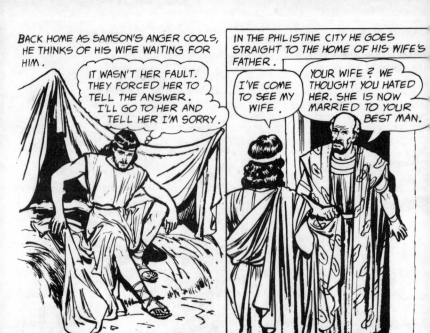

HERE IS HER YOUNGER SISTER--SHE'S EVEN MORE BEAUTIFUL. DO YOU WANT TO MARRY HER?

NO! I SHOULD HAVE KNOWN BETTER THAN TO TRUST A PHILISTINE. WHATEVER I DO NOW YOU WILL HAVE COMING TO YOU.

ON THE WAY HOME, HE GOES THROUGH FIELDS RICH WITH RIPENED GRAIN.

FIELDS AND VINEYARDS STOLEN FROM MY PEOPLE! I KNOW HOW I CAN MAKE THE PHILISTINES SORRY FOR WHAT THEY DID TO ME.

QUICKLY SAMSON SETS FOXES RACING THROUGH THE FIELDS AND VINEYARDS WITH FLAMING TORCHES. IN A MATTER OF MINUTES THE WHOLE COUNTRYSIDE IS ABLAZE.

IN THE CITY THE PHILISTINES WATCH WITH TERROR AS THE SKY GROWS RED.

SAMSON DID THIS! HE'S GETTING EVEN WITH HIS WIFE'S FATHER FOR MARRYING HER TO ANOTHER.

HER FATHER SHOULD HAVE KNOWN BETTER THAN TO TRICK SAMSON. COME ON, LET'S GIVE OUR COUNTRYMAN A TASTE OF HIS OWN MEDICINE.

THE ANGRY PHILISTINES SET FIRE TO THE HOME OF SAMSON'S FATHER-IN-LAW...BUT THEY DO NOT COUNT ON SAMSON'S RETURN.

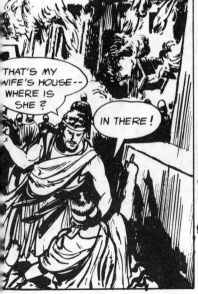

THAT'S MY WIFE'S HOUSE-- WHERE IS SHE?

IN THERE!

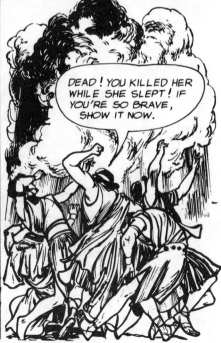

DEAD! YOU KILLED HER WHILE SHE SLEPT! IF YOU'RE SO BRAVE, SHOW IT NOW.

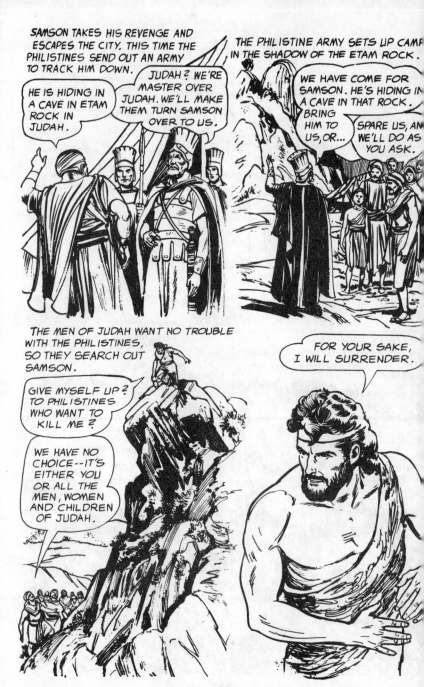

SAMSON TAKES HIS REVENGE AND ESCAPES THE CITY. THIS TIME THE PHILISTINES SEND OUT AN ARMY TO TRACK HIM DOWN.

HE IS HIDING IN A CAVE IN ETAM ROCK IN JUDAH.

JUDAH? WE'RE MASTER OVER JUDAH. WE'LL MAKE THEM TURN SAMSON OVER TO US.

THE PHILISTINE ARMY SETS UP CAMP IN THE SHADOW OF THE ETAM ROCK.

WE HAVE COME FOR SAMSON. HE'S HIDING IN A CAVE IN THAT ROCK. BRING HIM TO US, OR...

SPARE US, AND WE'LL DO AS YOU ASK.

THE MEN OF JUDAH WANT NO TROUBLE WITH THE PHILISTINES, SO THEY SEARCH OUT SAMSON.

GIVE MYSELF UP? TO PHILISTINES WHO WANT TO KILL ME?

WE HAVE NO CHOICE--IT'S EITHER YOU OR ALL THE MEN, WOMEN AND CHILDREN OF JUDAH.

FOR YOUR SAKE, I WILL SURRENDER.

244

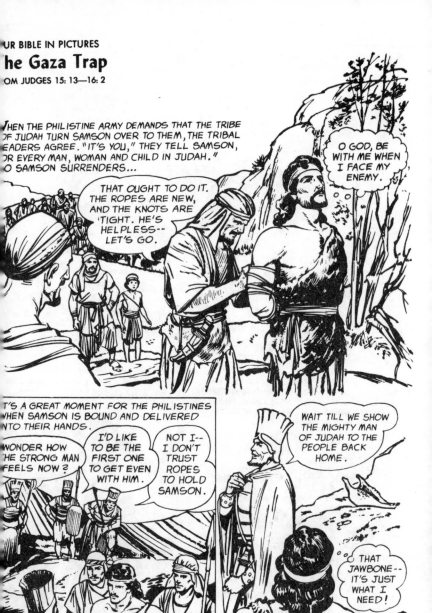

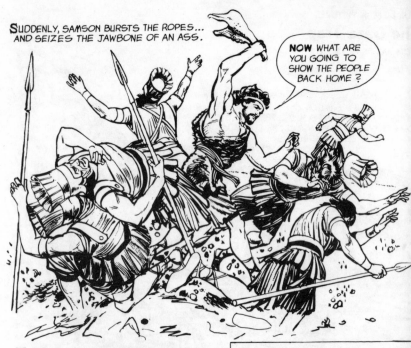

SUDDENLY, SAMSON BURSTS THE ROPES...
AND SEIZES THE JAWBONE OF AN ASS.

NOW WHAT ARE YOU GOING TO SHOW THE PEOPLE BACK HOME?

WITH DEADLY AIM SAMSON STRIKES DOWN ONE PHILISTINE SOLDIER AFTER ANOTHER. THOSE WHO CAN, RUN FOR THEIR LIVES. IN A SHORT WHILE THE ONE-MAN ATTACK IS OVER...

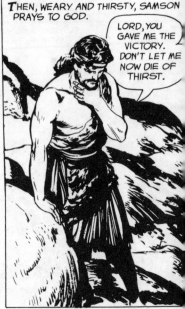

THEN, WEARY AND THIRSTY, SAMSON PRAYS TO GOD.

LORD, YOU GAVE ME THE VICTORY. DON'T LET ME NOW DIE OF THIRST.

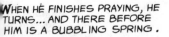

WHEN HE FINISHES PRAYING, HE TURNS... AND THERE BEFORE HIM IS A BUBBLING SPRING.

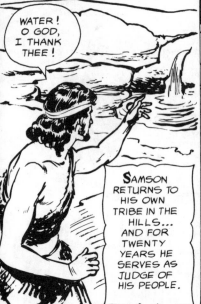

WATER! O GOD, I THANK THEE!

SAMSON RETURNS TO HIS OWN TRIBE IN THE HILLS... AND FOR TWENTY YEARS HE SERVES AS JUDGE OF HIS PEOPLE.

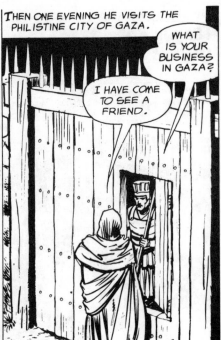

THEN ONE EVENING HE VISITS THE PHILISTINE CITY OF GAZA.

WHAT IS YOUR BUSINESS IN GAZA?

I HAVE COME TO SEE A FRIEND.

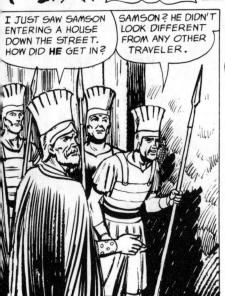

I JUST SAW SAMSON ENTERING A HOUSE DOWN THE STREET. HOW DID HE GET IN?

SAMSON? HE DIDN'T LOOK DIFFERENT FROM ANY OTHER TRAVELER.

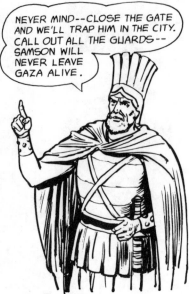

NEVER MIND--CLOSE THE GATE AND WE'LL TRAP HIM IN THE CITY. CALL OUT ALL THE GUARDS-- SAMSON WILL NEVER LEAVE GAZA ALIVE.

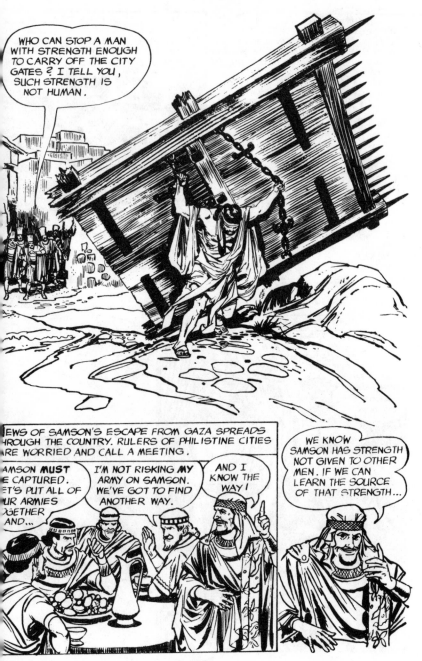

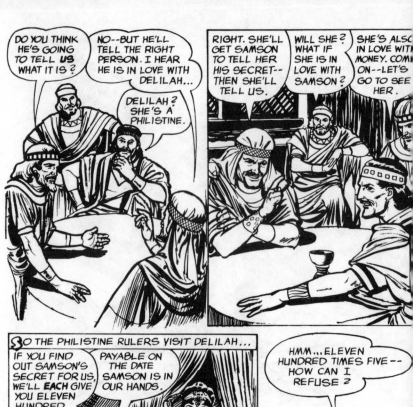

DO YOU THINK HE'S GOING TO TELL **US** WHAT IT IS?

NO--BUT HE'LL TELL THE RIGHT PERSON. I HEAR HE IS IN LOVE WITH DELILAH...

DELILAH? SHE'S A PHILISTINE.

RIGHT. SHE'LL GET SAMSON TO TELL HER HIS SECRET-- THEN SHE'LL TELL US.

WILL SHE? WHAT IF SHE IS IN LOVE WITH SAMSON?

SHE'S ALSO IN LOVE WITH MONEY. COME ON--LET'S GO TO SEE HER.

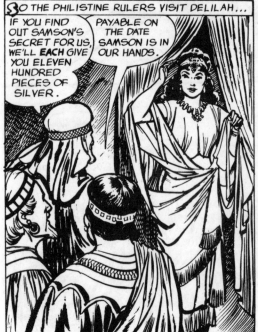

SO THE PHILISTINE RULERS VISIT DELILAH...

IF YOU FIND OUT SAMSON'S SECRET FOR US, WE'LL **EACH** GIVE YOU ELEVEN HUNDRED PIECES OF SILVER.

PAYABLE ON THE DATE SAMSON IS IN OUR HANDS.

HMM...ELEVEN HUNDRED TIMES FIVE-- HOW CAN I REFUSE?

250

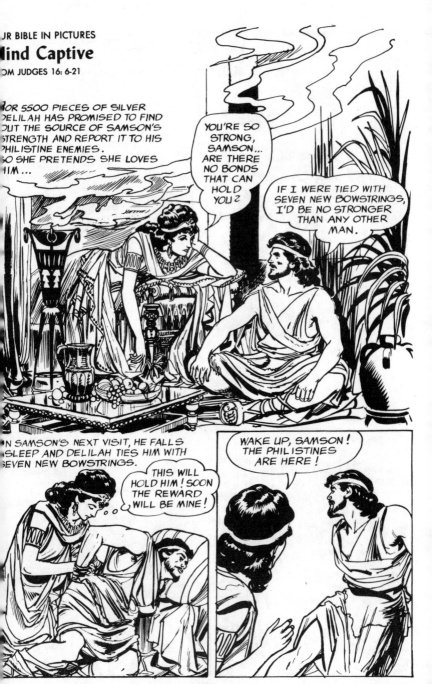

251

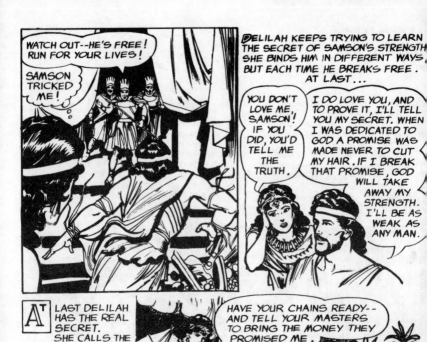

WATCH OUT--HE'S FREE! RUN FOR YOUR LIVES!

SAMSON TRICKED ME!

DELILAH KEEPS TRYING TO LEARN THE SECRET OF SAMSON'S STRENGTH. SHE BINDS HIM IN DIFFERENT WAYS, BUT EACH TIME HE BREAKS FREE. AT LAST...

YOU DON'T LOVE ME, SAMSON! IF YOU DID, YOU'D TELL ME THE TRUTH.

I DO LOVE YOU, AND TO PROVE IT, I'LL TELL YOU MY SECRET. WHEN I WAS DEDICATED TO GOD A PROMISE WAS MADE NEVER TO CUT MY HAIR. IF I BREAK THAT PROMISE, GOD WILL TAKE AWAY MY STRENGTH. I'LL BE AS WEAK AS ANY MAN.

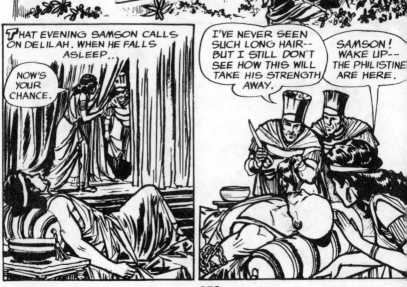

AT LAST DELILAH HAS THE REAL SECRET. SHE CALLS THE PHILISTINES AND PLANS TO TRAP SAMSON THAT NIGHT.

HAVE YOUR CHAINS READY-- AND TELL YOUR MASTERS TO BRING THE MONEY THEY PROMISED ME.

THAT EVENING SAMSON CALLS ON DELILAH. WHEN HE FALLS ASLEEP...

NOW'S YOUR CHANCE.

I'VE NEVER SEEN SUCH LONG HAIR-- BUT I STILL DON'T SEE HOW THIS WILL TAKE HIS STRENGTH AWAY.

SAMSON! WAKE UP-- THE PHILISTINE ARE HERE.

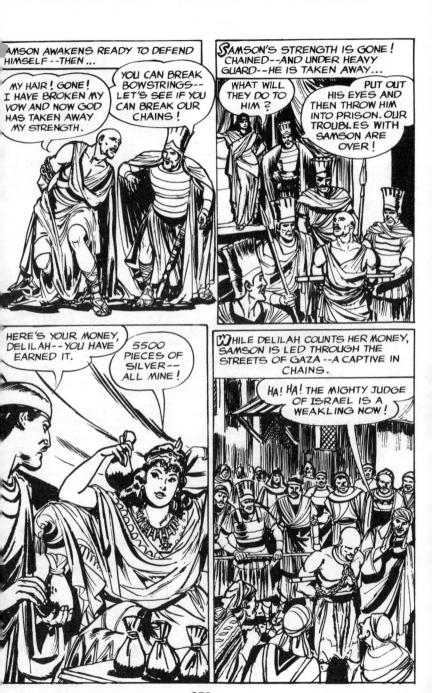

SAMSON AWAKENS READY TO DEFEND HIMSELF--THEN ...

MY HAIR! GONE! I HAVE BROKEN MY VOW AND NOW GOD HAS TAKEN AWAY MY STRENGTH.

YOU CAN BREAK BOWSTRINGS-- LET'S SEE IF YOU CAN BREAK OUR CHAINS!

SAMSON'S STRENGTH IS GONE! CHAINED--AND UNDER HEAVY GUARD--HE IS TAKEN AWAY...

WHAT WILL THEY DO TO HIM?

PUT OUT HIS EYES AND THEN THROW HIM INTO PRISON. OUR TROUBLES WITH SAMSON ARE OVER!

HERE'S YOUR MONEY, DELILAH--YOU HAVE EARNED IT.

5500 PIECES OF SILVER-- ALL MINE!

WHILE DELILAH COUNTS HER MONEY, SAMSON IS LED THROUGH THE STREETS OF GAZA --A CAPTIVE IN CHAINS.

HA! HA! THE MIGHTY JUDGE OF ISRAEL IS A WEAKLING NOW!

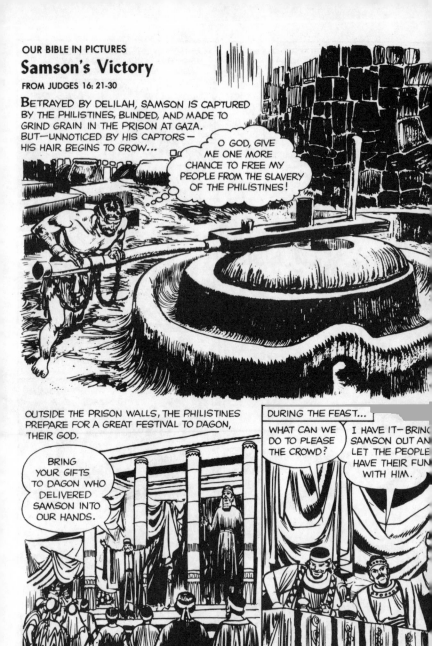

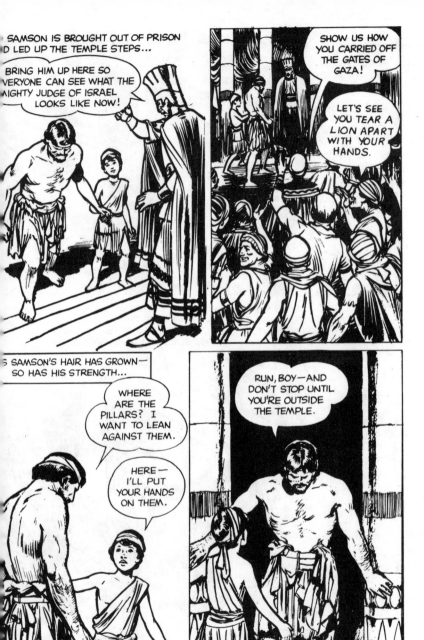

255

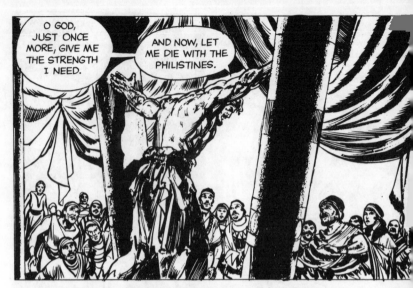

O GOD, JUST ONCE MORE, GIVE ME THE STRENGTH I NEED.

AND NOW, LET ME DIE WITH THE PHILISTINES.

USING ALL HIS MIGHTY STRENGTH, SAMSON PUSHES AGAINST THE PILLARS—AND THE GIANT TEMPLE TO THE HEATHEN GOD, DAGON, CRASHES TO THE GROUND. CRUSHED BENEATH IT ARE THE PHILISTINES WHO HAD MADE SLAVES OF SAMSON'S PEOPLE...

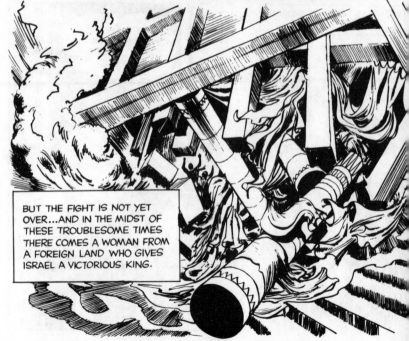

BUT THE FIGHT IS NOT YET OVER...AND IN THE MIDST OF THESE TROUBLESOME TIMES THERE COMES A WOMAN FROM A FOREIGN LAND WHO GIVES ISRAEL A VICTORIOUS KING.

256

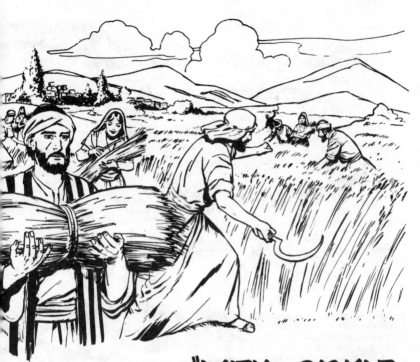

"WITH a SICKLE and the WIND"

MAY AND JUNE, THE BEGINNING OF THE LONG, DRY SEASON IN PALESTINE, WERE THE HARVEST MONTHS IN JESUS' TIME. THE HARVESTING WAS DONE BY HAND WITH SICKLES, LIKE THOSE STILL USED TODAY. MANY OF THE POORER PEOPLE HAD TO USE FLINT-BLADED SICKLES, AS IRON WAS EXPENSIVE...SOME PULLED THE WHEAT UP BY ITS ROOTS!

AFTER CUTTING (OR PULLING) THE WHEAT WAS BOUND INTO SHEAVES AND CARRIED TO WHERE IT WAS TO BE THRESHED— AN OPEN PLACE WITH A HARD-PACKED, SMOOTH FLOOR NEAR THE VILLAGE.

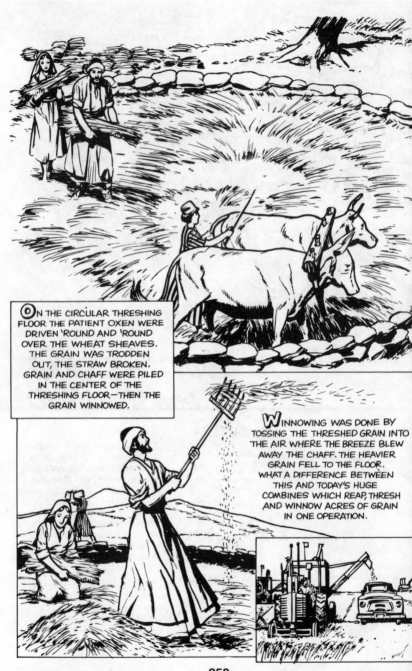

ON THE CIRCULAR THRESHING FLOOR THE PATIENT OXEN WERE DRIVEN 'ROUND AND 'ROUND OVER THE WHEAT SHEAVES. THE GRAIN WAS TRODDEN OUT, THE STRAW BROKEN. GRAIN AND CHAFF WERE PILED IN THE CENTER OF THE THRESHING FLOOR—THEN THE GRAIN WINNOWED.

WINNOWING WAS DONE BY TOSSING THE THRESHED GRAIN INTO THE AIR WHERE THE BREEZE BLEW AWAY THE CHAFF. THE HEAVIER GRAIN FELL TO THE FLOOR. WHAT A DIFFERENCE BETWEEN THIS AND TODAY'S HUGE COMBINES WHICH REAP, THRESH AND WINNOW ACRES OF GRAIN IN ONE OPERATION.

AFTER ALL THE GRAIN WAS THRESHED AND WINNOWED IT WAS PUT THROUGH A SIEVE AND THEN STORED. SEED FROM THE TARES, A WEED JESUS OFTEN MENTIONED IN HIS PARABLES, WAS PICKED OUT OF THE GRAIN BY HAND.

OFTEN THE FARMER SLEPT BESIDE HIS STORED GRAIN TO PREVENT ITS BEING STOLEN.

MOST OF THE SMALL FARMS IN PALESTINE WERE WORKED BY THE FARMER'S FAMILY. BUT MANY MEN WHO DID NOT OWN FARMS WOULD HIRE THEMSELVES OUT AS FARM WORKERS. JESUS REFERRED TO THEM IN HIS PARABLE OF THE HOUSEHOLDER WHO HIRED SUCH WORKERS (MATTHEW 20:1).

WHEN ALL THE HARVEST HAD BEEN BROUGHT IN, THE JEWS IN PALESTINE OBSERVED "THE FEAST OF THE TABERNACLES." THIS WAS A SEVEN-DAY PERIOD OF FEASTING TO REMIND THE PEOPLE OF THE TIME WHEN THEY LIVED IN TENTS IN THE WILDERNESS AFTER FLEEING FROM EGYPT. THEY BUILT SMALL SHELTERS OF BRUSH ON THEIR HOUSETOPS AND LIVED IN THEM FOR THE SEVEN DAYS. JESUS MUST HAVE OBSERVED THIS FEAST AS A BOY; JOHN 7:1-17 TELLS OF HIS OBSERVING IT WHEN HE WAS GROWN UP.

Famine

FROM RUTH 1: 1-5

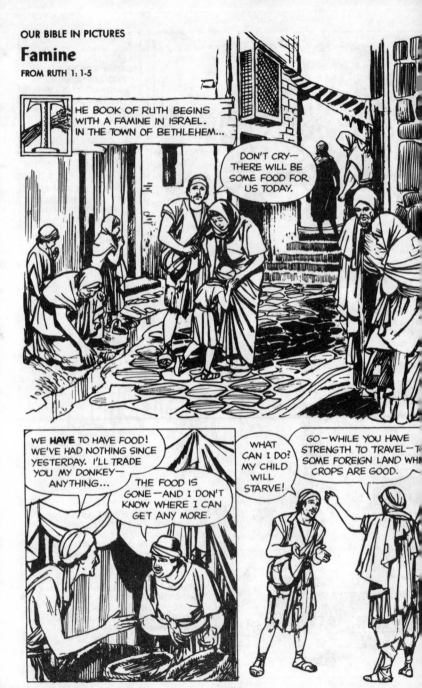

SO FAMILIES PACK UP THEIR BELONGINGS AND SET OUT, HOPING TO FIND FOOD ALONG THE WAY UNTIL THEY CAN REACH A LAND WHERE THERE IS PLENTY...

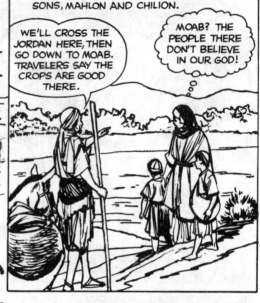

IN THE CARAVAN THAT LEAVES BETHLEHEM ARE ELIMELECH, NAOMI, AND THEIR TWO SONS, MAHLON AND CHILION.

WE'LL CROSS THE JORDAN HERE, THEN GO DOWN TO MOAB. TRAVELERS SAY THE CROPS ARE GOOD THERE.

MOAB? THE PEOPLE THERE DON'T BELIEVE IN OUR GOD!

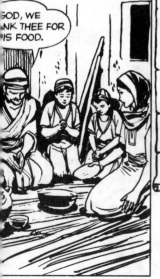

IN THE FOREIGN LAND OF MOAB, ELIMELECH AND THE BOYS FIND WORK IN THE GRAIN FIELDS...

GOD, WE THANK THEE FOR THIS FOOD.

HARVEST SEASONS COME AND GO—FOOD IS PLENTIFUL, AND THE ISRAELITE FAMILY PROSPERS. THEN—SUDDENLY—ELIMELECH DIES.

NAOMI IS HEARTBROKEN...

AS LONG AS WE LIVE, MOTHER, YOU WILL NEVER WANT FOR FOOD OR CARE.

HOW FORTUNATE I AM TO HAVE SONS LIKE YOU.

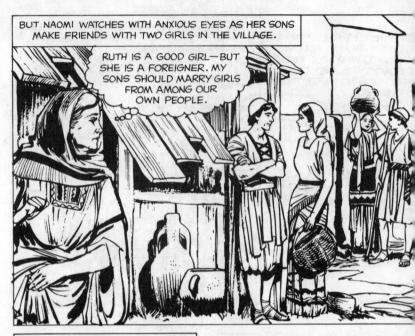

BUT NAOMI WATCHES WITH ANXIOUS EYES AS HER SONS MAKE FRIENDS WITH TWO GIRLS IN THE VILLAGE.

RUTH IS A GOOD GIRL—BUT SHE IS A FOREIGNER. MY SONS SHOULD MARRY GIRLS FROM AMONG OUR OWN PEOPLE.

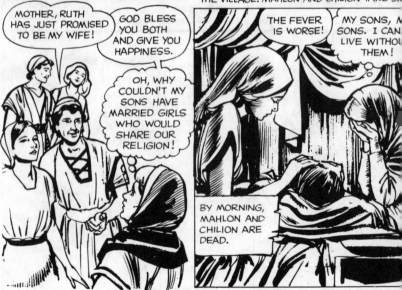

BUT IN SPITE OF ALL NAOMI CAN DO, THE BOYS FALL IN LOVE WITH THE MOABITE GIRLS...AND ONE DAY...

MOTHER, RUTH HAS JUST PROMISED TO BE MY WIFE!

GOD BLESS YOU BOTH AND GIVE YOU HAPPINESS.

OH, WHY COULDN'T MY SONS HAVE MARRIED GIRLS WHO WOULD SHARE OUR RELIGION!

NAOMI'S SONS MARRY AND THE MOABITE GIRLS COME TO LIVE IN HER HOME. THEN WITHOUT WARNING—AN EPIDEMIC STRIKE[S] THE VILLAGE. MAHLON AND CHILION TAKE SI[CK]

THE FEVER IS WORSE!

MY SONS, [M]Y SONS. I CAN[NOT] LIVE WITHOU[T] THEM!

BY MORNING, MAHLON AND CHILION ARE DEAD.

262

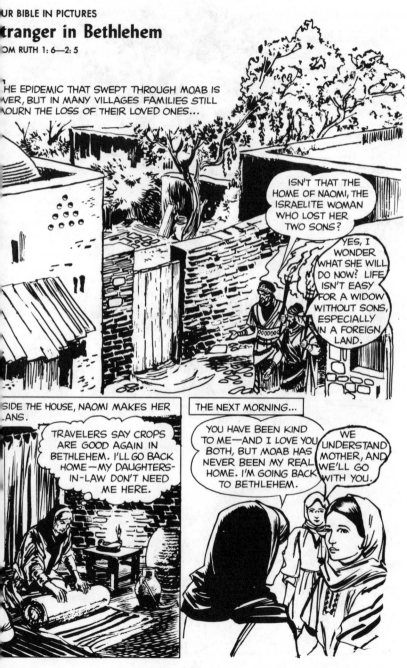

tranger in Bethlehem

OM RUTH 1: 6—2: 5

HE EPIDEMIC THAT SWEPT THROUGH MOAB IS VER, BUT IN MANY VILLAGES FAMILIES STILL OURN THE LOSS OF THEIR LOVED ONES...

ISN'T THAT THE HOME OF NAOMI, THE ISRAELITE WOMAN WHO LOST HER TWO SONS?

YES, I WONDER WHAT SHE WILL DO NOW? LIFE ISN'T EASY FOR A WIDOW WITHOUT SONS, ESPECIALLY IN A FOREIGN LAND.

SIDE THE HOUSE, NAOMI MAKES HER LANS.

TRAVELERS SAY CROPS ARE GOOD AGAIN IN BETHLEHEM. I'LL GO BACK HOME—MY DAUGHTERS-IN-LAW DON'T NEED ME HERE.

THE NEXT MORNING...

YOU HAVE BEEN KIND TO ME—AND I LOVE YOU BOTH, BUT MOAB HAS NEVER BEEN MY REAL HOME. I'M GOING BACK TO BETHLEHEM.

WE UNDERSTAND MOTHER, AND WE'LL GO WITH YOU.

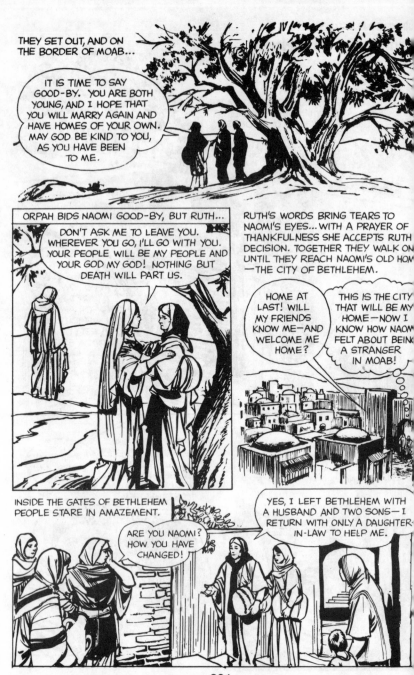

THEY SET OUT, AND ON THE BORDER OF MOAB...

IT IS TIME TO SAY GOOD-BY. YOU ARE BOTH YOUNG, AND I HOPE THAT YOU WILL MARRY AGAIN AND HAVE HOMES OF YOUR OWN. MAY GOD BE KIND TO YOU, AS YOU HAVE BEEN TO ME.

ORPAH BIDS NAOMI GOOD-BY, BUT RUTH...

DON'T ASK ME TO LEAVE YOU. WHEREVER YOU GO, I'LL GO WITH YOU. YOUR PEOPLE WILL BE MY PEOPLE AND YOUR GOD MY GOD! NOTHING BUT DEATH WILL PART US.

RUTH'S WORDS BRING TEARS TO NAOMI'S EYES... WITH A PRAYER OF THANKFULNESS SHE ACCEPTS RUTH DECISION. TOGETHER THEY WALK ON UNTIL THEY REACH NAOMI'S OLD HOM —THE CITY OF BETHLEHEM.

HOME AT LAST! WILL MY FRIENDS KNOW ME—AND WELCOME ME HOME?

THIS IS THE CITY THAT WILL BE MY HOME—NOW I KNOW HOW NAOM FELT ABOUT BEIN A STRANGER IN MOAB!

INSIDE THE GATES OF BETHLEHEM PEOPLE STARE IN AMAZEMENT.

ARE YOU NAOMI? HOW YOU HAVE CHANGED!

YES, I LEFT BETHLEHEM WITH A HUSBAND AND TWO SONS—I RETURN WITH ONLY A DAUGHTER-IN-LAW TO HELP ME.

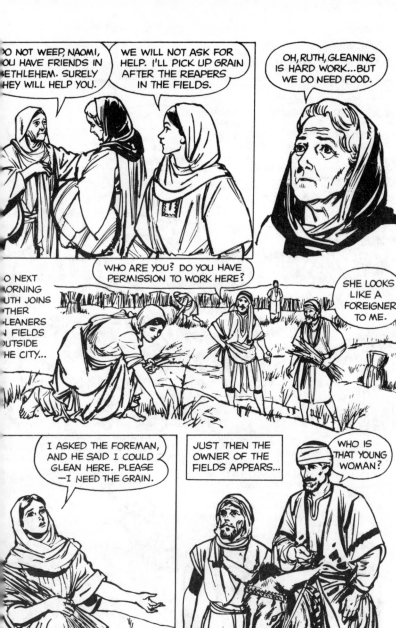

265

Naomi's Strategy

FROM RUTH 2: 6—3: 18

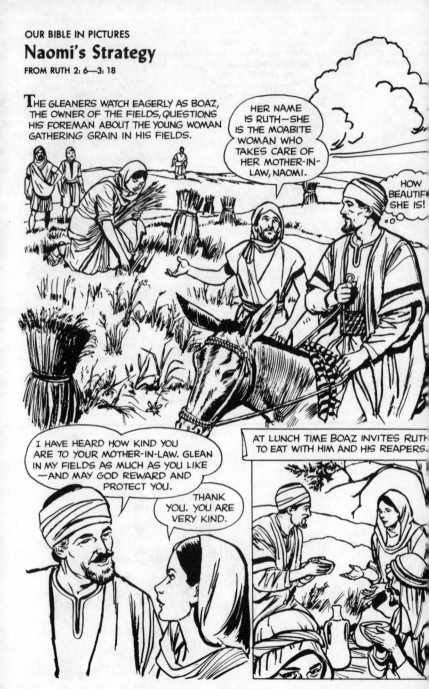

THE GLEANERS WATCH EAGERLY AS BOAZ, THE OWNER OF THE FIELDS, QUESTIONS HIS FOREMAN ABOUT THE YOUNG WOMAN GATHERING GRAIN IN HIS FIELDS.

HER NAME IS RUTH—SHE IS THE MOABITE WOMAN WHO TAKES CARE OF HER MOTHER-IN-LAW, NAOMI.

HOW BEAUTIF[UL] SHE IS!

I HAVE HEARD HOW KIND YOU ARE TO YOUR MOTHER-IN-LAW. GLEAN IN MY FIELDS AS MUCH AS YOU LIKE —AND MAY GOD REWARD AND PROTECT YOU.

THANK YOU. YOU ARE VERY KIND.

AT LUNCH TIME BOAZ INVITES RUTH TO EAT WITH HIM AND HIS REAPERS.

266

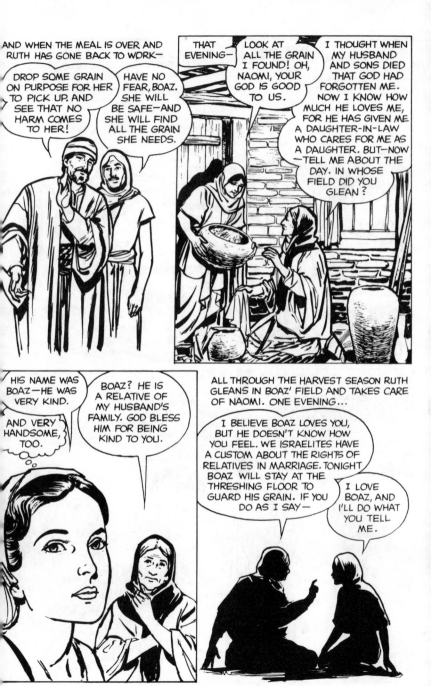

267

RUTH GOES TO THE THRESHING FLOOR AS NAOMI TOLD HER TO DO.

I ASK YOUR HELP AND PROTECTION, BOAZ, BECAUSE YOU ARE A RELATIVE OF MY HUSBAND'S FAMILY.

I LOVE YOU, RUTH, AND I AM GLAD YOU HAVE ASKED ME TO TAKE CARE OF YOU. BUT THERE IS A CLOSER RELATIVE THAN I, AND, ACCORDING TO OUR CUSTOM, HE HAS THE FIRST RIGHT TO TAKE YOUR DEAD HUSBAND'S PLACE.

THE NEXT MORNING...

BOAZ DOES LOVE ME; BUT OH, NAOMI, HE SAYS THERE IS A CLOSER RELATIVE WHO HAS MORE RIGHT THAN HE.

DON'T WORRY— BOAZ WILL NOT REST UNTIL HE HAS HANDLED THIS ACCORDING TO OUR CUSTOM.

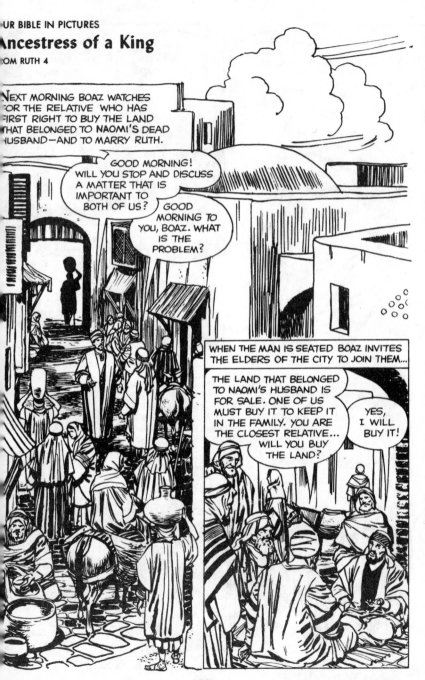

269

ACCORDING TO OUR CUSTOM, THE DAY YOU BUY THE LAND YOU MUST ALSO MARRY NAOMI'S DAUGHTER-IN-LAW, RUTH.

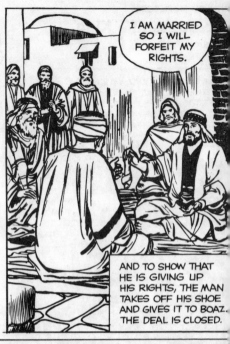

I AM MARRIED SO I WILL FORFEIT MY RIGHTS.

AND TO SHOW THAT HE IS GIVING UP HIS RIGHTS, THE MAN TAKES OFF HIS SHOE AND GIVES IT TO BOAZ. THE DEAL IS CLOSED.

YOU ARE WITNESSES THAT I NOW HAVE THE RIGHT TO BUY THE LAND AND MARRY RUTH?

WE ARE WITNESSES. GOD BLESS YOU, BOAZ, AND MAY RUTH BECOME THE MOTHER OF A FAMOUS FAMILY IN ISRAEL.

BOAZ HURRIES TO NAOMI'S HOUSE WITH THE NEWS

THIS IS INDEED A HAPPY DAY FOR ME. I HAVE ARRANGED TO BUY THE LAND, AND NOW I HAVE COME TO CLAIM RUTH IN MARRIAGE.

GOD BLESS YOU, BOAZ. SHE WILL BE A GOOD WIFE.

THE NEWS OF RUTH AND BOAZ' COMING MARRIAGE SPREADS RAPIDLY THROUGHOUT ALL BETHLEHEM, FOR BOAZ IS A WELL-TO-DO LANDOWNER. AT THE WEDDING THERE IS FEASTING, MUSIC AND LAUGHTER...

ARE YOU HAPPY, MY DEAR?

HAPPIER THAN I EVER DREAMED I COULD BE. GOD HAS BEEN GOOD TO ME.

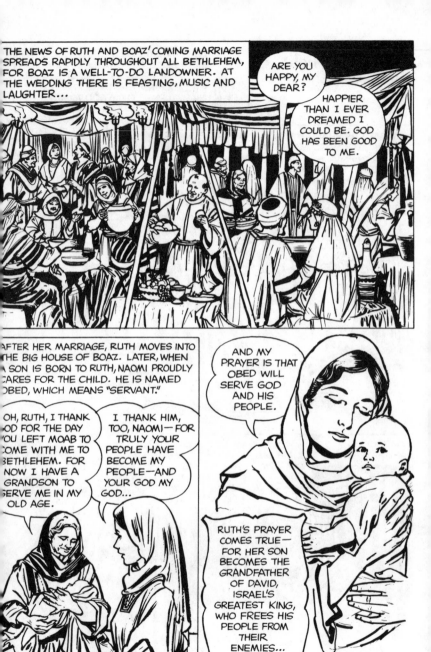

AFTER HER MARRIAGE, RUTH MOVES INTO THE BIG HOUSE OF BOAZ. LATER, WHEN A SON IS BORN TO RUTH, NAOMI PROUDLY CARES FOR THE CHILD. HE IS NAMED OBED, WHICH MEANS "SERVANT."

OH, RUTH, I THANK GOD FOR THE DAY YOU LEFT MOAB TO COME WITH ME TO BETHLEHEM. FOR NOW I HAVE A GRANDSON TO SERVE ME IN MY OLD AGE.

I THANK HIM, TOO, NAOMI — FOR TRULY YOUR PEOPLE HAVE BECOME MY PEOPLE — AND YOUR GOD MY GOD...

AND MY PRAYER IS THAT OBED WILL SERVE GOD AND HIS PEOPLE.

RUTH'S PRAYER COMES TRUE — FOR HER SON BECOMES THE GRANDFATHER OF DAVID, ISRAEL'S GREATEST KING, WHO FREES HIS PEOPLE FROM THEIR ENEMIES...

271

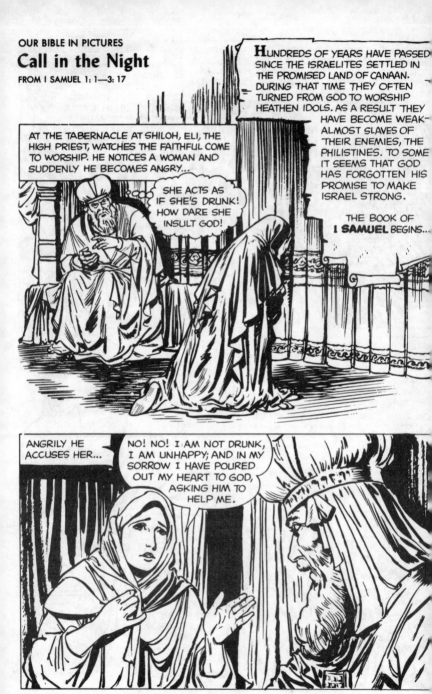

OUR BIBLE IN PICTURES
Call in the Night
FROM I SAMUEL 1: 1—3: 17

HUNDREDS OF YEARS HAVE PASSED SINCE THE ISRAELITES SETTLED IN THE PROMISED LAND OF CANAAN. DURING THAT TIME THEY OFTEN TURNED FROM GOD TO WORSHIP HEATHEN IDOLS. AS A RESULT THEY HAVE BECOME WEAK—ALMOST SLAVES OF THEIR ENEMIES, THE PHILISTINES. TO SOME IT SEEMS THAT GOD HAS FORGOTTEN HIS PROMISE TO MAKE ISRAEL STRONG.

THE BOOK OF I SAMUEL BEGINS...

AT THE TABERNACLE AT SHILOH, ELI, THE HIGH PRIEST, WATCHES THE FAITHFUL COME TO WORSHIP. HE NOTICES A WOMAN AND SUDDENLY HE BECOMES ANGRY...

SHE ACTS AS IF SHE'S DRUNK! HOW DARE SHE INSULT GOD!

ANGRILY HE ACCUSES HER...

NO! NO! I AM NOT DRUNK, I AM UNHAPPY; AND IN MY SORROW I HAVE POURED OUT MY HEART TO GOD, ASKING HIM TO HELP ME.

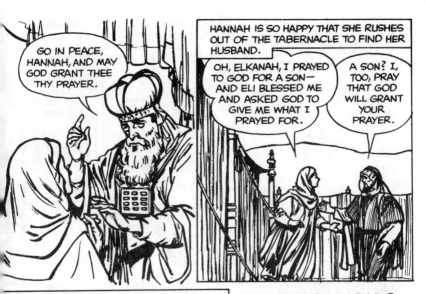

GO IN PEACE, HANNAH, AND MAY GOD GRANT THEE THY PRAYER.

HANNAH IS SO HAPPY THAT SHE RUSHES OUT OF THE TABERNACLE TO FIND HER HUSBAND.

OH, ELKANAH, I PRAYED TO GOD FOR A SON—AND ELI BLESSED ME AND ASKED GOD TO GIVE ME WHAT I PRAYED FOR.

A SON? I, TOO, PRAY THAT GOD WILL GRANT YOUR PRAYER.

GOD ANSWERS HANNAH'S PRAYER—AND WHEN THE BOY IS OLD ENOUGH TO LEAVE HIS MOTHER, SHE BRINGS HIM TO ELI.

WHEN I ASKED GOD FOR A SON, I PROMISED THAT HE WOULD SERVE THE LORD ALL HIS LIFE. SO I HAVE BROUGHT HIM HERE TO BE TRAINED IN GOD'S HOUSE. HIS NAME IS SAMUEL.

GOD BLESS YOU, HANNAH. LEAVE THE BOY WITH ME AND I WILL TEACH HIM TO BE A SERVANT OF THE LORD.

SAMUEL STAYS WITH ELI AND EAGERLY LEARNS WHAT GOD EXPECTS OF THOSE WHO SERVE HIM. EACH YEAR WHEN HANNAH AND HER HUSBAND COME TO WORSHIP, SHE BRINGS SAMUEL A NEW COAT.

IT'S JUST LIKE A PRIEST'S ROBE. THANK YOU, MOTHER.

OLD ELI IS PROUD OF SAMUEL—BUT HE IS BROKENHEARTED WHEN HE THINKS OF HIS OWN TWO SONS. AS PRIESTS, THEY HAVE SINNED AGAINST GOD AND CHEATED THE PEOPLE. ELI KNOWS THAT HE, TOO, IS GUILTY BECAUSE HE HAS DONE NOTHING TO STOP THEM.

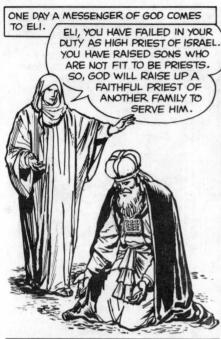

ONE DAY A MESSENGER OF GOD COMES TO ELI.

ELI, YOU HAVE FAILED IN YOUR DUTY AS HIGH PRIEST OF ISRAEL. YOU HAVE RAISED SONS WHO ARE NOT FIT TO BE PRIESTS. SO, GOD WILL RAISE UP A FAITHFUL PRIEST OF ANOTHER FAMILY TO SERVE HIM.

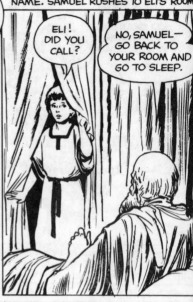

ONE NIGHT SOON AFTER, SAMUEL IS AWAKENED BY A VOICE THAT CALLS HIS NAME. SAMUEL RUSHES TO ELI'S ROOM.

ELI! DID YOU CALL?

NO, SAMUEL— GO BACK TO YOUR ROOM AND GO TO SLEEP.

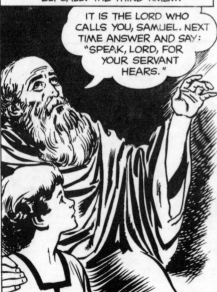

THREE TIMES SAMUEL THINKS HE HEARS ELI CALL. THE THIRD TIME...

IT IS THE LORD WHO CALLS YOU, SAMUEL. NEXT TIME ANSWER AND SAY: "SPEAK, LORD, FOR YOUR SERVANT HEARS."

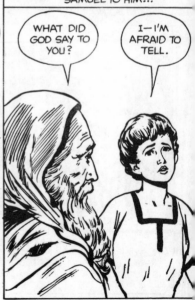

THE NEXT MORNING ELI CALLS SAMUEL TO HIM...

WHAT DID GOD SAY TO YOU?

I—I'M AFRAID TO TELL.

274

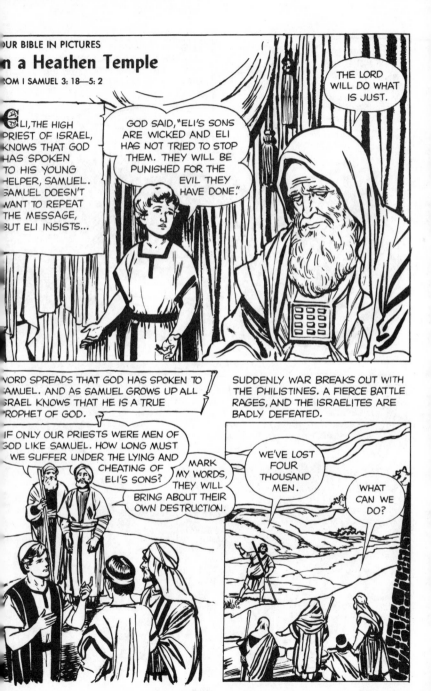

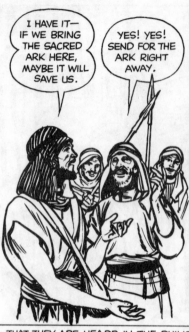

I HAVE IT— IF WE BRING THE SACRED ARK HERE, MAYBE IT WILL SAVE US.

YES! YES! SEND FOR THE ARK RIGHT AWAY.

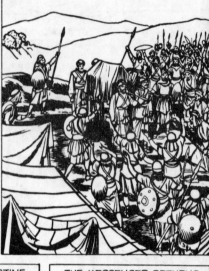

ELI'S TWO SONS GO WITH THE OTHERS TO GET THE SACRED ARK FROM THE TABERNACL WHEN THEY BRING IT TO CAMP, THE ISRAELIT SHOUT WITH SO MUCH JOY...

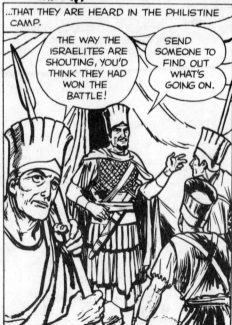

...THAT THEY ARE HEARD IN THE PHILISTINE CAMP.

THE WAY THE ISRAELITES ARE SHOUTING, YOU'D THINK THEY HAD WON THE BATTLE!

SEND SOMEONE TO FIND OUT WHAT'S GOING ON.

THE MESSENGER RETURNS WITH STARTLING NEWS...

THEY'VE BROUGHT THE ARK OF THEIR GOD INTO CAMP.

YOU MEAN—THE SAME GOD WHO SENT SO MANY PLAGUES ON THE EGYPTIANS THAT THEY HAD TO FREE THE ISRAELITES? HOW CAN WE FIGHT THAT KIND OF POWER?

IF WE DON'T, WE'LL BE SLAVES TO THE ISRAELITES WHO HAVE BEEN _OUR_ SLAVES ...COME ON, LET'S TAKE THE ADVANTAGE AND STRIKE FIRST!

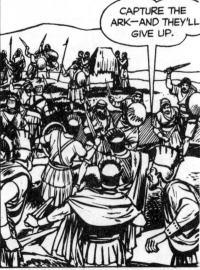

THE PHILISTINES ATTACK! BUT THE ISRAELITES, BELIEVING IN THE POWER OF THE ARK, COUNTER ATTACK WITH SUDDEN FURY.

CAPTURE THE ARK—AND THEY'LL GIVE UP.

THE ARK IS CAPTURED, AND THE ISRAELITES FLEE IN TERROR. A MESSENGER TAKES THE NEWS TO ELI...

THE BATTLE IS LOST—YOUR SONS ARE DEAD—AND THE PHILISTINES HAVE CAPTURED THE ARK.

THE ARK! CAPTURED?

AT THE NEWS, ELI FALLS AND BREAKS HIS NECK. MEANWHILE THE PHILISTINES TRIUMPHANTLY CARRY THE ARK HOME AND PLACE IT IN THE TEMPLE OF THEIR GOD, DAGON.

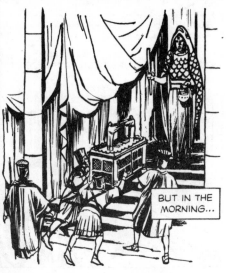

BUT IN THE MORNING...

The Turning Point

FROM I SAMUEL 5: 3—7: 10

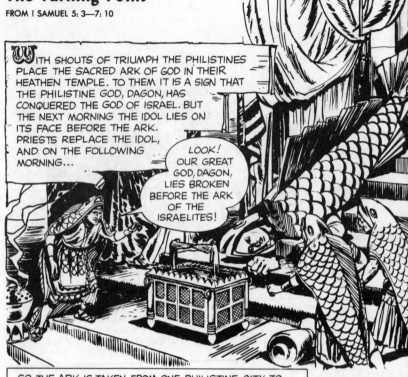

WITH SHOUTS OF TRIUMPH THE PHILISTINES PLACE THE SACRED ARK OF GOD IN THEIR HEATHEN TEMPLE. TO THEM IT IS A SIGN THAT THE PHILISTINE GOD, DAGON, HAS CONQUERED THE GOD OF ISRAEL. BUT THE NEXT MORNING THE IDOL LIES ON ITS FACE BEFORE THE ARK. PRIESTS REPLACE THE IDOL, AND ON THE FOLLOWING MORNING...

LOOK! OUR GREAT GOD, DAGON, LIES BROKEN BEFORE THE ARK OF THE ISRAELITES!

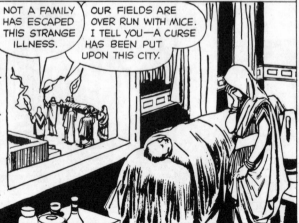

SO THE ARK IS TAKEN FROM ONE PHILISTINE CITY TO ANOTHER...AND IN EACH CITY A PLAGUE BREAKS OUT...

NOT A FAMILY HAS ESCAPED THIS STRANGE ILLNESS.

OUR FIELDS ARE OVER RUN WITH MICE. I TELL YOU—A CURSE HAS BEEN PUT UPON THIS CITY.

THE PHILISTINES SOON REALIZE THAT THEIR TROUBLES BEGAN WHEN THEY CAPTURED THE HOLY ARK OF ISRAEL. FINALLY THEY RETURN THE ARK TO ISRAEL, BUT ISRAEL IS WORSHIPING IDOLS. THE ARK IS PLACED IN A HOUSE AND ALMOST FORGOTTEN.

BUT AFTER YEARS OF STRUGGLE UNDER THE PHILISTINES, THE ISRAELITES ARE READY TO LISTEN WHEN SAMUEL SPEAKS...

RETURN TO THE LORD! WORSHIP HIM WITH ALL YOUR HEARTS, AND GOD WILL DELIVER YOU FROM THE PHILISTINES.

SAMUEL IS RIGHT! LET US THROW AWAY OUR IDOLS•AND WORSHIP GOD.

LET US ALL GO TO THE CITY OF MIZPEH AND PRAY TOGETHER!

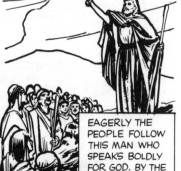

EAGERLY THE PEOPLE FOLLOW THIS MAN WHO SPEAKS BOLDLY FOR GOD. BY THE THOUSANDS THEY SET OUT...

BUT THE GREAT MARCH TO MIZPEH IS DISCOVERED BY THE PHILISTINES.

IF THOUSANDS OF ISRAELITES ARE MASSING AT MIZPEH IT CAN MEAN ONLY ONE THING — THEY PLAN TO ATTACK US.

LET'S STRIKE BEFORE THEY DO, AND **THIS** TIME WE'LL CRUSH THEM SO BADLY THEY'LL NEVER FIGHT AGAIN!

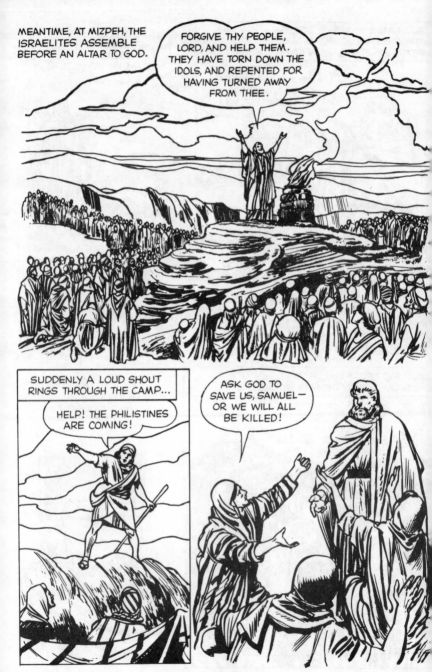

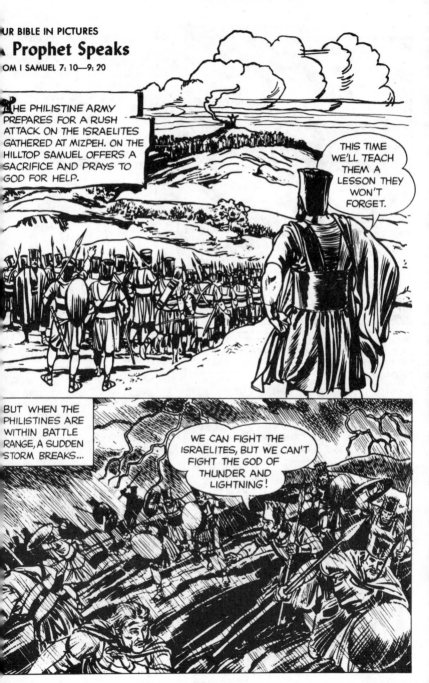

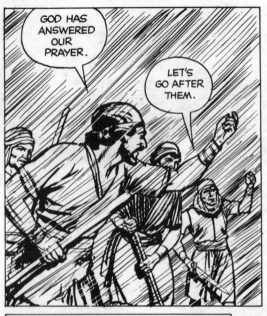

GOD HAS ANSWERED OUR PRAYER.

LET'S GO AFTER THEM.

THE PHILISTINE DEFEAT IS A TURNING POINT IN ISRAEL'S HISTORY—NEVER AGAIN DO THE PHILISTINES INVADE ISRAEL WHILE SAMUEL IS ITS LEADER. TO REMIND HIS PEOPLE THAT IT WAS GOD WHO HELPED THEM WIN THEIR VICTORY, SAMUEL ERECTS A STONE WHICH HE CALLS EBENEZER (STONE OF HELP).

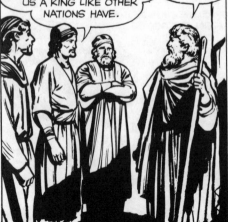

FOR YEARS SAMUEL JUDGES THE PEOPLE OF ISRAEL, AND THERE IS PEACE. BUT AS HE GROWS OLD THE TRIBAL LEADERS BECOME WORRIED...

SAMUEL, YOU ARE GROWING OLD, AND YOUR SONS ARE NOT WORTHY TO TAKE YOUR PLACE AS JUDGE OF ISRAEL. GIVE US A KING LIKE OTHER NATIONS HAVE.

I WILL PRAY TO GOD ABOUT YOUR REQUEST.

LATER—

THE LORD HAS TOLD ME TO WARN YOU WHAT A KING WILL DO—HE WILL SEND YOUR SONS TO BATTLE, YOUR DAUGHTERS WILL BECOME HIS SERVANTS, AND YOUR BEST CROPS WILL BE USED TO FEED HIS COURT.

MAYBE SO, BUT WE STILL WANT A KING!

282

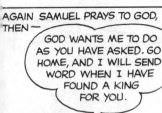

AGAIN SAMUEL PRAYS TO GOD, THEN—

GOD WANTS ME TO DO AS YOU HAVE ASKED. GO HOME, AND I WILL SEND WORD WHEN I HAVE FOUND A KING FOR YOU.

A FEW DAYS LATER SAMUEL SETS OUT EAGERLY FOR THE GATE OF THE CITY—

YESTERDAY GOD TOLD ME THAT TODAY I WOULD MEET A MAN, HERE, WHO IS THE ONE TO BE THE KING OF ISRAEL.

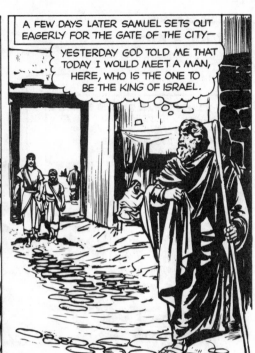

AT THE GATE, A YOUNG FARMER WHO IS LOOKING FOR HIS LOST DONKEYS STOPS SAMUEL.

I NEED HELP. CAN YOU TELL ME WHERE I MIGHT FIND THE PROPHET, SAMUEL?

I AM THE PROPHET. DON'T WORRY ABOUT YOUR DONKEYS —THEY HAVE BEEN FOUND. COME WITH ME TO WORSHIP THE LORD, AND TOMORROW I WILL TELL YOU WHAT GREAT THINGS ARE IN STORE FOR YOU.

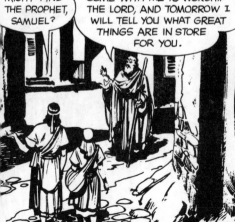

GREAT THINGS— FOR ME? WHAT DOES HE MEAN?

Test for a King

FROM I SAMUEL 9: 20—11: 7

THE YOUNG FARMER, SAUL, IS STUNNED WHEN SAMUEL TELLS HIM THAT GREAT THINGS ARE IN STORE FOR HIM. THEY WORSHIP GOD TOGETHER, THEN SAMUEL INVITES SAUL TO A SPECIAL FEAST.

WHY SHOULD THIS YOUNG MAN BE SO HIGHLY HONORED?

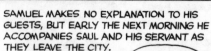

SAMUEL MAKES NO EXPLANATION TO HIS GUESTS, BUT EARLY THE NEXT MORNING HE ACCOMPANIES SAUL AND HIS SERVANT AS THEY LEAVE THE CITY.

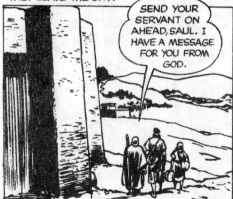

SEND YOUR SERVANT ON AHEAD, SAUL. I HAVE A MESSAGE FOR YOU FROM GOD.

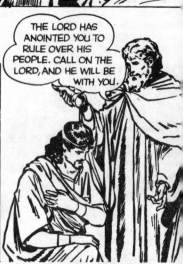

THE LORD HAS ANOINTED YOU TO RULE OVER HIS PEOPLE. CALL ON THE LORD, AND HE WILL BE WITH YOU.

SURPRISED—AND A LITTLE FRIGHTENED—AT ALL THAT HAS HAPPENED TO HIM, SAUL STARTS HOME. BUT ON THE WAY THE SPIRIT OF GOD COMES TO HIM. HOWEVER, WHEN HE REACHES HOME, HE DOES NOT TELL ANYONE THAT HE HAS BEEN ANOINTED KING!

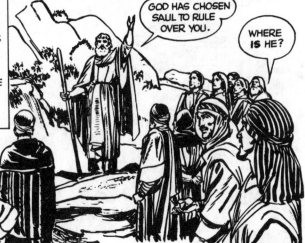

WHEN SAMUEL CALLS THE PEOPLE TO MIZPEH, SAUL GOES, TOO. BEFORE ALL ISRAEL SAMUEL MAKES A SURPRISING ANNOUNCEMENT.

GOD HAS CHOSEN SAUL TO RULE OVER YOU.

WHERE **IS** HE?

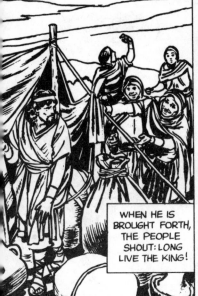

A SEARCH IS QUICKLY MADE, AND SAUL—WHO IS AWED BY THE THOUGHT OF BEING KING—IS FOUND HIDING.

WHEN HE IS BROUGHT FORTH, THE PEOPLE SHOUT: LONG LIVE THE KING!

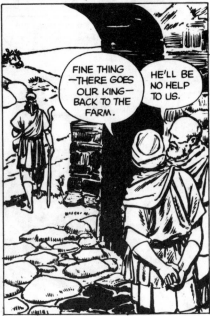

AT MIZPEH THE PEOPLE SHOUTED THEIR PRAISES TO SAUL—BUT AFTER HE RETURNS HOME, SOME COMPLAIN.

FINE THING —THERE GOES OUR KING— BACK TO THE FARM.

HE'LL BE NO HELP TO US.

SAUL'S TEST AS A LEADER COMES WHEN HE RETURNS HOME FROM HIS FIELDS ONE DAY AND FINDS THE WHOLE VILLAGE WEEPING.

WHAT'S THE MATTER?

HAVEN'T YOU HEARD? THE AMMONITES HAVE SURROUNDED JABESH. THEY THREATEN TO PUT OUT AN EYE OF EVERY MAN IN THE CITY.

WE'LL SHOW THE AMMONITES THEY CAN'T THREATEN ISRAEL!

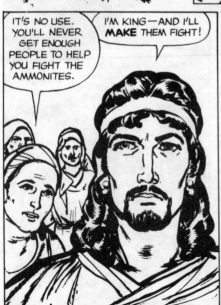

IT'S NO USE. YOU'LL NEVER GET ENOUGH PEOPLE TO HELP YOU FIGHT THE AMMONITES.

I'M KING—AND I'LL **MAKE** THEM FIGHT!

BIG TALK—BUT WAIT UNTIL HE TRIES TO BACK IT UP.

286

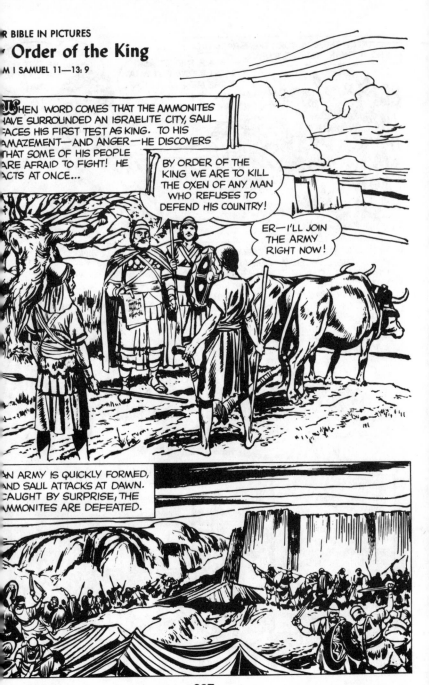

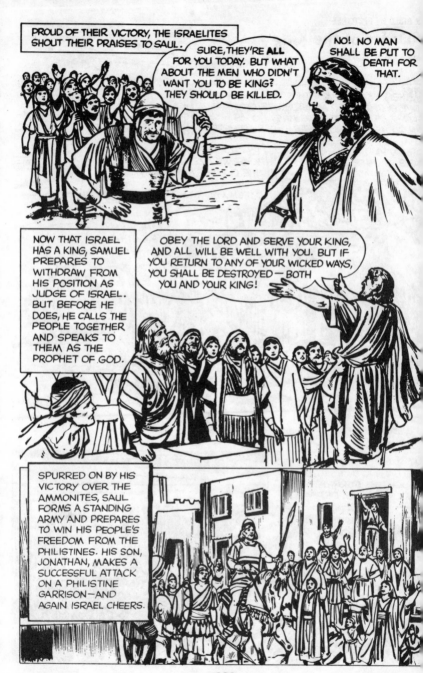

PROUD OF THEIR VICTORY, THE ISRAELITES SHOUT THEIR PRAISES TO SAUL.

SURE, THEY'RE **ALL** FOR YOU TODAY. BUT WHAT ABOUT THE MEN WHO DIDN'T WANT YOU TO BE KING? THEY SHOULD BE KILLED.

NO! NO MAN SHALL BE PUT TO DEATH FOR THAT.

NOW THAT ISRAEL HAS A KING, SAMUEL PREPARES TO WITHDRAW FROM HIS POSITION AS JUDGE OF ISRAEL. BUT BEFORE HE DOES, HE CALLS THE PEOPLE TOGETHER AND SPEAKS TO THEM AS THE PROPHET OF GOD.

OBEY THE LORD AND SERVE YOUR KING, AND ALL WILL BE WELL WITH YOU. BUT IF YOU RETURN TO ANY OF YOUR WICKED WAYS, YOU SHALL BE DESTROYED — BOTH YOU AND YOUR KING!

SPURRED ON BY HIS VICTORY OVER THE AMMONITES, SAUL FORMS A STANDING ARMY AND PREPARES TO WIN HIS PEOPLE'S FREEDOM FROM THE PHILISTINES. HIS SON, JONATHAN, MAKES A SUCCESSFUL ATTACK ON A PHILISTINE GARRISON — AND AGAIN ISRAEL CHEERS.

BUT WHEN WORD REACHES THE MAIN ARMY OF THE PHILISTINES...

TAKE THIRTY THOUSAND CHARIOTS, SIX THOUSAND HORSEMEN AND ALL OUR INFANTRY—SET UP A CAMP AT MICHMASH. FROM THERE WE CAN SEND OUT RAIDING PARTIES THAT WILL DRAW SAUL FROM HIS STRONGHOLD AT GILGAL.

IN SPITE OF FORMER VICTORIES MANY OF THE ISRAELITES LOSE COURAGE WHEN THEY SEE THE SIZE OF THE ENEMY FORCES.

THE PHILISTINES OUTNUMBER US BY THOUSANDS. I'M HIDING OUT UNTIL THIS IS OVER.

THERE'S A PIT DOWN THE VALLEY— I'LL HIDE THERE.

EVEN IN THE CAMP OF KING SAUL, THE SOLDIERS ARE AFRAID.

A RAID ON A PHILISTINE GARRISON IS ONE THING—FIGHTING THE WHOLE PHILISTINE ARMY IS ANOTHER.

THE MEN ARE LOSING THEIR NERVE. WE CAN'T WAIT MUCH LONGER FOR SAMUEL TO COME AND OFFER THE SACRIFICE TO GOD.

YOU'RE RIGHT. WE'LL WAIT NO LONGER. **I'LL** MAKE THE OFFERING!

The King Disobeys

FROM I SAMUEL 13: 10—15: 14

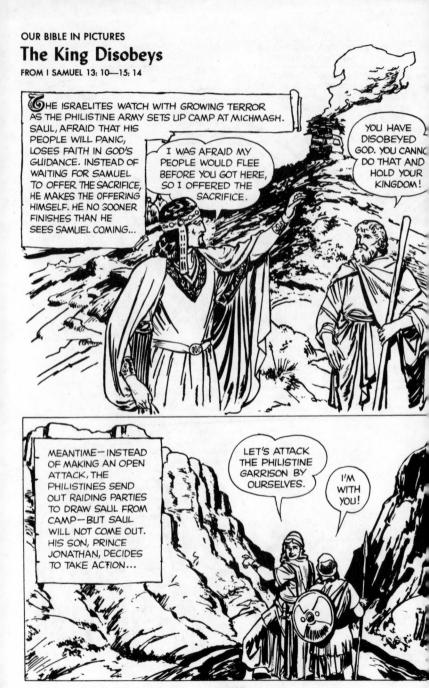

THE ISRAELITES WATCH WITH GROWING TERROR AS THE PHILISTINE ARMY SETS UP CAMP AT MICHMASH. SAUL, AFRAID THAT HIS PEOPLE WILL PANIC, LOSES FAITH IN GOD'S GUIDANCE. INSTEAD OF WAITING FOR SAMUEL TO OFFER THE SACRIFICE, HE MAKES THE OFFERING HIMSELF. HE NO SOONER FINISHES THAN HE SEES SAMUEL COMING...

I WAS AFRAID MY PEOPLE WOULD FLEE BEFORE YOU GOT HERE, SO I OFFERED THE SACRIFICE.

YOU HAVE DISOBEYED GOD. YOU CANNO DO THAT AND HOLD YOUR KINGDOM!

MEANTIME—INSTEAD OF MAKING AN OPEN ATTACK, THE PHILISTINES SEND OUT RAIDING PARTIES TO DRAW SAUL FROM CAMP—BUT SAUL WILL NOT COME OUT. HIS SON, PRINCE JONATHAN, DECIDES TO TAKE ACTION...

LET'S ATTACK THE PHILISTINE GARRISON BY OURSELVES.

I'M WITH YOU!

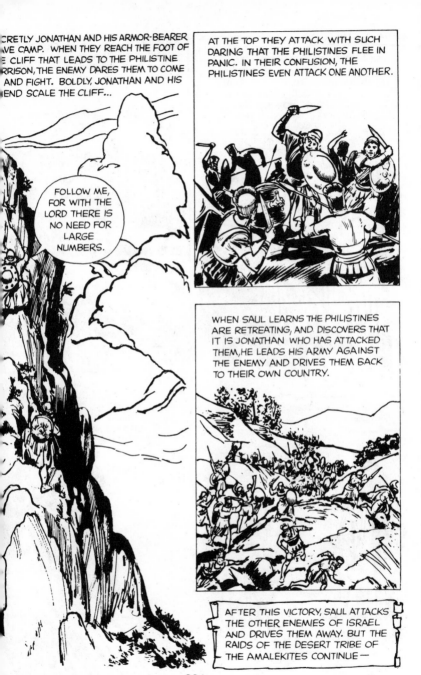

...CRETLY JONATHAN AND HIS ARMOR-BEARER ...VE CAMP. WHEN THEY REACH THE FOOT OF ...E CLIFF THAT LEADS TO THE PHILISTINE ...RRISON, THE ENEMY DARES THEM TO COME ...AND FIGHT. BOLDLY, JONATHAN AND HIS ...END SCALE THE CLIFF...

FOLLOW ME, FOR WITH THE LORD THERE IS NO NEED FOR LARGE NUMBERS.

AT THE TOP THEY ATTACK WITH SUCH DARING THAT THE PHILISTINES FLEE IN PANIC. IN THEIR CONFUSION, THE PHILISTINES EVEN ATTACK ONE ANOTHER.

WHEN SAUL LEARNS THE PHILISTINES ARE RETREATING, AND DISCOVERS THAT IT IS JONATHAN WHO HAS ATTACKED THEM, HE LEADS HIS ARMY AGAINST THE ENEMY AND DRIVES THEM BACK TO THEIR OWN COUNTRY.

AFTER THIS VICTORY, SAUL ATTACKS THE OTHER ENEMIES OF ISRAEL AND DRIVES THEM AWAY. BUT THE RAIDS OF THE DESERT TRIBE OF THE AMALEKITES CONTINUE—

FINALLY SAMUEL CALLS SAUL TO HIM...

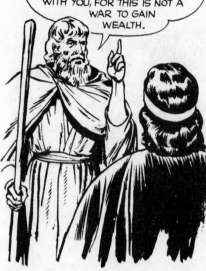

THE LORD WANTS YOU TO DESTROY THE AMALEKITES WHO HAVE BEEN ENEMIES OF ISRAEL EVER SINCE OUR PEOPLE LEFT EGYPT. BRING NOTHING AWAY WITH YOU, FOR THIS IS NOT A WAR TO GAIN WEALTH.

SAUL ATTACKS THE AMALEKITES AND DRIVES THEM BACK TOWARD EGYPT, B HE BRINGS THE BEST OF THE SHEEP A OXEN HOME WITH HIM.

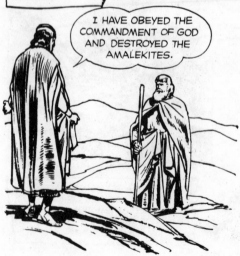

AT GILGAL, HE COMES FACE TO FACE WITH SAMUEL...

I HAVE OBEYED THE COMMANDMENT OF GOD AND DESTROYED THE AMALEKITES.

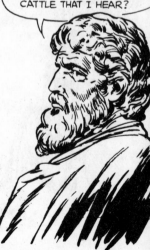

IF YOU HAVE OBEYED GOD, THEN WHAT IS THE MEANING OF THIS NOISE OF SHEEP AND CATTLE THAT I HEAR?

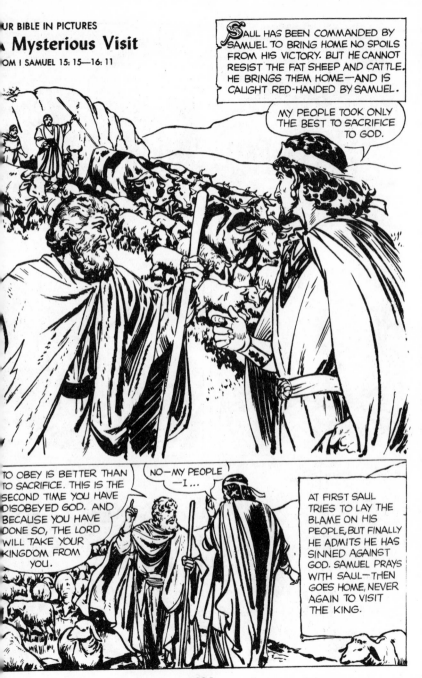

A Mysterious Visit

SAUL HAS BEEN COMMANDED BY SAMUEL TO BRING HOME NO SPOILS FROM HIS VICTORY. BUT HE CANNOT RESIST THE FAT SHEEP AND CATTLE. HE BRINGS THEM HOME—AND IS CAUGHT RED-HANDED BY SAMUEL.

MY PEOPLE TOOK ONLY THE BEST TO SACRIFICE TO GOD.

TO OBEY IS BETTER THAN TO SACRIFICE. THIS IS THE SECOND TIME YOU HAVE DISOBEYED GOD. AND BECAUSE YOU HAVE DONE SO, THE LORD WILL TAKE YOUR KINGDOM FROM YOU.

NO—MY PEOPLE —I...

AT FIRST SAUL TRIES TO LAY THE BLAME ON HIS PEOPLE, BUT FINALLY HE ADMITS HE HAS SINNED AGAINST GOD. SAMUEL PRAYS WITH SAUL—THEN GOES HOME, NEVER AGAIN TO VISIT THE KING.

293

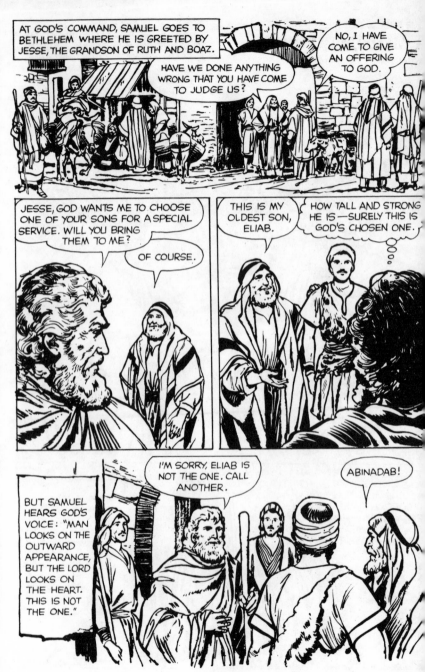

294

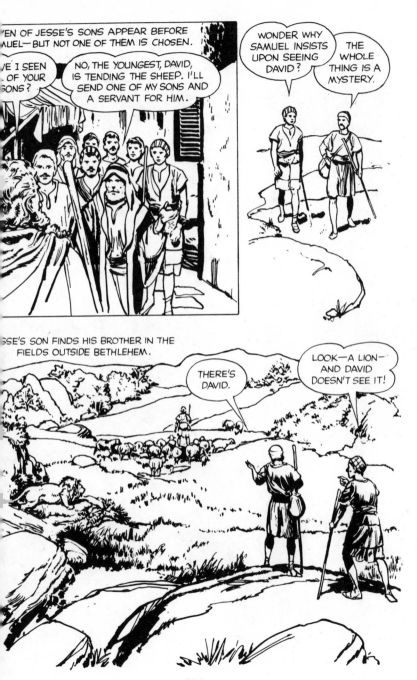

295

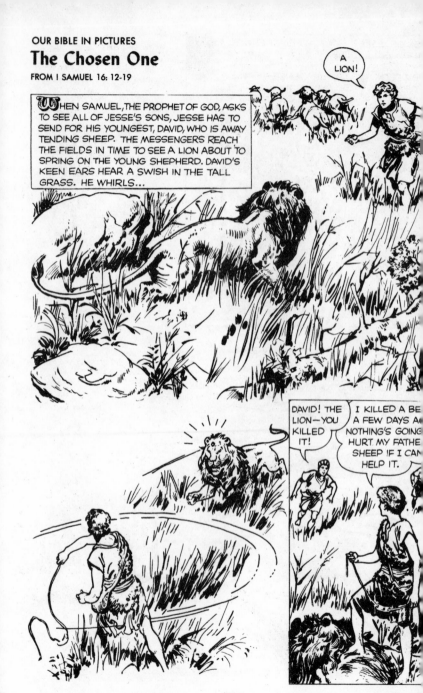

YOU'RE A BRAVE SHEPHERD, DAVID. BUT HURRY HOME—SAMUEL WANTS TO SEE YOU. I'VE BROUGHT A MAN TO STAY WITH THE SHEEP.

ME? BUT WHY?

ON THE HIKE BACK TO THE CITY, DAVID CONTINUES TO WONDER. BUT WHEN SAMUEL SEES THE YOUNG SHEPHERD BOY, HE KNOWS HIS SEARCH HAS ENDED, FOR HE HEARS GOD SAY: *"THIS IS MY CHOSEN ONE."*

BEFORE JESSE AND HIS SONS, SAMUEL BLESSES DAVID AND ANOINTS HIS HEAD WITH OIL.

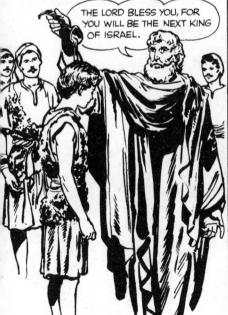

THE LORD BLESS YOU, FOR YOU WILL BE THE NEXT KING OF ISRAEL.

DAVID DOES NOT KNOW WHEN HE WILL BE MADE KING. BUT AS HE GOES BACK TO HIS SHEEP HE HAS A SPECIAL FEELING OF GOD'S PRESENCE WITH HIM.

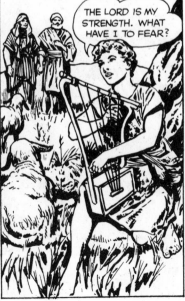

THE LORD IS MY STRENGTH. WHAT HAVE I TO FEAR?

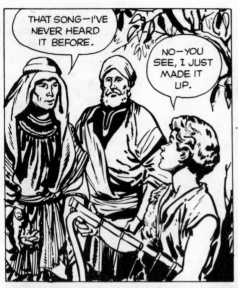

THAT SONG—I'VE NEVER HEARD IT BEFORE.

NO—YOU SEE, I JUST MADE IT UP.

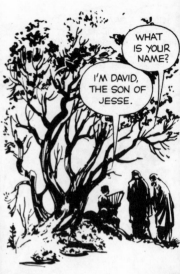

WHAT IS YOUR NAME?

I'M DAVID, THE SON OF JESSE.

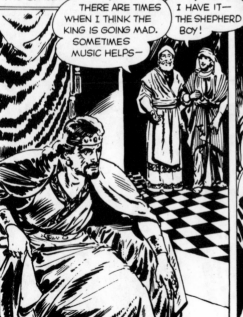

BACK AT THE PALACE THE MEN GO TO SEE KING SAUL—BUT THEY FIND HIM STARING WILDLY INTO SPACE.

THERE ARE TIMES WHEN I THINK THE KING IS GOING MAD. SOMETIMES MUSIC HELPS—

I HAVE IT— THE SHEPHERD BOY!

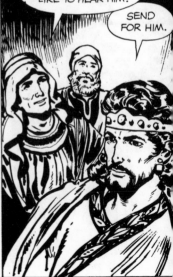

O KING, WE KNOW A YOUNG SHEPHERD WHO PLAYS THE HARP AND SINGS BEAUTIFUL SONGS. IT IS PLAIN THAT GOD IS WITH THE BOY. WOULD YOU LIKE TO HEAR HIM?

SEND FOR HIM.

298

Bible Reading

For the family . .

For the under 7's

Simon and Sarah

Bible truths are presented
in a way which young members
of the family will understand and enjoy.

Six-year-old Simon,
and Sarah, who is five,
discover many new and exciting
things about God through
their everyday lives and experiences.
The series of twelve books
may be started at any point,
as each book is a separate
unit, containing thirty days'
material.

*Fully illustrated with things to do
and pictures to colour.*

For the 7–8's

Stepping Stones

Stepping Stones are 12 books, designed for the boy or girl who has completed the 'Simon and Sarah' books but is not yet ready for 'Quest'.

This series takes the major stories and characters of the Bible and shows vividly how they apply to the life experiences of boys and girls today.

They are fully illustrated and contain a complete range of puzzles, quizzes and other activity materials.

A New look for . .

quest *8-11's*

Covers carefully selected parts of the
Bible over a two-year period.
 Pictures, puzzles, questions to answer
. . . all help to aid understanding of the
Bible readings.

key notes *11-14's*

Interesting and lively comment on a large
part of the Bible over a four-year period.
The series gives many opportunities for
personal discovery and practical
application.

As from 1979 both these publications will
take on a new, larger format, making it
possible to present the notes in a more
imaginative and lively way.
Quest and Key Notes will continue to be
dated and published quarterly.

For older teens and adults . .

LIVING TRUTH

Four paperbacks for new
Christians who want to come
to grips with the teaching of
the New Testament.

A popular style and a popular
version (Living Bible) lead
the reader into a developing
awareness of God's message
for today. Cartoon illustra-
tions give the series an
instant-tell appeal.

LOVING THE JESUS WAY
GOING THE JESUS WAY
LIVING THE JESUS WAY
GROWING THE JESUS WAY

DAILY BREAD

Daily Bread notes give straightforward
devotional and practical comment and cover
most of the Bible in four years. This popular
series is enjoyed by a wide variety of people.

Dated and published quarterly.

TODAY

Designed like a newspaper with topical photos,
headlines and human situations with which the
reader can easily identify, showing that the Bible
is relevant to everyday life. Discussion questions
with Bible references make it useful for any
type of group as well as for individuals. There
are eight magazines of 32 pages, each giving
three months' readings.